POMPEII'S LIVING STATUES

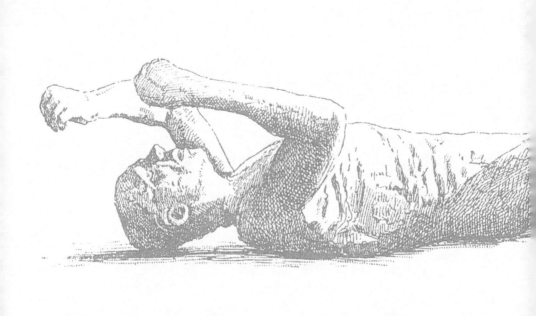

POMPEII'S LIVING STATUES

Ancient Roman Lives Stolen from Death

Eugene Dwyer

The University of Michigan Press

Ann Arbor

First paperback edition 2013

Published in the United States of America by
The University of Michigan Press
Printed and bound by CPI Group (UK) Ltd, Croydon, CR0 4YY

2016 2015 2014 2013 5 4 3 2

A CIP catalog record for this book is available from the British Library.

Library of Congress Cataloging-in-Publication Data

Dwyer, Eugene J.
 Pompeii's living statues : ancient Roman lives stolen from death /
Eugene Dwyer.
 p. cm.
 Includes bibliographical references and index.
 ISBN 978-0-472-11727-7 (cloth : alk. paper)
 1. Pompeii (Extinct city)—Antiquities. 2. Excavations
(Archaeology)—Italy—Pompeii (Extinct city) 3. Fiorelli, Giuseppe,
1823–1895. 4. Human remains (Archaeology)—Italy—Pompeii (Extinct
city)—History. 5. Disaster victims—Italy—Pompeii (Extinct city)—
History. 6. Plaster casts—History. 7. Figure sculpture—Italy—
Pompeii (Extinct city)—History. 8. Dead in art—History.
9. Archaeology and history—Italy—Pompeii (Extinct city) I. Title.
DG70.P7D89 2010
937'.7256807—dc22 2009052180

Frontispiece: Victim No. 14 (Drawing by Gusman [after Sommer?].)

ISBN 978-0-472-03550-2 (pbk. : alk. paper)

If I shall be fortunate enough to encounter new bodies among the ashes, being better equipped with all the means necessary for obtaining good results in a work of such importance, my casts will come out more perfectly. For now it is a satisfactory compensation for the most exacting labors to have opened the way to obtaining an unknown class of monuments, through which archaeology will be pursued not in marbles or in bronzes, but over the very bodies of the ancients, carried off by death, after eighteen centuries of oblivion.

—GIUSEPPE FIORELLI (1863)

Whoever beholds these most noteworthy of all statues that the world possesses considers them not without deep emotion. For what was once only the fantasy that a poet might have conjured up, he has in full-blown reality in front of him, and as evidence of the moment itself.

—FERDINAND GREGOROVIUS (1884)

Preface

"Stolen from death"—*rapiti alla morte,* were the words used by the archaeologist Giuseppe Fiorelli to describe his sensational discoveries. The modern science of archaeology had succeeded in winning back the nameless victims of an ancient catastrophe by casting them in plaster as they lay frozen in their last moments of life. The news was carried around the world; the results were recorded in the new medium of photography. The promise of a new day, which had recently witnessed the rebirth of Italy, was good news for humanity. In 1863 it seemed that science was on the verge of obtaining what religion had heretofore failed to achieve. If the explanation recently offered by Göran Blix for the phenomenal popular success of archaeology during the nineteenth century is correct, the recovery of Pompeii's victims (all of them) was only a matter of time. The prospect of recovering the history, if not the actual body, of everyone who had lived at an earlier time was compensation for the loss of belief in Heaven. In a provocative essay on the sense—or absence—of time in early studies of Pompeii, Eric Moormann has shown that it became fashionable to regard Pompeii as a city with its own predestruction history only after about 1860. Before that, the city was seen as an ideal, subject to timeless description. Afterward, a new wave of materialist historians gave the world a new picture of Pompeii: the city stripped of its timeless glory and revealed as a second- or third-rate Roman provincial town. With the beginning of historical archaeology began Pompeii's fall from grace. Fiorelli's casts came at the precise moment of Pompeii's transition from ideal to reality. Moor-

mann has drawn attention to an extraordinary contemporary appreciation of this moment by the poet Renato Fucini (1843–1921):

> Of all its beautiful sister cities of Magna Grecia, Pompeii is the city which knew best how to die, because violent death by asphyxiation is the only death suitable to beauty. Among the gigantesque ruins of Agrigento and of Syracuse, among their skeletons corroded by time, the archaeologist can study nothing but osteology, while the cadaver of Pompeii has all of its members intact. Its blood has stopped flowing, but has not lost its red color which gleams under its soft skin. The breath has ceased and the body is not decayed.[1]

Though he was much indebted to the archaeology of Giuseppe Fiorelli, the poet conjures up the timeless Pompeii of the Romantics. The ideal city seems to Fucini to be the embodiment of one of Fiorelli's Pompeians, "stolen from death." Like the Pompeian casts, the city of Pompeii still bore its flesh and seemed to express life. How different from the "osteology" of the anatomist or the lifeless nudes favored by the academic artists. Fiorelli's cadavers displayed the struggle of life against death, a quality that is lost once a body has been laid out for burial through the mediation of the living. A similar response to the immediacy of the Pompeian victims can be found in the account of the journalist Cesira Pozzolini-Siciliani published at about the same time as Fucini's: "Although cold and petrified like statues, in the midst of all these dead things one might say that they impart some motion and a certain feeling of life." Like Fucini, Pozzolini was struck by the fact that the skeletal remains had been enveloped by bodily tissues that, although long since wasted away, had left their distinct form in the volcanic matrix. The casts, with their skeletal support, were an *additive* medium, rather than the normally *subtractive* medium of plaster casts. They were, in fact, skeletons clothed in plaster, auto-icons with the "presence" or "inherence" of real human beings.[2] Yet, at the same time, they were also works of art.

It would appear that Fucini represented a voice against progress, yet

there is much in the story of Fiorelli's casts to show that the leading scientists of the day also shared in the poet's sense of the loss of innocence. By the end of the century, it would become clear as well that scientific archaeology would, in the end, fail to save the Pompeians. Nevertheless, popular beliefs persist: Pompeii was not frozen in time. It is more useful to think of it as a movie that has been running continuously since antiquity, speeding up from the time of the city's rediscovery 250 years ago. For those of us who have come in late, there is a good chance that we missed some important things. If this metaphor does not satisfy, think of the excavation at Pompeii as a fire that has been spreading for 250 years, consuming bits and pieces of the surrounding landscape. As in any fire, the fuel is constantly being reduced as the center deteriorates. The brightest parts are to be seen at the periphery. So, too, at Pompeii, the brightest walls are those most recently excavated. After a few years, the frescoes become dull and the plaster falls. If we combine the two metaphors, we can see the advantage of reviewing some of the footage shot earlier—in the case of the first plaster casts of Pompeian victims, at a time when the fire was burning in the very center of the city (see map). Most of the individuals covered in this book died well within the confines of the city, with no hope of escape. Strangely, most of them perished well above street level. These victims represent a small number—about 1 percent—of the total population killed in the eruption. Their effect on nineteenth-century viewers, seen directly in Fiorelli's museum or indirectly through photographs, was palpable. By demonstrating in the most graphic way possible that the destruction of Pompeii was a real inferno and that the Pompeians were comparable with other victims of fire and flood, that they were not especially beautiful, and that they wore pants like everyone else, the casts did their part in tearing down the classical ideal. For that, they are no less wonderful. No other archaeological context anywhere in the world has so far yielded anything remotely comparable.

Throughout the text I make use of the standard system of referring to Pompeian locations by (1) a Roman numeral indicating one of the city's nine *regions*, followed by (2) an Arabic numeral indicating a *block*

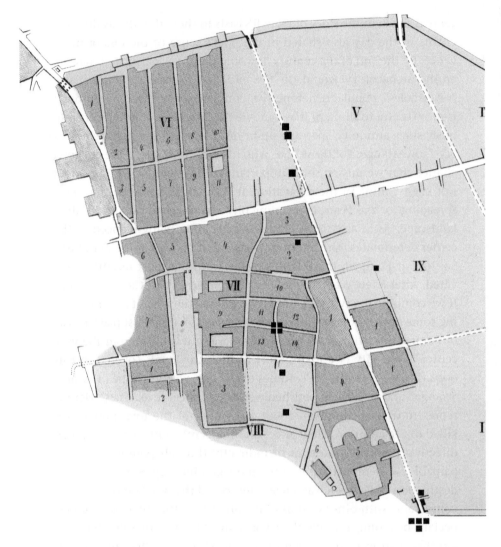

Pompeii excavations, 1868–, with locations of victims indicated. (Adapted from *Giornale degli scavi di Pompei*, n.s., 1 [1868].)

or *insula* within this region, and (3) one or more Arabic numerals indicating individually numbered *entryways* within the block (e.g., VIII.4.1/53).

This book attempts to tell the story of how the first casts came to be, how a second generation of better casts took their place, and how the fame of casts of both generations was managed through their exhibition on site and spread by the new photographic media. It will attempt to show how the photographic medium initially supplemented precise verbal descriptions and eventually came to the forefront in the process of validating the casts first as individual objects and only later as objects in an archaeological context. The contemporary descriptions and the photographs have thus been presented here both as documents of artifacts that have been lost or altered by subsequent restorations and as reactions of various interpretive communities. Though the inventor of the casts, Giuseppe Fiorelli, was inclined to think of three-dimensional modeling as the ultimate form of documentation, he was quick to appreciate the value of photographs. Nevertheless, in these early days of modern archaeology, there was some tension to be found between the two forms of documentation. The meaning that the casts had for Fiorelli will be illustrated by several passages from his own writing. For many admirers of Fiorelli, it suffices to say that the casts were seen as the monument to one of the founders of modern archaeology.

The main story covered in this book arises from the history of the excavations, which can be read in the Italian sources and documents. To this may be added occasional foreign interventions—direct, as during the Napoleonic period, or indirect, as in the case of German scholarship—and foreign reception. English, French, and German correspondents played very important parts in spreading the fame of the discoveries, and the awareness of foreign response always factored in Italian policy. The story of the casts is truly international. This is the justification for translating the texts into a single language, English. The translations are my own unless otherwise credited. Infelicities abound, occasionally in the effort to preserve the tone of the original, but often, I fear, from my inability to express the author's original meaning.

This project began as an attempt to distinguish one cast from another—to devise an iconography of the casts—in the course of a National Endowment for the Humanities seminar on the history of collections. Why not treat the famous plaster casts from Pompeii as a collection, I thought—write an iconography of the casts, so to speak? It soon became apparent that others had been that way before: Fiorelli himself; the photographers Michel Amodio, Giorgio Sommer, Roberto Rive, and Giacomo Brogi, who produced their wonderful series of images; artists like Tito Angelini and Achille d'Orsi; and generations of visitors to Pompeii who made efforts to describe the individual casts and to collect their images in various formats. To collect images of the casts, it was necessary to collect contemporary photographs and to compare these with contemporary descriptions. An international market in information and collectibles now makes it possible to pursue this material with a computer and a postal address. When this book went to press I had not seen Estelle Lazer's *Resurrecting Pompeii*.

Years ago, through the generosity of the late Prof. Alfonso de Franciscis, superintendent of antiquities for Naples and Caserta, I had the opportunity to observe firsthand the meticulous organization and record keeping of Fiorelli and his colleagues. I can still remember reading from a scrap of paper in the archives the note of an anonymous correspondent from the excavations of Pompeii describing the making of the first plaster cast of a victim. Although I copied everything in those days, I neglected to copy this. I hope it is still there for someone else to discover.

In access and opportunities to study Pompeii, past and present, I have been the beneficiary of the high regard and affection shown to the person and now to the memory of my teacher Peter H. von Blanckenhagen by the leadership of the Pompeian excavations and the Naples Museum and by the librarians of the American Academy in Rome and the Istituto Archeologico Germanico as well as by other distinguished scholars and "Pompeianisti": Alfonso de Franciscis, Giuseppina Cerulli-Irelli, Enrica Pozzi Paolini, Stefano De Caro, Pier Giovanni Guzzo, Frank Brown, Lawrence Richardson jr., and Halsted Vander Poel. I would also like to thank each of the following friends, colleagues, and fellow schol-

ars for advice, encouragement, and help given to me at various stages of this project: Elizabeth Bartman, Sinclair Bell, Sarah Blick, Melissa Dabakis, Hartmut Döhl, Simone Dubrovic, Jane Fejfer, Laurentino García y García, Victoria Gardner Coates, Elaine Gazda, Sharon Herson, Jeffrey C. Jones, Anne Laidlaw, Claire Lyons, Babette Martini, Carol Mattusch, Robin Meador-Woodruff, Eric Moormann, John Pepple, Nancy Ramage, Angela Salas, Jon Seydl, Francesca Tronchin, Kristen Van Ausdall, Thomas Willette, and Daniel Younger. I am especially grateful to the editors of the University of Michigan Press, Ellen Bauerle, Mary Hashman, and Chris Hebert, and to Alexa Ducsay, each of whom provided valiant and timely support to this project, as did Michelle Fontenot of the Kelsey Museum. I would also like to express my gratitude to the Kelsey Museum for permission to reproduce photographs from their collection, and to the Philadelphia Museum of Art for permission to reproduce a photograph of the Franque painting in their collection. A sabbatical leave from Kenyon College provided necessary time for writing.

I dedicate this book with love to my wife Ellen Mankoff, most sympathetic and percipient of readers.

Contents

CHAPTER I

Forerunners

On 3 February 1863, Giuseppe Fiorelli, director of the Pompeii excavations, poured a dilute mixture of plaster of paris and glue into a cavity made in the soil by the body of a victim of the volcanic eruption. When the plaster had set and the cast was removed from its envelope of hardened volcanic ashes, even Fiorelli was startled by what he saw. News of the discovery spread quickly, thanks to the presence of foreign journalists in Naples.[1] The casts of three more victims followed in quick succession. The need to protect the casts led to the creation of a small museum in a house that had been excavated in the eighteenth century, which soon became a necessary stop for the growing number of visitors to Pompeii. Yet nothing spread the fame of the casts so much as the hundreds of reproductions made of them, in the form of shocking cartes de visite, cabinet prints, and stereo cards turned out by professional photographers in Naples, as well as the engraved book illustrations made after these photos. The casts of the victims rapidly altered the public image of Pompeii from the ideal city conjured up by Bulwer-Lytton at the height of the Romantic era to a more familiar and realistic site of natural disaster.

Fiorelli's "discovery" was quite simple and required no new technology. His contemporaries, without detracting from the praise that was due him, marveled that such casts had not been made before. The same opportunities—some even better—had presented themselves during the long history of digging at Pompeii, and gesso had been used by artists to cast bodies since the Renaissance.[2] Yet for a number of simple

reasons, the procedure was not and could not have been done successfully before the 1860s. The reason for this is that the casts were an artifact of a revolution in government and in science that came about only in 1860. The understanding of the science of vulcanology had first to change from what it had been earlier in the century. The attitude of the state toward archaeology and toward the treatment of human remains had first to change from what it had been earlier. Most important, the administration of the excavations at Pompeii had to change—and Giuseppe Fiorelli was the agent of change.

Almost by itself, Fiorelli's discovery and exploitation of the casts changed the purpose of archaeology from an exclusive focus on the collection and classification of artifacts to the material reconstruction of ancient history. For a century and a half previously, the mission of excavators at Herculaneum and Pompeii had been to dig up and remove to safekeeping the items of painting and sculpture, furniture, papyri, inscriptions, and even bits of architecture encountered at the two sites. For the same reason, before the "French decade" (1805–15), the state had been content merely to rent the land on which the digging took place. The king claimed the antiquities, empowered by some of the most progressive patrimony laws in Europe, but he willingly returned the land to agricultural use once it had been explored. For a brief period, first under Joseph Bonaparte and then under his successor, Joachim Murat, as kings of Naples, the state determined the full extent of the ancient city and purchased the land above it with the intention of uncovering it. The restoration of the Bourbon monarchy to the throne of Naples in 1816 slowed the pace of excavation at Pompeii, and the state even resold much of the land to private owners. The buried city of Pompeii had by that time, however, become an object of interest for tourists as an architectural entity and as a place where the modern visitor might commune with the ancient dead: Pompeii had been considered a "city of the dead" for some time before Fiorelli, in the words of Luigi Settembrini, "discovered human pain" so that "whoever is human can feel it."[3] This reputation, which was no doubt well merited, had been built on particular discoveries and monuments that preceded Fiorelli's discovery of 1863. Before looking in greater detail at

Fiorelli's discovery, it will be necessary to have a look at some of the changes in science, the nature of the excavations, and the representation of death itself that led up to it.

Despite the location of Naples between Avernus and Vesuvius, both at one time widely believed to be entrances to the Underworld, and despite the elaborate cult of death for which Naples is famous, it was the visit of two foreigners, men from beyond the Alps, that made Pompeii's reputation as the "city of the dead" and elevated the discovery and the contemplation of the bodies of ancient victims to a level of great meaning. The visits of J. J. Winckelmann between 1759 and 1765 had a transforming effect on the Neapolitans.[4] The man who was the first to treat ancient statues like living flesh and blood was the same to delight in living human beings as if they were ancient works of art. Yet his influence on the study of the dead at Pompeii was indirect. On his initial visit to Naples, he received a cool—even hostile—reception that prevented his gaining access to the most important discoveries. Subsequent visits were even more difficult, since he had an unfortunate habit of publishing his criticisms of certain members of the local establishment, pedants as well as various other types of scoundrels. Unfortunately, his visits to Herculaneum and Pompeii did not coincide with the discovery of any ancient victims, and so we are deprived of his specific comments on the Pompeian dead.[5] Nevertheless, we can infer his sentiments—what he *would* have written—from many passages in his voluminous writings that never cease to concern themselves with human life and death. One of Winckelmann's ideas about the human body and how it grew to a godlike state of perfection in the South was to find many echoes among those who, like Hippolyte Taine, visited Pompeii and its museums at a later time. Turning his attention toward the Bay of Naples, Winckelmann wrote in the *History of Ancient Art:* "The lower portion of Italy, which enjoys a softer climate than any other part of it, brings forth men of superb and vigorously designed forms, which appear to have been made, as it were, for the purposes of sculpture."[6] It was impossible for the Neapolitans to bear a grudge against a man who wrote such things, and it was even more impossible not to come around to his way of thinking. Winckelmann introduced

a new fervor, akin to the religious, into the study of antiquity. More than any other person, he was the driving force behind the neoclassical revolution that swept Europe in the 1760s.

Winckelmann's impact on the study of Herculaneum and Pompeii may be seen in his remarkable observations of the archaeological context of both sites and in his attempt to devise a unified theory of the eruption. Herculaneum, he concluded, had been buried not in lava but in fiery ash and torrential rain, whereas Pompeii and Stabiae did not experience the same amount of rain, for their ash was of a looser composition.[7] Winckelmann also concluded, too hastily as it turned out, that the inhabitants of Pompeii and Stabiae, like those of Herculaneum, had had sufficient time to flee the volcano and save their lives.[8] He apparently knew of no bodies found at either Pompeii or Herculaneum but only of those found at Stabiae (Gragnano), where "three female bodies, one of which appeared to be the maid of the other two and was carrying a wooden casket: this lay beside her and had decomposed in the ash. The two other ladies both had golden bracelets and earrings, which were sent to the museum."[9] In Pompeii, Winckelmann noted, many heavy items had been discarded far from their original location in their houses by those fleeing. Unfortunately, he gave no examples in support of this attractive theory. His lasting contribution to the archaeology of these sites, however, was to see them as places where human activity took place and left evidence.

Two of the greatest finds of victims overcome by the final phase of the eruption—namely, the victims found in the Temple of Isis and those in the Barracks of the Gladiators—were made just after Winckelmann's last visit to Pompeii.[10] At the beginning of the year 1765, the excavators passed from the Theater to what they soon recognized as a temple of Isis.[11] This site was immediately recognized as something that had never been seen before: a fully decorated ancient temple. Its discovery dictated an entirely new archaeological policy, as it became the first site in Pompeii to be excavated without being intended for reburial. Although it was most prized for its paintings and sculptures, the temple also preserved the remains of several of its priests. The *Giornale* of the excavators mentions but one skeleton, found in the kitchen near

a table and lying on some chicken bones.[12] There is, however, some indirect evidence that more human remains were uncovered. François de Paule Latapie, writing in 1776, mentioned a stunning discovery:

> In another room adjoining the refectory there was found a skeleton with a bronze axe, having attempted to break through the wall next to him. It is not unreasonable to suppose that he was a sacrificant who, being unable to flee by means of the courtyard, where the volcanic debris was too abundant, had attempted to make his way through the opposite wall.[13]

Although not recorded in the *Giornale,* this discovery entered into the growing literature on Pompeii, being mentioned by Mazois and by Dyer and even forming part of the action in the last frantic episode of Bulwer-Lytton's *Last Days of Pompeii* (1834). Bulwer-Lytton, who displayed a talent for interpreting archaeological evidence and was well advised in Pompeian matters by the reigning English antiquary of the time, Sir William Gell, seems to have made an effort to incorporate into his narrative the fates of nearly all the colorful victims known before 1832. In the case of the axe-wielding Isis priest, the story that was passed along to Bulwer-Lytton was far more interesting than the official record in the *Giornale* would lead us to have expected. This particular victim who died in an attempt to escape burial by piercing a wall was the first of several such victims to be found in the course of the excavations. Although such discoveries might be subject to different interpretation—namely, as salvagers or treasure hunters who had died in their attempts to enter the ruins—it is interesting that the first body found under these circumstances was identified as a man who had been attempting to escape the volcano.[14]

Working in the vicinity of the Temple of Isis in the autumn of 1766, the excavators stumbled onto one of the most remarkable finds ever made in Pompeii or elsewhere. In a building now known as the Theater Portico, they began to find numerous fugitives, as well as quantities of bronze arms, some finely decorated in relief. At the time, they did not realize that they had come upon the remains of Pompeii's leading in-

dustry, a school of gladiators located in proximity to the theater where they may have performed. The victims, however, seem to have been a group of fugitives who had sought temporary refuge here during the last, cataclysmic phase of the eruption. While the gladiatorial armor from this single find in Pompeii now forms a spectacular exhibit in the Naples Museum, the archaeological context soon produced even more startling results. In a room adjoining the portico, excavators found a lockable stock with places for ten persons.[15] Four skeletons were found in the same room, but from the language of the *Giornale* (namely, "perhaps prisoners"), there was no clear evidence recorded that they had been found confined in the stock at the time of death.[16] The stocks were eventually sent to the Naples Museum, where they were exhibited among the "utilitarian objects."[17] The fact that the bodies were not observed to have been locked into the leg stock, however, did not prevent "the dark brain of Piranesi" (as Victor Hugo and Marguerite Yourcenar called it) from imagining the worst in a drawing now in Berlin.[18]

Because of the discoveries made in the Theater and in the Villa of Diomedes uncovered shortly afterward, the excavators began to take more careful notice of the specific context in which victims were being found. The Pompeian excavators were becoming archaeologists. In one of the rooms was found "a complete skeleton crouching on the ground—a most curious sight."[19] Another was found in the portico, "between the layers of pumice (lapilli) and ashes."[20] The excavation of the Barracks of the Gladiators also provided fuel for imaginative speculation along the same lines as Piranesi's. Bodies that are now recognized as those of fugitives who had sought refuge in the building while they were bearing their most precious belongings were once interpreted, from the gold jewelry on their persons, as rich women who had been consorting with gladiators at the time of the eruption. Such supposed impropriety did not seem to have occurred to the excavator, who simply mentioned the facts of the discovery, but it was repeated again and again during the Romantic period and may be read even now.[21] The contemporary *Giornale* author makes it very clear that the most treasure-laden group consisted of no fewer than eighteen individuals, children and dogs included.[22] The speculation, even if it did not measure up to the standards of Winckelmann, proved that everyone loved a

good story. Where bodies had been found and reported previously in the *Giornale* because they usually promised the recovery of some precious items, the writers of these reports began, as a consequence of the rich Pompeian finds, to look for evidence of the manner in which the victims perished.

Another discovery in the Barracks of the Gladiators, misinterpreted at the time, has been represented again and again as an example of the iniquity of the Pompeians. In one of the rooms, the excavators found a terracotta pot without a bottom. The pot held the bones of a creature that has subsequently been identified as a dormouse, a delicacy intended for the Roman table.[23] The *Giornale* referred to it as "a newborn creature" (*una creatura, che pare da poco nata*), and Francesco La Vega, who directed the excavations, identified the bones as the "bones of a child" (*ossa di fanciullo*).[24] With time, the fevered imagination of antiquaries and tourists embellished the earlier suspicions, so that the object came to be described by Austen Henry Layard, in the *London Quarterly Review* for 1864, as "a bottomless wine-jar, in which were the bones of a new-born child." "Were these the proofs," he speculated, "of a crime committed by one of the miserable inmates of the prison?"[25]

In 1769, the year following Winckelmann's tragic death, the young Austrian emperor Joseph II paid a visit to his sister, Maria Carolina, the young queen of Naples. Joseph's visit had even more direct consequences for the excavations than Winckelmann's four earlier visits, since he seems to have played a decisive role in encouraging the young queen to become involved in archaeological matters. La Vega's entry in the *Giornale* provides a rare glimpse into history, as he recorded—in uncharacteristic diary mode—a conversation that was to have serious consequences. When Joseph asked why the work at Pompeii was proceeding so slowly and with no apparent plan, he was told somewhat defensively by La Vega that "eventually all would be done."[26] The Emperor replied that Pompeii was a job for three thousand men and asked who was in charge of the operation? When La Vega answered that it was the Marchese Tanucci, the Queen showed her displeasure. It took the young queen several years to get rid of the powerful Tanucci, but she had her way in the end.

During the same fateful visit, a notable event occurred when Joseph

was taken to a subterranean room in the House of the Emperor Joseph
II (VIII.2.38/39). There, he and the rest of the party saw an intact skele-
ton, presumably of a victim who had perished in that place. "For a long
time," it is reported, "the Emperor stood reflectively before these to-
kens of an intense human drama."[27] Trite as this may seem, it appears
to have been a novelty at the time.

The same scene was repeated several years later. Traveler P.-J. O.
Bergeret de Grancourt wrote:

> In one house, among others, in the room downstairs where they must
> have done the washing, we could see all the implements, the stove, the
> washtub, etc. . . . and a heap of volcanic ash upon which rested the
> skeleton of a woman, as if, having tried to escape from the choking
> ashes coming in from all sides, she had finally fallen backwards and
> died. Everything about the placement and position of her bones indi-
> cated that this was clearly what had happened, and one remains
> stunned at the contemplation of the events of 1,700 years ago.[28]

In view of the enduring popularity of the subject, it can be inferred that
Joseph's visit introduced a new sensibility into the relations between
the living and the dead in Pompeii. The basement room of the em-
peror's reflection became the setting for the iconography of a scene that
was often to be repeated over the course of the next hundred or so
years. French architect Charles François Mazois published an engraving
of a nearly identical scene, with the costumes of the visitors adapted to
the fashions of his time (ca. 1810), as did the Englishman Henry
Wilkins in his suite of engravings of 1819 (fig. 1).[29] A new sensibility,
even more emotive, is apparent in the response of Charles Dupaty to
the sight of a room full of bones in one of the houses he visited in 1785:

> But what do I perceive in that chamber. They are ten deaths heads. The
> unfortunate wretches saved themselves here, where they could not be
> saved. This is the head of a little child: its father and mother then are
> there! Let us go up stairs again; the heart feels not at ease here.[30]

But it was an excavation in the Villa Suburbana, also known as the Villa of Diomedes, that provided the most affecting and pitiable scene of the volcano's victims. The fate of the victims in the cellar of the Villa Suburbana had long made students of Pompeii aware of the possibility of natural casts. The excavation of the gruesome scene, not surprisingly, played an important role in the evolution of modern scientific archaeology from what had previously been a hunt for treasure.

The excavator La Vega showed uncharacteristic sensibility and historical awareness in his report of the excavation:

12 December—During the past week, we have begun to remove the fill in a corridor that is covered by a vault and surrounds the garden of the house already mentioned and is some kind of cellar. When we had dug a few feet into said corridor, we found the skeletons of eighteen adults, not including a boy and a baby. It can easily be concluded that these, and perhaps others who may yet be found as we continue this excavation, were overcome in this part of the house, the most removed from suffering any damage, but which was not able to protect them from the rain of ashes, which fell after that of the lapillo and, as can be seen, was accompanied by water that found its way into all the parts where the first rain had not been able to penetrate. This inundation of highly fluid matter hardened after some time into very dense earth, so as to surround and envelop the bodies on all sides, while these perished owing to their fragility. This material has preserved the impression and the hollow. Similarly preserved is the impression of a wooden casket and one of a large stack of small wooden boards. The same fate happened to the unfortunates who were discovered. Nothing remains of their flesh but hollows and impressions in the earth, and within these the bones have hardly moved from their original configurations. The hair is preserved on some of the skulls, and some of the arrangements appear to be braided. Of their clothing, there is found only the ashes, but these preserve the texture of the material as it covered their bodies; thus one distinguishes very well both the fineness of the weaving and the coarseness. In order to preserve some evidence of that which I observed, I de-

cided to cut no less than sixteen pieces of the impressions of these bodies. In one of them can be seen the breast of a woman covered by her dress, and in all of them there are remains of garments, sometimes two or three, one on top of another. I also carefully removed a skull with the accompanying hair, and all of these things I sent to the museum. From what little that I was able to make out of the garments, it is evident that many had hoods on their heads; that these fell over their shoulders; that they wore two or three garments, one over the other; that their stockings were of woven material or of cloth cut like trousers; that some of them did not have any shoes at all. With regard to the shoes, it can be supposed that those observed would have been slaves of inferior status. It was clearly by means of the jewelry, by the fineness of the garments, and by the coins found nearby that one woman was distinguished above the others.[31]

Exactly one hundred years after this was written, Charles-Ernest Boulé elaborately paraphrased La Vega's moving account, adding, in post-Fiorellian hindsight, a lament for the opportunity that had been lost:

> Alas! The artists or the scholars who were present at the discovery had no idea to profit from such fortune, to stop the workers, to repair the damage they had done, and to pour liquid plaster into the cavities that presented themselves. They would thereby have brought back to life the heap of victims, and we would have beheld an image of a drama no less moving than the depictions of *The Massacre of Chios* or of *The Wreck of the Medusa*. A thought so simple did not occur to them.[32]

When the Romantic Dupaty visited the Villa of Diomedes, the observations he made were full of enthusiasm:

> I cannot be far from the country-house of *Aufidius;* for there are the gates of the city. Here is the tomb of the family of Diomedes. Let us rest a moment under these porticoes where the philosophers used to sit.
>
> I am not mistaken. The country-house of *Aufidius* is charming; the paintings in fresco are delicious. What an excellent effect have those

blue grounds! With what propriety, and consequently with what taste, are the figures distributed in the panels! Flora herself has woven that garland. But who has painted this Venus? This Adonis? This youthful Narcissus, in that bath? And here again, this charming Mercury? It is surely not a week since they were painted.

I like this portico round the garden; and this square covered cellar round the portico. Do these *Amphorae* contain the true Falernian? How many *consulates* has this wine been kept?[33]

Because La Vega had removed much of the evidence, Dupaty was spared the horrific sight in the cellar. He did see some of what was found there when he visited the Royal Museum in Portici:

But I must not omit one of the greatest curiosities in this celebrated cabinet: it consists in the fragments of a cement of cinders, which in one of the eruptions of Vesuvius, surprised a woman, and totally enveloped her. This cement compressed and hardened by time around her body, has become a compleat mould of it, and in the pieces here preserved we see a perfect impression of the different parts to which it adhered. One represents half of her bosom, which is of exquisite beauty; another a shoulder, a third a portion of her shape, and all concur in revealing to us that this woman was young, and that she was tall and well made, and even that she had escaped in her shift; for some pieces of linen are still adhering to the ashes.[34]

In contrast with the romanticism of Dupaty and lending support to Beulé's lament was an observation made by Joseph-Jérôme Lalande, who visited Herculaneum and Pompeii numerous times, beginning in the mid 1750s, and established himself as one of the cities' chief foreign correspondents, praised for his cool precision. Describing the bodies found beneath the Villa of Diomedes, he noted the impression of a "reversed woman" (*une femme renversée*) found in the volcanic mud, intuiting the possibility of making a positive cast, as did René de Chateaubriand, when he wrote: "Death, like a sculptor, has moulded his victim."[35]

La Vega's account of his excavation was buried in the Neapolitan archives and remained unknown until Fiorelli published it in 1860. Dupaty's travel memoir was better known but would not have become part of Pompeian literature if the Architect-Director of the excavations, Carlo Bonucci, had not referred to it in his own popular guidebook of 1827. Bonucci's pleasantly written description of the house was to influence, among others, Sir Edward Bulwer-Lytton:

> From the garden one passes into a subterranean gallery, which was well lighted and intended for summer walks. There were found some amphorae in which the wine of Vesuvius and the equally famous wine of Pompeii was aging. In this cellar were found, one next to the other, twenty skeletons, among which two were children. With them were found, in gold, one necklace, one string of blue stones, and four finger rings with incised stones; in silver, two finger rings, one hairpin, one furniture leg, and thirty-one coins; of bronze, one candelabrum, one vase, forty-four coins, and one bunch of keys. They belonged, perhaps, to the family of Aufidius and had sought refuge in this site, but they were overcome by the ash and the water, which formed a kind of mud, enveloping their bodies and accurately preserving their forms. Many fragments of this hardened ash can be seen in the Royal Museum in Naples. One preserves the form of a beautiful breast; another the contour of an arm and its adornments; another a portion of the shoulders and of the back. All show that these women were young, slim, and well proportioned but that they did not flee almost nude, as Dupaty claims, since not only the impressions of their blouses but also those of [other] clothing still remain quite visible in the impressed ash. There is also preserved the skull of one of these girls with a residue of blond hair, her back teeth, and the bone of an arm.[36]

Another famous Pompeian victim who emerged at the end of the eighteenth century was the so-called sentinel: a Roman soldier who died at his post beside the Herculaneum Gate.[37] Sir William Gell explained this phantom most eloquently:

Within this recess was found a human skeleton, of which the hand still grasped a lance. Conjecture has imagined this the remains of a sentinel, who preferred dying at his post to quitting it for the more ignominious death, which, in conformity with the severe discipline of his country, would have awaited him.[38]

While the evidence for this extraordinary discovery consisted of no more than an empty niche in Pompeii, the legend gained strength from his supposed remains in the Royal Museum. Visiting the museum in 1851, Benjamin Silliman saw "the helmet and skull of the Roman sentinel found at his post in the city gate at Pompeii, with his short sword by his side."[39] A guide of the same period mentions "a helmet of a very plain shape, with a skull in it," which "was that of a sentry" whose "arms were found alongside of him."[40] With time this myth was exploded and the sentry dismissed. A later, more critical guidebook explained: "This helmet was long shown as the one found upon the sentry who died at his post at Pompeii. It is certain however that the story is not worthy of credit, and that the so-called sentry-box was merely a tomb with a seat for the public."[41]

The story of the sentinel depended on an erroneous understanding of the volcanic eruption that caused Pompeii and its victims to be destroyed. Before the late nineteenth century, it was thought that Pompeii was destroyed in one great cataclysm during which the inhabitants either fled or died in the attempt to flee. Today we know that Vesuvius erupted in two major phases.[42] The first, "Plinian" phase consisted of an explosive emission of mostly inert material that rained down on Pompeii for about eighteen hours. Much of the city was buried under a layer of cinders (*lapillo* or *lapilli*), which collapsed roofs and filled the streets to a level of several meters. Some victims were struck by large stones cast off by the volcano, and some died when buildings collapsed during this phase. Certainly, no sentry would have stood at his post while being gradually buried during this phase.[43] Many people, however, may have tried to wait out the eruption in what they considered a safe place. The second, "Pelean" phase of the eruption occurred when the column of

material thrown off by the volcano collapsed under its own weight and descended across open country between the volcano and the city, flattening and carrying along with it everything in its path. When this "pyroclastic surge" arrived at Pompeii, it was oven-hot, oxygen depleted, and permeated with moisture. It covered the earlier layer and also penetrated anywhere that was not airtight—that is, all of the city's remaining hiding places—leaving a layer of sediment that resembled mud (*fango*). Victims unlucky enough to be caught in this mud, or hardened ash, became naturally made body casts. When the site was discovered 1,800 years later, their bodies had long vanished, but their impressions (and their bones) remained. The victims in the cellar of the Villa of Diomedes had been sheltered from the cinders but died in the surge. Only a correct understanding of the volcanic eruption permits a correct interpretation of the remains that were discovered.

The French decade, 1805–15, saw radical changes to the administration of the excavations. Pompeii and the other sites were placed under a central administration headed by Michele Arditi, who was also director of the new Naples Museum. At the behest of Interior Minister Miot, Arditi devised a plan to uncover the organic city of Pompeii. Together with the circuit of the walls, the street that was presumed to form the north-south axis of the town became the focus of a greatly expanded workforce beginning in 1807.[44] The plan was to excavate the entire area between the Villa of Diomedes (variously known as the "casa di campagna," the "villa pseudurbana of M. Arrius Diomedes," or the "villa of Aufidius") to the north and the theaters and the associated Barracks of the Gladiators and Temple of Isis to the south. Some structures along this route had already been uncovered. The Herculaneum Gate itself and several houses near it within the city—namely, the House of Actaeon (later known as the House of Sallust), the House of the Vestals, and the House of the Surgeon—were the most famous of these. In front of (i.e., to the north of) the Herculaneum Gate, the street was known as the Street of Tombs, with such prominent features as the Guardhouse (or Tomb of M. Cerrinius Restitutus), the Mammia exedra (where Goethe's patroness, duchess Anna Amalia, was famously portrayed by Tischbein), and the tomb of the Istacidii.

Great finds were promised by Arditi, though, in fact, Pompeii had often disappointed the authorities in Naples with its poverty as compared with Herculaneum. Nevertheless, the French administration and Queen Caroline herself held a more "topographical" interest in the excavations than had their Bourbon predecessors and were more likely to be pleased with the opening of new perspectives. Perhaps this attitude reflected a new scientific approach to archaeology, or perhaps it reflected expectations that were more attuned to the experience of tourism. In any case, the reigning paradigm had begun to shift toward the viewing of archaeological sites and contexts and away from antiquities collecting per se.

At the end of the year 1811, the excavators were working in the Street of Tombs at the place where it begins to divide into two streets each leading to the west. Here three skeletons were found, one with a sizable collection of gold and silver coins.[45] In what must have been a first in the history of the excavations, the director of the excavations at Pompeii, Pietro La Vega (brother and successor to Francesco as director of the excavations at Pompeii), was ordered by Naples to give more precise details concerning the archaeological context. In his revised report of 1 February, La Vega wrote:

In my report of [11 January 1812] I noted that a skeleton had been found together with 69 gold and 121 silver coins. I was then directed by a letter of 25 Jan. to make a description of how this discovery was made and of all the circumstances. Hence, I say to you that in the excavation that we are now making of the street that leads from the gate of the city to the so-called "country house," at a distance of 270 palms [71.5 m] from the gate along said street and precisely 12 palms above the pavement, just at the point where the stratum of lapilli ends and that of water mixed with ash begins, were found two human skeletons, one in front of the other by a few palms. The first [skeleton] lay on its stomach, with feet toward the city gate. The other was found on its back, and with both arms extended. At the right thigh of the latter were found the 69 gold and 127 [sic] silver coins previously reported. The coins were mixed together. The feet of the second skeleton were also toward the city gate.

Subsequently, there was found another [skeleton] 5 or 6 palms ahead of the first, still in the same stratum of the lapilli, in a position similar to the others but with the body lying exactly in reverse. It appears that the first two men were attempting to enter the city from the country or from houses in that direction. I do not know how to explain these two skeletons' being found having fallen with their heads in the direction of Vesuvius, from which would have come the flood of water and ash. All reason would have it that they ought to have been found [lying] in the opposite direction. *All three skeletons left the imprint of their bodies in the ash, but it was impossible to save this because it disintegrated immediately upon lifting it.* (emphasis mine)[46]

For the next discovery of a skeleton, La Vega reverted to his usual style.[47] He was similarly laconic about the circumstances of the discovery of another three skeletons in approximately the same area later in the summer.[48]

The most affecting group of fleeing victims, however, that of a mother and three children, was found in November 1812 and uncovered in the presence of Queen Caroline.[49] The painter Joseph Franque was present at the excavation and subsequently represented the victims in an ambitious history painting now in the Philadelphia Museum of Art (fig. 2).[50] In the words of Donald Rosenthal, "Franque's use of material directly derived from the excavations of 1812 makes him one of the earliest artists to draw on the archaeology of Pompeii in composing a picture."[51] Exhibited in the Salon of 1827, the painting was described in the catalog as follows:

A mother, terrified by the eruption of Vesuvius, flees in a chariot with her two daughters, bearing a young child in her arms. This unfortunate family is surprised and enveloped by a rain of fire, the fury of which increases moment by moment. The older of the two girls has already fallen; the other tries to rush to her mother who, no longer able to support herself, falls dragging the girl with her.[52]

Carlo Bonucci, who wrote a well-known guide in French, must have collaborated with Franque in his description. The two were colleagues

in the Neapolitan Academy of Fine Arts, both the painting and the guidebook date from 1827, and Bonucci wrote of the same scene:

> Vesuvius had for an instant suspended his fury, when an unfortunate mother bearing an infant in her arms, and with two young daughters, endeavoured to profit by the opportunity, and to fly from their country-house to Nola, the city least threatened by this unspeakable catastrophe! Arrived at the foot of the above-mentioned hemicycle, the volcano recommenced its ravages with redoubled fury. Stones, cinders, fire, melted and boiling substances, rained from all sides, and surrounded the miserable fugitives. The unfortunates sought refuge at the foot of a tomb, where reposed perhaps the ashes of their fathers; and invoking in the most frightful despair the gods, deaf to their prayers, they closely embraced their mother as they breathed out their last sigh, and in this situation they remained—In the same way has a successor of Phidias depicted Niobe, who embraces her last remaining children, turns her face to the heavens, and expires in pain with them.[53]

In addition to (correctly) alluding to a pause in the volcano's activity, Bonucci, in explaining the victims' intentions in their flight, touched on something that clearly had disturbed La Vega in his official account of the victims found in the same location a few months earlier: where were the individuals headed when they met their deaths on this street that led out of Pompeii in the direction of Vesuvius? La Vega assumed, quite logically, that they would have been headed away from the volcano. His observation that the feet of two of the victims pointed in the direction of the Herculaneum Gate and the city beyond it, however, would not have persuaded the most incompetent of police inspectors that they had been headed toward the gate. Yet Bonucci was no doubt equally wrong in suggesting that the victims had been headed toward Nola on the other side of Vesuvius, even if that city did escape the rain of lapilli. To approach Nola from the northwestern gate of Pompeii would have meant heading into even worse conditions. Bonucci's account indicates that excavators, guides, and visitors were beginning to puzzle out forensic details of the sort that would not have been known to earlier students of Pompeii. Reading his description in

conjunction with Franque's painting shows the important influence of antique sculptural prototypes like the Florence *Niobe* in the contemporary process of visualizing the victims' fate.

The fate of a mother and her children was without a doubt the most piteous spectacle among the victims of Pompeii found up until that point. In the spring of 1826, another moving discovery was made. During a customary excavation in the presence of some distinguished visitors in a house known as the House of Queen Caroline, a portion of the escarpment collapsed, revealing some columns on one side of a peristyle and, above them, the skeleton of a man crushed between the capitals and a vault. Near him was the skeleton of a woman and a purse with gold and silver coins in it. Both were obviously fugitives who had sought shelter under the vault. Further excavation revealed the bodies of another couple, also fugitives, who had also been buried by the vault. Unlike the first couple, these were not killed instantly by the fallen ceiling but must have survived the first accident as they lay together wrapped in each other's arms. Guglielmo Bechi wrote:

> The sight of these two skeletons still lying in that embrace, which was the last movement of their life, testified so movingly to those around them that the terrible phenomenon that had cut short their days had not sufficed to quench their love for each other.[54]

Bonucci envisioned the fate of four skeletons found in the alley next to the House of Sallust quite differently, showing little sympathy for their fate:

> A young woman fleeing with her three slaves. Might she not have been the pretty girlfriend of Sallust, who, expelled from the lap of luxury by hostile fate, tried to save herself by traveling this street and there found her death? The unfortunate woman may have left behind her in her bedroom her perfume jar, her Penates, and her money. All of these items were of gold. Next to the bodies were collected thirty-two coins, a disk of silver that might have been a mirror, some gold rings adorned with engraved stones, two earrings, a necklace, and five bracelets, all of gold.[55]

In this case, the author condemns not the manner in which the victims fell but the vanity of the mistress in lingering to collect her precious treasures or "woman's world" (*mundus muliebris*)—a theme that appears again and again among those who read the bodies of the victims.[56] The poor mistress of the House of Sallust has been held up as a negative example: she died because she went back for her possessions, while her husband got away.[57]

The discovery of seven skeletons along with an enormous hoard of gold and silver coins in a cellar several weeks later, on 29 May 1826, led Bechi to conclude in the same publication:

> The error of many Pompeians was to seek safety from the eruption underground. Those most prepared to save themselves in this manner have been found, together with their provisions, in the cellars and the basements (as demonstrated by the many skeletons found in [the Villa of Diomedes], [in the House of the Emperor Joseph II], behind the basilica, and elsewhere), while in the piazzas, in the streets, and in the houses have been found but few skeletons.[58]

The aqueous nature of the surge layer at Pompeii had become clear to most investigators, particularly in the wake of the evidence from the Villa of Diomedes. Carmine Lippi had gone so far as to suggest in his book of 1816 that Pompeii had been destroyed by a flood unrelated to the eruption of AD 79.[59]

On 30 January 1829, the skeleton of a woman was found opposite the door of the House of the Dioscuri. She had been about to flee when she was struck down. With her was a purse containing a pair of gold earrings in the form of scales with pearls in the balance, five gold rings and five more engraved stones, some coins, and a tiny glass perfume bottle.[60] The circumstances of her death are oddly reminiscent of that of the mistress of the House of Sallust, and it may be assumed that the guides made similar remarks about her character and lack of discretion.

An American, Thomas Gray, adapted Bonucci's description of the victims found in 1812 into a tableau of the death of principal characters in his novel *The Vestal, or A Tale of Pompeii*, published in Boston in 1830. Gray relocated the site of the unfortunate mother's last moments

from the crossroads to the Mammia hemicycle just outside the Herculaneum Gate. Although he does not give his source, it is likely that Gray also used a description of the embracing skeletons of 1826 for his characters Lucius and Lucilla, who met their end lying "side by side beneath that deadly and burning mass, their arms twined around each other's neck, united at last only in death."[61]

The author who most successfully appropriated the lives and the deaths of the victims of Pompeii was, of course, Edward Bulwer-Lytton, who wrote *The Last Days of Pompeii*, first published in 1834. For his knowledge of Pompeii, Bulwer-Lytton was indebted to the English resident Sir William Gell and to the director and author of the standard guidebook, Carlo Bonucci. In the manner of the professional guides of the day, Bonucci's guide was strong on anecdotes, and many of his anecdotes related to the discovery of bodies. For Romantics, Pompeii was nothing if not the "city of the dead."

While digging along the flank of the Temple of Jupiter in the Forum in 1818, the excavators discovered two skeletons. Despite using the greatest possible care, they found nothing near the first but a single large bronze coin attached to an encasement of bone, and they found nothing at all near the other, who lay under a column of marble. Between the two victims was found a bronze helmet.[62] Aside from the gruesome fate of being crushed by a falling column, there seems nothing remarkable about this discovery. Yet something remarkable must have interested Bulwer-Lytton in this victim, since he appropriated him for his character the diabolical Arbaces in his novel *The Last Days of Pompeii*:

> . . . the skeleton of a man literally severed in two by a prostrate column; the skull was of so striking a conformation, so boldly marked in its intellectual, as well as its worse physical developments, that it has excited the constant speculation of every itinerant believer in the theories of Spurzheim who has gazed upon that ruined palace of the mind. Still, after the lapse of the ages, the traveler may survey that airy hall within whose cunning galleries and elaborate chambers once thought, reasoned, dreamed, and sinned, the soul of Arbaces the Egyptian.[63]

Not only did Bulwer-Lytton use the skull in his novel, but tradition holds that he brought it back to England and kept it in his study.[64]

Bulwer-Lytton was indebted to Bonucci not only for his character of Arbaces, fated to be crushed by a column in the Forum, but for others of his characters as well. He appropriated the hungry priest of Isis for his character Calenus and the priest with the axe for Burbo. The Roman sentry stands at his post at the Herculaneum Gate, revealed to Diomed and his company as they head for his cellar, well-stocked with food, where a slow and terrible death awaits them. All these persons were by now familiar from other sources available to many of Bulwer-Lytton's readers. Bulwer-Lytton's hero and heroine escape, however, with the help of an ingenious invention, the blind girl Nydia, who alone is not confused by the darkness of the eruption.

At the time Bulwer-Lytton published *The Last Days of Pompeii*, antiquaries were still fairly optimistic in their estimates of those who had survived the eruption. In a note accompanying the novel of 1834, Bulwer-Lytton noted that though "three hundred fifty or four hundred skeletons" had been discovered and "a great part of the city is yet to be disinterred," there was "every reason to conclude that they were very few in proportion to those that escaped."[65] From Pliny's letters, it is clear that some had indeed survived to tell the tale. Although Pliny's uncle was fated to die on the beach at Stabiae, accompanied by his slaves, others of his party were able to escape the fatal surge on foot by reaching the heights above the city. These, when they returned, recovered the body of their commander and brought the younger Pliny the news of his uncle's death. As Bulwer-Lytton implied, antiquaries of his time made their calculations by estimating a reasonable number for the population of Pompeii and subtracting the number of those killed, increasing the latter by a proportional amount based on the unexcavated area of the city. No one ever claimed much accuracy for this method, and the range of estimates varied greatly. Yet this method and the conclusion that most of the Pompeians had survived suited those like Bulwer-Lytton who fictionalized accounts of the destruction, since each needed someone to survive to tell the tale; and they all adhered to the prevailing belief of the time that the only escape during the final hours

lay by the sea.[66] The hopelessness of escape by sea was only made evident by excavations undertaken in 1881.[67]

Authors like Gray and Bulwer-Lytton were not always able to distinguish good information from bad. Carlo Bonucci's guidebook, an important source for both, was a case in point. Published in both French and Italian editions, it was full of information but also full of idiosyncratic conjectures. Sir William Gell's *Pompeiana* was not much better. Both Bonucci and Gell suffered from the fact that what passed for scholarship in Naples was to some extent isolated from that of the rest of Europe.[68] Important information concerning the excavations was officially treated as if it were a state secret. Controversies were waged between one Neapolitan scholar and another.[69] The excavations of Pompeii and other sites were quite naturally reflective of the general condition of scientific discourse in Naples. In order to understand how this affected the recovery and ultimately the exploitation of human remains at Pompeii, it will be useful to take a brief overview of how the state and the academy influenced the excavations.[70]

Despite an influx of scholars from Florence and Rome, the Neapolitan academies, including the Accademia Ercolanese and the Accademia di Belle Arti, which exercised a certain degree of institutional control over the excavation, exhibition, and publication of the archaeological sites, had become somewhat inbred by the middle of the nineteenth century.[71] To some extent, this was, for better or for worse, a reflection of the interest taken in antiquities by the reigning monarch. The first modern king of Naples, Charles of Bourbon, who reigned from 1734 to 1759, conceived and maintained an active interest in the excavations. Although his main concern was in the collection of antiquities for the museum in his palace in Portici, he instituted the practice of attending special excavations.[72] Most important, he founded the Accademia Ercolanese, in 1755, for the purpose of publishing the paintings, statues, and other artifacts in his museum. After he ascended the Spanish throne in 1759, he made a point of leaving all of his antiquities to his son and successor, Ferdinand.

The native-born Ferdinand was not very interested in the archaeological sites, although he recognized their value in enhancing his

standing among other European monarchs. During the Napoleonic era, Ferdinand was forced to flee to Sicily, where he lived under English protection. In 1805 Joseph Bonaparte assumed the throne in Naples and took an active role in founding a museum on the French model. In 1807 he was succeeded as king by Joachim Murat, who reigned together with Queen Caroline, sister of Napoleon. With the fall of Napoleon and the death of Murat in 1815, Ferdinand was restored as King of Naples. The Royal Museum and the expanded excavations at Pompeii survived the change in regime, with some significant modifications. The Royal Museum became the Royal Borbonic Museum, and its collections (which included both the Farnese Collections inherited by Ferdinand through his father's family and the antiquities garnered from Herculaneum and Pompeii) were declared to be the personal property of the monarch, independent of the kingdom. This last condition was, of course, contested by some where it concerned the antiquities from Herculaneum and Pompeii. As for the excavations at Pompeii, the budget was cut back drastically, and much of the land that had been purchased for future excavation was sold back into private hands.[73]

Ferdinand's successor, Francis I (1825–30), who had himself conducted excavations in Torre Greco before the beginning of the French decade, showed more interest in the antiquities than his father. During his brief reign, open-air excavations were begun in Herculaneum, and an impressive series of illustrated volumes devoted to the collections of the Naples Museum and the excavations of Pompeii was successfully begun.[74] His early death in 1830 and the succession of his son Ferdinand II (1830–59) saw the beginning of a difficult period for Naples that included epidemics of cholera (1836–37 and 1854–55) and rebellion (1847–49). Under Ferdinand's reign, the Naples Museum was obliged to remove "immodest statues" from display and actually to immure the notorious pornographic collection. Periods of civil disorder disrupted the excavations of Pompeii in 1821, 1848, and 1860.[75]

From the first discovery of the buried cities, tension arose between the Neapolitan "owners" and foreign visitors. In the beginning, King Charles was hard pressed to secure his patrimony—understood to consist of the artifacts from beneath the soil—from leaving the kingdom.

His own antiquarian interests eventually led him to employ experts who were able to conduct the excavations, collect and conserve the artifacts, and publish those that might be of artistic or antiquarian interest. Of course, many mistakes in each of these areas were made before the king was able to claim a certain measure of success. From the beginning, Charles and those he employed in this endeavor were subjected to withering criticism from abroad. Nevertheless, he persisted in his effort not only to claim all of the artifacts for his and his successors' collection but also to exercise control over the copyright of this material.

In the matter of intellectual property, Charles and his successors were ultimately unsuccessful in controlling discourse on the buried cities and their art. Though the eight folio volumes of engravings published under the title *Le Antichità di Ercolano* (1757–92) were an artistic success, their texts were less satisfactory.[76] Reckoning came during the Napoleonic era, when the English gained control over the Herculaneum papyri and when the French regime in Naples enabled the publication of Mazois' authoritative study of architecture and topography, *Les Ruines de Pompéi*.[77] In the 1820s, the epicenter of archaeological studies in Italy became the Instituto di Corrispondenza Archeologica in Rome, under the patronage first of the Prussian ambassador and then of the German state. The regular reports from Naples published in the *Bullettino* of this institute from 1829 on proved to be the most reliable source of information on the excavations in Naples. The period 1850–1900 saw the publication of important monographs on Pompeii in French, German, and English.[78] German mastery of color printing made Wilhelm Zahn's elephant-folio plates of Pompeian wall painting an indispensable tool for scholars and artists, and W. Helbig's monograph published in 1868 gave archaeologists a fully documented catalogue raisonné of the ancient paintings.[79]

It was in the study of epigraphy that foreign scholarship, particularly that of the German professors, truly excelled during the second half of the nineteenth century. That was the age of the *Corpus Inscriptionum Latinarum*, a creation of Theodor Mommsen and the Prussian Academy. Mommsen envisioned the work as an autopsied (i.e., eyewitnessed) transcription of all known inscriptions from the lands of the

Roman Empire. While collecting inscriptions in Naples in the fall of 1845, Mommsen had met the director of the Naples Museum, Francesco Maria Avellino, and his protégés Giulio Minervini and Giuseppe Fiorelli.[80] Like Mommsen, Fiorelli was a student of pre-Roman Italic languages and epigraphy and numismatics. A professional and personal friendship between the two dates from this period. By a strange twist of fate, Fiorelli was instrumental both in opening the field of Neapolitan scholarship to foreigners, particularly Germans, and in regaining international prestige for Neapolitan archaeology. A look at his eventful life and works is warranted before moving to his most famous discovery.

Giuseppe Fiorelli (1823–96) was born and educated in Naples (fig. 3).[81] Although he achieved a degree in legal studies at age eighteen, he chose a career in archaeology, as he was "inclined by the nature of his peaceful and tranquil spirit to prefer to the tumultuous occupations of the forum the placid and austere study of archaeology and to live more among the ancients than his contemporaries."[82] Fate had something rather different in store for him, though he began his archaeological career modestly enough. Two years later, at the age of twenty, he published an article on numismatics in the *Bullettino dell'Instituto di Corrispondenza Archeologica* that won him membership in Italian and foreign academies, including the Accademia Ercolanese and the Instituto di Corrispondenza Archeologica itself. In 1844, at the age of twenty-one, he was appointed to the post of Inspector in the Soprintendenza Generale degli Scavi (becoming Inspector of the Pompeii excavations in 1847). His brief was to safeguard the antiquities and to see that the administrators of the excavations followed regulations issued by the Soprintendenza. His post put him in direct conflict with Carlo Bonucci, who, though demoted from the post of Architect-Director for dishonesty in 1831, was in control of the excavations due to the illness of his successor. In 1846 Fiorelli had served as vice president of the Archaeological Session of the Congress of Italian Scientists. During the brief period in 1847–48 when, pressed by the democratics, King Ferdinand agreed to a constitution for Naples, Fiorelli also participated in a committee to reform the Royal Borbonic Museum and the archaeolog-

ical service. The report of this committee recommended, among other reforms, the creation of a site museum devoted to human remains, an idea that was ultimately realized under Fiorelli's direction in 1875.

With the collapse of the constitutional government following riots on 15 May 1848, repression followed. Fiorelli was arrested on 24 April 1849 on the accusation of Carlo Bonucci, who had sensed his opportunity to act against the young upstart.[83] Fiorelli was imprisoned for about two months, during which time he began to edit for publication manuscripts of the *Giornale degli scavi di Pompei*. Immediately upon the appearance of the first fascicle, the police entered his home and seized the printed copy and his manuscripts.[84] This time, it was the complaint of a member of the Accademia Ercolanese, Bernardo Quaranta, that brought the police down on him. Fiorelli was imprisoned until January 1850, when his case was dismissed. He remained unemployed until 1853, when Leopold, Count of Syracuse, the brother of King Ferdinand II, hired him as his personal secretary. Leopold also made it possible for Fiorelli to return to archaeology as excavator of Cuma. Under Leopold's protection, Fiorelli was able to resume publishing on Pompeii, including a work on the Oscan (i.e., pre-Roman) inscriptions (1854) and a great plan of the city at a scale of 1:333 (1858).

It was as Leopold's secretary, however, that Fiorelli was to achieve even greater fame than as a Pompeianist. Upon the death of the much disliked and much feared King Ferdinand II in 1859, Ferdinand's son Francis succeeded to the throne as the second Bourbon king of that name. In May 1860, in the wake of popular uprisings in Sicily, Garibaldi invaded that island with the intention ultimately of uniting Italy under King Victor Emmanuel of Savoy. He crossed the Straits of Messina on 18–19 August, took Reggio on the twenty-third, and turned his attention toward Naples. Victor Emmanuel's minister Cavour suggested that, in order to gain some control over events, Leopold write to his nephew and suggest a graceful abdication. On 24 August, a letter from Leopold to Francis, written by Fiorelli, urged the monarch to avoid civil war by his own noble self-sacrifice.[85] The letter was widely admired, and Fiorelli's star was once more on the rise. In late 1860, Fiorelli was made Inspector-Director of Excavations and installed in the chair of ar-

chaeology in the University of Naples. In his *Appunti autobiografici,* he noted with satisfaction under the year 1861:

> The complete reorganization of the administration of the excavations and the continuation of those resumed in Pompeii do not prevent me from lecturing three days of the week in the university or, as president of the faculty of letters and philosophy, from participating in the many searches for new chairs, from reviewing many works presented for adoption in the schools, or from joining in the plans for new university legislation.[86]

One more person needs an introduction before proceeding to the events of the next chapter. Luigi Settembrini (1813–76) was to play an important role in announcing Fiorelli's discovery and legitimizing his success. In 1863, at the time of Fiorelli's first casts, Settembrini was Professor of Italian Literature at the University of Naples. Ten years older than Fiorelli, Settembrini had been attracted as early as 1837 by Mazzini's republican idea of a united Italy. In 1847 he had published anonymously a devastating pamphlet, *Protest of the People of the Two Sicilies.*[87] Under the short-lived Constitution of 1848, Settembrini served as Minister of Public Instruction. After the revolution in Naples collapsed, he was tried and sentenced to death, commuted to life at hard labor. During eight years of imprisonment, his case became celebrated internationally. In 1859 he was finally ordered deported to the United States, but the captain of the ship that was to take him and his fellow patriots was persuaded to land them in Ireland. He returned to Italy in time for the unification.

The next chapter will deal with the progressive reforms introduced at Pompeii after 1860 under Fiorelli. Without these reforms, the discovery of the casts would hardly have been possible. It should be recognized at this point, however, that some reforms had taken place during Fiorelli's earlier tenure between 1844 and 1849 and during his absence from the excavations—though it is impossible to estimate how much *indirect* influence he may have had even during the period of his banishment, 1850–60.[88]

Although it has often been credited to Fiorelli—and deservedly so from the point of view of the rigorous application of principle—the practice of excavating sites in horizontal layers in order to preserve the upper parts of the structure was first applied consistently in the excavation of the House of the Russian Princes (VII.1.25), begun in March 1852.[89] More mundane alterations in the routine signal a desire to "survey and control." References to the use of a twenty-four-hour day, sporadic at first, began to appear in the *Giornale* in 1844.[90] Linear measurements, which had earlier been recorded by halving fractions, began to be recorded in tenths of a *palmo Napoletano* in 1847 and then in hundredths at the beginning of 1851, with fractional notation still the norm. In 1853 decimal notation (e.g., "pal. 0.10") became standard. Each of these changes added to the ability of Pompeii's administration and that of the Soprintendenza in Naples to protect the antiquities of Pompeii and to control theft, which had more or less systematically plagued that rich site. The most effective control, however, was to be found in the system of topographical notation devised and published by Fiorelli in 1858—while he was still in banishment.[91] Fiorelli divided the plan of Pompeii into nine *Regiones*, each of which was comprised of *insulae*. The entryways of the houses and the other buildings in each *insula* were then numbered, usually in a clockwise direction. According to Fiorelli's system, each entryway in the entire city received a unique reference number.

Scientific progress also affected the treatment of human remains at Pompeii during this period. Between the relatively relaxed atmosphere of winter 1832–34—when Bulwer-Lytton stayed in Naples and befriended Bonucci (who presumably gave him the skull of "Arbaces")—and the 1850s, important changes took place that, among other things, affected the study of human remains at Pompeii. Naples experienced serious outbreaks of cholera in 1836 and 1837, resulting in thousands of deaths.[92] One of the consequences of these outbreaks was the growth of popular suspicion of medical doctors. The committee on the reform of the Royal Borbonic Museum and the archaeological excavations of which Fiorelli had been a member under the Constitution of 1848 had recommended the creation of a museum at Pompeii for keeping arti-

facts and skeletal remains that would not otherwise be sent to Naples.[93] King Ferdinand, for political and religious reasons, was strongly opposed to the suggestion. The scientific study of the skeletons foreseen in this ill-fated proposal was eventually taken up by Stefano Delle Chiaje, who made a collection of available specimens in the 1850s for his anatomical museum at the University of Naples. He studied the pathology and the evidence of ancient surgical procedures on the skeletal remains but was not above noticing that the physiognomy of the victims betrayed a "relaxed and libidinous lifestyle."[94] As Delle Chiaje's data indicate, he was obliged to work with disintegrated skeletons. The *Giornale* shows that an effort was at last being made to secure the human remains uncovered in the course of excavations. As early as 1855, skeletons discovered in the excavations were collected in the secure storage depot located in the (so-called) Tempio di Mercurio.[95]

This introduction must close, unfortunately, on a note of mystery. In the *Annali dell'Instituto di Corrispondenza Archeologica* (the companion publication to the *Bullettino*) for December 1859, Serge Ivanoff published an article that discussed, inter alia, folding house doors from Pompeii.[96] In his article, he referred to two doors represented by gesso casts "in the small Museum of Pompeii."[97] "They were cast, as they were discovered," he wrote, "from the impressions left in the ashes hardened by so many centuries. The memorable disaster found the door half-closed, and thus have the wooden leaves left their architectonic design in the ashes." These items are close enough in date to raise the question of their relationship to the casts of human victims made in 1863. Naturally, they move us to ask who made the casts of the doors and when.

By an interesting coincidence, this plaster cast that must have been made prior to 1859 (and before Fiorelli's appointment as Inspector-Director)—and which must be considered as a forerunner of the casts of victims—is the very first item to be illustrated in Fiorelli's new journal.[98] When Fiorelli took control of the excavations on 20 December 1860, he made clear his intention of proceeding one insula at a time, declaring in the *Giornale* entry for that day: "This morning the excavations of Pompei were reopened, and work was concentrated on clearing

the insula that remains as yet untouched between the Temple of Isis and the new baths."[99] He initiated the publication of his excavations with a systematic description of the insula, beginning with the first shop (VIII.4.1/53) along the north side of the insula as one comes from the Forum.[100] Because the shop seems to have been used by a dyer, Fiorelli designated it "Taberna Offectoris," explaining that the *offectores,* or dyers, had been mentioned elsewhere in a painted inscription. In his discussion of the cast of the door, Fiorelli makes no mention of Ivanoff's publication or the "Small Museum" and even implies that his own drawing is original. Breton, who described the shop ("Boutique du teinturier") in the third edition of his Pompeian monograph (1869), even attributed the discovery to Fiorelli.[101] Fiorelli's own text, however, is ambiguous.

From Ivanoff's article, we know that the cast had been removed from the shop. Consequently, it is not surprising that Fiorelli simply launches into a description of the door without giving its exact location in the shop. Later in his description, he risks confusing the reader by referring to another (similar?) shop door: "The Pompeian door recently discovered, . . . which belonged to the fifth shop of the second insula to the right in the *vicoletto* to the north of the Forum, toward the west [i.e., VII.6.29], exhibits for the first time an example of such closure (namely, *clostrum*)."[102] The shop is no doubt the same one referred to in the *Giornale* for 14 February 1859, which "contains the impression of a door [and is] in the *vicoletto* that runs alongside the Prisons of the Forum."[103] Fortunately, this part of the mystery has been solved by Mario Pagano, who discovered that the idea to make a cast of the door published by Ivanoff first occurred to Domenico Spinelli, Principe Sangiorgio, in November 1856.[104] At that time, Sangiorgio wrote to the Minister of Public Instruction:

> In a tour I made yesterday together with the Commission in Pompeii I observed an impression of a double door that was discovered recently in the current excavations. Since it is a matter of great importance to have a model of it, I have accordingly made it a matter of urgency that the modeler (*il formatore*) De Simone be called immediately to the spot

to make an impression in gesso, since the ground in which the impression is to be found is the next to fall.[105]

Although it is still unclear when and by whom the cast was made, it is highly probable that Sangiorgio saw the impression of the door in the shop (VIII.4.1/53) described by Fiorelli, since the excavators were working in just that location in November 1856.[106] It is difficult to understand how Fiorelli could have failed to give credit to Ivanoff and to Sangiorgio, especially since the latter was still technically his boss in 1861.[107] With time and success, Fiorelli probably had second thoughts about his own conduct in the matter of the shop door. The description of the "Shop of the Dyer" in his *Descrizione di Pompei* of 1875 contains no mention of the door, an indication that he later had reservations about the earlier description.[108] Fiorelli's errors in 1861 may have been due to having too much on his plate. On the bright side, the cast of the door may have given him the idea for his later casts.

CHAPTER 2

First Impressions

The discovery of a dramatic new means of recording the human suffering that had taken place at Pompeii during the volcanic eruption was the direct result of new historical consciousness and new scientific purpose, both following in the wake of the great political changes of 1860. Giuseppe Fiorelli, who discovered the means of casting the bodies of human victims, had taken over the direction of the excavations in December 1860. He was personally responsible for implementing historical and scientific changes in the conduct of excavations that literally made it possible to recognize "lost opportunities" and to learn from mistakes made in the course of digging. As a historian, he instituted a great change in historical awareness by publishing a daily record of excavation, the *Giornale,* from 1748 to 1860. As a scientist, he made the reconstruction and interpretation of the archaeological context, rather than the recovery of artifacts, the primary mission of the excavators. In particular, two episodes involving the discovery of human bodies, one in 1861 and the other thirty years earlier, illustrated lost opportunities that Fiorelli did not care to see repeated. (Luigi Settembrini's account, quoted below, makes it clear just how Fiorelli was able to implement his successful policy.)

The body of a woman found in the tablinum of the House of Holconius in 1861 presented a touching picture of one victim's fate, while clearly showing the limits of scientific archaeology of the time. Austen Henry Layard reported the discovery for the *Quarterly Review:*

On removing the last layer of rubbish, we come upon a perfect skeleton; it is that of a woman, probably the mistress of the house. She had attempted to fly on that fatal night, and had thought to save her jewel-case—the "mundus muliebris"—"the woman's all"—enclosed in its wooden casket or pyxis. We find the hinges, the lock, and the ornamental fittings, which, being of bronze and ivory, have been preserved, whilst the woodwork has perished. Scattered around her are its contents—her golden earrings, bracelets, and a necklace hung with curious amulets, such as objects in coral, supposed to bring fecundity, a closed hand with two fingers extended to ward off the evil eye, a bee in onyx of exquisite workmanship, as an augury of good, and little bells whose sound drives away contagion, her jeweled rings, a fragment of her ivory comb, her bronze looking-glass, the ivory pins that gathered up her tresses, and a few small glass and alabaster vases and bottles which held her ointments and perfumes. If the lava-mud has penetrated into the chamber the mould of the casket itself may be preserved, so that a perfect cast may be taken of it, and even the impression of the linen garments which formed part of her wardrobe may be plainly seen. Near her lies a terracotta lamp, with its elegant dolphin-shaped cover. It had fallen from her hand when she sank exhausted, after in vain groping her way through the thick darkness.[1]

From Layard's account, it appears that attempts were made by the excavators to cast some of the impressions found in the volcanic mud—unsuccessfully, or so it would seem, for the excavators' journal mentions only the discovery of "a human skull" on this occasion.[2]

It may be that Layard was reading into the present context his knowledge of a similar scene recorded thirty years earlier, when the body of another woman was found in the House of the Faun (March 1831) and an earlier attempt at casting had been tried unsuccessfully. The official journalist of the excavations that day was uncharacteristically eloquent:

But one of the most precious treasures ever uncovered in Pompeii was found to one side in the [second atrium of the house]. The woman who

was carrying these objects had abandoned her attempt to save them, throwing her *mondo muliebre* to the pavement, and sought refuge in the tablinum. Her skeleton was uncovered in an attitude that entirely conveyed the terrible agony of her final minutes. Her arms tried ineffectually to hold up the pavement that had begun to collapse from the floor above her and that finally buried her. The traces of her fine and light garment were quite visible about her. But the shape of her foot and her shoe [especially] attracted our attention. We drew it and attempted unsuccessfully to record the impressions of other parts of her body and especially the face, which would have been a monument unique of its kind.[3]

It is unlikely that any of the principals involved in the excavation of 1861 had been present at the earlier excavation, though there might well have been some living memory of the excavation in the House of the Faun. It is, however, certain that Fiorelli himself, who directed the work in the role of Inspector of the Excavations, would have been familiar with the earlier journal entry, and it is also likely that he would have shared this information with Layard.

Both episodes share the common theme of the noblewoman and her attachment to her jewelry, as well as her untimely and gruesome fate. Guidebooks to Pompeii had habitually pointed out the noted examples of women who had, like the wife of Sallust, presumably been victimized by the volcano because their vanity had caused them to linger in order to gather up their jewelry—even as their husbands escaped. Beyond this little moral lesson, however, there is a more profound similarity between the two incidents. In each case, the motive of the excavators or of writers like Layard present at the excavations was the direct experience of antique beauty. This obsession had already taken root thanks to the young woman from the cellar of the Villa of Diomedes. The journalist of 1831 recorded the excavators' attempts to find a more complete model of ancient beauty. Determination of the cause of death, which ultimately emerged as the primary interest of the Pompeian excavators whenever a corpse was found, played only a secondary role here. The virtual silence of the official journal in 1861

makes it seem unlikely that attitudes had changed or that the recovery of human remains played a significant part in hypothesizing the causes and circumstances of Pompeii's destruction. On the contrary, as may be seen in the excavation diaries from earlier periods, the recovery of human remains was interpreted officially as heralding little more than the prospect of discovering treasure: if no treasure was reported, the excavators needed to make some excuse in order to deflect suspicions that they had pocketed the coins themselves. Unofficially, the themes of moralizing the fates of the victims and eroticizing their remains worked on the imagination as well, possibly as a psychological reaction to the kind of material guilt that the excavators might have felt for uncovering the bodies.

The Neoclassical Age had been preoccupied by the uninhibited lives of the ancients. We have already seen how some writers were relieved to discover that the victims in the cellar of Diomedes had worn clothes. Other writers of the time were more content to have visions of unclothed beauty when they thought of the ancient world. The perfect beauty of the naked figure in Greek and Roman art was attributed to the artists' daily experience of the nude:

> The painters of these pictures enjoyed a unique advantage, one which no others have possessed, even those of the Renaissance, of living amid congenial social customs, of constantly seeing figures naked and draped in the amphitheater and in the baths, and besides this, of cultivating the corporeal endowments of strength and fleetness of foot. They alluded to fine breasts, well-set necks, and muscular arms as we of the present day do to expressive countenances and well-cut pantaloons.

Thus wrote Hippolyte Taine in his *Travels in Italy* of 1865.[4] At the time of his writing, the evidence from Pompeii did not seem to contradict Taine's ideas about ancient clothing.

As of 1861, an overriding scientific purpose of the excavations and a more realistic view of the classical world had yet to be found, though this was all about to change. By the early 1850s, the Pompeian bodies had begun to be studied for evidence of the volcanic eruption as well as

for the information they might yield concerning diseases among the ancient population and the surgical skills of Roman physicians. The eminent anatomist Stefano delle Chiaje had been permitted to collect human remains from Pompeii for his museum of pathological anatomy at the University of Naples. By the end of the decade, bones were being collected in secured locations in the excavations.[5]

With the change of government that took place in 1860, Giuseppe Fiorelli was appointed Inspector of the Excavations at Pompeii and given the responsibility of reorganizing the site and its operations and administration. He was quick to appreciate the importance of this charge to the local and international reputation of the House of Savoy. He welcomed the new government's official patronage of the excavations at Pompeii in the form of a substantial start-up grant. In the introduction to his published version of the *Giornale degli scavi di Pompei* of 1861, he linked the future of the Pompeian excavations as a scientific enterprise to the future glory of the Italian state.[6] The same publication contained a document titled *Governo degli scavi: Regolamento temporaneo* (Government of the Excavations: Temporary Rules). Despite the fact that the document bears the name of the Principe di San Giorgio, "Soprantendente Generale, Direttore del Museo Nazionale e Scavi di Antichità," the plan for Pompeii detailed in the first chapter shows, from the very first article, Fiorelli's ideas for systematizing the site of Pompeii: first, the circuit of the walls and the gates of the city must be revealed, then the principal streets, and then the insulae, or blocks; new excavations must complete work begun in the older excavations in a systematic way. Among the other articles, one stipulated that "ancient buildings must be uncovered in horizontal strata." Perhaps the most revolutionary part of the new rules was to be found in the second chapter, stating the powers and the duties of the "Ispettore degli scavi," Fiorelli. He was to report directly to the Soprantendente Generale and to have complete authority over all those who worked in the excavations under him.[7] He was to go to Pompeii twice each week and to visit the other sites under his authority—namely, Capua, Herculaneum, and Pozzuoli—once each week. The complete authority granted to the in-

spector gave him unprecedented influence over the course of the excavations. Fiorelli was not one to let this power lapse.

On 20 December 1860, Fiorelli started up the excavations at Pompeii after a year of inactivity.[8] The excavations were concentrated on the block that Fiorelli had designated as "insula IV" of "Region VIII," a large block in the center of the city, containing three noble houses.[9] The House of Holconius (VIII.4.4; fig. 4) was one of these houses, and the woman discovered in January 1861 was the first important discovery of the new regime. Unfortunately, despite being noticed and described by distinguished foreign authors like Thomas Henry Dyer,[10] Ernest Breton,[11] Johannes Overbeck,[12] and Layard, her importance was more as a negative example than as a stunning find, thanks to the excavators' inability to preserve the remains. Fiorelli may well have asked himself how such a find might be saved.

The remainder of 1861 and the year that followed brought many important discoveries as reward for the new, disciplined approach to the excavations. Over the next three years, Fiorelli devoted his attention to finishing the large insulae VIII.4 and VII.1, which had been begun earlier, and to finishing the excavation of the large area that lay between the Forum and the Stabian Baths. In the entire area, only two noble houses stood out: the House of Cornelius Rufus (VIII.4.15), which had already been begun, and the double house to the north of the Stabian Baths, subsequently named the House of Siricus (VII.1.25/47). The buildings between the Forum and the Stabian Baths were, for the most part, unprepossessing little structures, though they included the important Grand Lupanar (VII.12.18/19) and the Hotel of the Christians (VII.11.11). In the course of these excavations, Fiorelli gave considerable attention to the preservation of organic remains. Much wooden furniture—often believed to have been scarce in Pompeii—was encountered, and the forms were preserved in plaster casts.[13]

In a brief period of time, a new view of Pompeii began to emerge. In addition to furniture and movable objects, second stories had, in some cases, been preserved. Most important, Pompeii began to look like an organic city, with its streets consisting of arteries and back alleys. As the

city was organized around the intersection of two major east-west streets and two major north-south streets, Fiorelli's nine regions bore some resemblance to objective reality. As isolated excavations were tied together in an urban continuum, individual neighborhoods began to emerge. The locations of fountains, water towers, and even bakeries and taverns began to take on meaning. In his publication of the excavations under his direction, he introduced topographical description and analysis of excavated zones as a supplement to the daily record of excavation. In addition to directing the excavations toward unfinished insulae, Fiorelli attempted to organize the documentation of parts of the city that had already been excavated. He managed this task by publishing the daily reports of the excavators—the *Giornale degli scavi*—from manuscripts available to him for the period 1748–1860, promising to make a complete topographical index.[14] He also directed Felice Padiglione to begin building a cork model of the excavated parts of the city at a scale of 1:100, taking care to reproduce every painted wall and mosaic floor.

Fiorelli was at his best, however, when it came to finding an audience to whom the emerging city might be presented. Being a man of distinctly scholarly character and ambition, as well as being politically astute and well connected, Fiorelli's first thoughts were to raise the prestige of Pompeii and of Neapolitan archaeology in the eyes of the international community. He had long been a habitué of Detken's bookstore in Naples, the center of a mainly German archaeological circle. He was a personal friend of Theodor Mommsen from as far back as the early 1840s. As he gained power and influence in the administration of archaeological sites and museums in Naples, he freely offered his available time to foreign scholars, especially if they were German and came with a letter from Mommsen. In a short time, Fiorelli had gained enormous stature among European scholars.[15]

Ultimately more important than his reputation among scholars was Fiorelli's success as administrator of the Pompeii excavations and other institutions that were under his control. Fiorelli's plan of uncovering, if not restoring, Pompeii as an organic city demanded that he first consolidate the city within its historical boundaries by uncovering the city

wall in its entire circuit. Pompeii the city would thus emerge as a single entity, rather than as a series of haphazard excavation pits strewn across a landscape of cultivated fields. Earlier attempts had been made to recover such a city. During the French regime of the Napoleonic period, a great effort had been made to trace the city wall, and the state had purchased all of the land believed to be within the limits of the ancient city. Upon being restored to power in 1816, the Bourbon regime had sold off most of the unexcavated land to private interests. Nevertheless, maps of the city had been made, and the organic integrity of the city of Pompeii existed at least on paper from about 1812 onward. The archivist Fiorelli had studied the French project and, with the powers given to him in 1860, had begun to transform Pompeii from a hypothesis into a reality.

In order to uncover the circuit of the walls, Fiorelli had to remove an enormous mountain of fill that had been taken from the areas of the city excavated between 1816 and 1859 and dumped directly on the northwestern border of the city. In order to remove this fill, the administration of the excavations contracted with a private company, paying a fixed fee to dig it up and carry it by rail away from the site of Pompeii.[16] The consolidation of the archaeological site within its own integral boundaries thus made the city wall once again an effective barrier and transformed the gates of the ancient city into entrances. Fiorelli was able to institute an admission fee, by which he could raise money to support the excavations and even to increase his staff. To insure his plan against corruption, Fiorelli demanded a military discipline from his personnel. He demonstrated his resolve by forbidding the custodians to accept gratuities of any sort and by introducing a turnstile at the entrance to the excavations. These regulations encouraged tourism while guaranteeing that tourist money would flow into the excavations themselves.

The fame of Pompeii had grown steadily since the end of the preceding century. By the turn of the nineteenth century, Pompeii had eclipsed Herculaneum as a station on the Grand Tour. The discoveries made during the "French decade" had contributed monuments to the itinerary of Pompeii, and the publication of Sir Edward Bulwer-Lytton's

novel *The Last Days of Pompeii* in 1834 had greatly promoted the city in the imagination of Europeans and Americans. Between 1820 and 1860, reviews such as *The Edinburgh Review, Blackwoods,* and *The Quarterly Review,* to name a few, kept the reading public informed on the progress of the excavations. By the 1850s, a respectable number of discursive guidebooks devoted solely to Pompeii could be found in English, French, and German.[17]

The change of regimes in Naples had brought dramatic improvement in Fiorelli's prospects. In addition to his position as Inspector of Excavations, he was appointed professor of archaeology at the University of Naples, where he lectured three times a week. It was his exalted position at Pompeii, however, that brought him into contact with Europe's leading historical and intellectual figures. In his brief autobiographical notes, he singled out as important visitors Layard, the excavator of Nineveh; Anthony Panizzi, head librarian of the British Museum; and his superior Terenzio Mamiami, the First Minister of Public Instruction in the new Kingdom of Italy.[18] The list could be extended to many pages if we were to judge from the number of authors who claim to have been received by him. Within a short time, Fiorelli's excavations were being recognized as among the most well organized and scientific in Europe. Certainly, the scale of the Pompeian excavations was without equal.

The scientific benefits—measured in terms of knowledge gained about ancient life in all of its aspects—were undeniable in Fiorelli's new excavations. The need to show results in terms of artistic masterpieces, a harsh reality that had always hung over the excavations at Pompeii, was still apparent. The restoration of a balcony or a staircase leading to an upper story or of a necklace of the woman from the House of Holconius, interesting as it was, could not satisfy this requirement. Fortunately for Fiorelli, the excavations were yielding significant results in the way of more conventional masterpieces: bronze sculpture and frescoes worth detaching and transporting to the Naples Museum. During the summer of 1861, the excavation in the House of the Citharist (I.4.5/25/28) produced a fine female portrait

bust in bronze and a set of animals, as well as several marble reliefs. In the House of Siricus (VII.1.25/47) were found several imposing frescoes, including one of Thetis with the arms of Achilles. The discovery most prized for its artistic merit, however, was the large bronze statuette of Dionysos found in June 1862 in a small and unassuming house next to the Grand Lupanar.[19] This kind of find, which was immediately elevated to masterpiece status, brought Pompeii the sort of attention that Fiorelli's plans required.

Fiorelli also saw the need to leave some of the interesting pieces in the houses in which they had been found. This type of conservation was first practiced successfully in Pompeii in the House of Marcus Lucretius (IX.3.5), excavated in 1847. Bronzes were out of the question, but some marble statues like the Amorino in the House of Holconius (fig. 4) and the portrait of Cornelius Rufus and the atrium table in the neighboring house (VIII.4.15) were allowed to remain where they had been discovered. The interesting ambiences that were thus re-created immediately drew the attention of artists and commercial photographers who were beginning to make a living from views of the ruins. Commercial access to the excavations and the license to exploit them now came under the purview of the Inspector-Director, who saw every reason to encourage new forms of publicizing the site, so long as visitors were not harassed, coerced, or charged excessive prices for souvenirs. Photographers especially, like Giorgio Sommer, Achille Mauri, Michele Amodio, and Roberto Rive, showed great inventiveness in marketing an increasingly canonical series of Pompeii views. Well-known sites like the Theater and Amphitheater, the temples of Isis and Venus, and the Forum made up the list of essential subjects, but Fiorelli's new excavations constituted a necessary supplement. Collections of photographic views assembled in the 1860s and 1870s almost invariably contain views of the House of Holconius and the House of Cornelius Rufus and, as we shall soon see, casts of the bodies found by Fiorelli. When Heinrich Brunn visited Pompeii in the spring of 1863, he was able to report positively in the *Bullettino dell'Instituto di Corrispondenza Archeologica:*

Having arrived at Pompeii, we received a favorable impression right at the entrance from the strict and severe order that had been introduced at the initiative of the current inspector of the excavations, sig. Giuseppe Fiorelli. . . . But it is not enough that the workforces have grown: so has the method of excavating been changed and improved in its essentials. The old method was to excavate the streets first and to enter the houses from street level, proceeding from room to room. The consequence of this method was that the upper parts of the walls, which had sustained more damage, easily collapsed. By contrast, the excavations proceed vertically, and as the earth is removed from above, an opportunity is afforded to reinforce those parts of the walls that are seen to be damaged. This method has made it possible for Fiorelli to ascertain the existence of a balcony that wound around the upper floor of a house, and in general, more remains of upper stories have been preserved in the last two years of excavation than in many previous decades.[20]

If we were to attempt to read the mind of Fiorelli—who (in the words of Marc Monnier) "is all intelligence and activity"—on the eve of his great discovery of 3 February 1863, we would have to consider his grasp of the present, the past, and the future. This is hardly an easy task; it perplexed his contemporaries as much as it has those who have attempted to assess his legacy. Indeed, it was a remarkable set of circumstances that led to the discovery and the successful casting of four human bodies where they lay in a back alley near the Forum. Some of the conditions that allowed this discovery were contingent on Fiorelli's excavation plan, some on his innovative command structure. Without any doubt, the fame and notoriety the discovery brought altered the public and scholarly reception of the Pompeian excavations and the excavator Fiorelli. Understanding how these factors influenced the course of events may make it clear why this breakthrough happened when it did and why a similar discovery could not have happened earlier in the history of the excavations.

Sometime before the beginning of February 1863, Fiorelli had in-

structed the workers to cease digging immediately and to inform him if they had encountered any cavities when digging in the layer of so-lidified ash that rested atop the layer of loosely packed cinders above the ancient ground level. These were very specific instructions based on his suspicions that such cavities might have been caused by the decay of organic material originally buried in the eruption. Casts had been made successfully of doors and other wooden objects, and the proce-dure was by now standard in Fiorelli's excavations. Whether or not he anticipated the casting of human forms, he would have known about the impressions from the woman in the cellar of Diomedes and also about the opportunities lost when the women of 1831 and 1861 were found with their jewelry. Judging by his own account (see below), pub-lished shortly after the discovery, he was surprised by the results. In any case, he would never have had the opportunity to cast buried human remains if he had not been removing the earth in horizontal layers, that is, from the top down. While this technique—which may have been introduced at Pompeii by the architect Gaetano Genovese—was intended mainly to recover and to preserve the upper stories of Pom-peian houses and their contents, an unintended result was the possi-bility of recovering the remains of persons who had been struck down in the city's streets while they fled atop the heaped-up cinders.

On 3 February (a Tuesday), one of Fiorelli's crews was engaged in clearing the uppermost layer of a small insula (VII.11) behind the Cal-cidicum, or, as it is now called, the Building of Eumachia: "Two hun-dred, sixty-eight workers with eighteen carts [worked] on the insula bordered on one side by the Vicolo delle Terme Stabiane, on two sides by the first and the second *vicolo* perpendicular to that mentioned, and on the fourth side by the *vicolo* following that which is behind the Cal-cidicum." As they were digging in what must have been the southwest corner of their excavation, they encountered a human skeleton "in the first *vicolo* perpendicular to that of the *terme* and precisely at the point that forms an intersection with the other that follows the one behind the Calcidicum." They duly reported the discovery of the small finds found with the body:

Gold = A pair of earrings in the form of a head of garlic, each one 0.07 pal[mi] in height = Another pair of earrings, each one 0.05 pal[mi], with two pendant pearls, one of which is almost destroyed = a ring 0.06 pal[mi] in diameter, upon which is mounted a small green stone, perhaps a diasper [i.e., jasper]. *Silver* = ninety-nine small coins. *Bronze* = six coins of medium size = one of large size and two of medium size, adhering to two iron keys.

The *Giornale* report for the next day, 4 February, was very brief and to the point: "The skeleton encountered yesterday has been entirely uncovered, and into the impression left in the earth was introduced some liquefied gesso, which produced a male figure, almost complete, with traces of his clothing" (figs. 5–8 and 36). On 5 February, nothing was reported on this excavation. On 6 February, more remains were encountered in the same location: "In the same first *vicolo* perpendicular to that of the [Stabian] Baths, other skeletons have been encountered at the same level as the one indicated on the third of this month and about ten palmi before reaching the corner of the other *vicolo* following that of the Calcidicum." Finally, on 7 February, the result of the previous day's discovery and yet another (the fourth) body appeared:

Having introduced some liquefied gesso into the cavity in the earth where the skeletons were encountered yesterday, the forms of two women have been removed, one of which is lying on the right side, the other with her face toward the soil, and both of them are lying with their heads diametrically opposed to the other [figs. 9–11 and 40]. At about one hundred palmi from these skeletons, toward the center of the said road, other human bones have been encountered.

These last bones proved to be those of another woman (figs. 12 and 39). Careful exploration of the same area at last produced what was believed to be the treasure associated with the fourth victim. On 20 February, a small collection of objects was found, together with the cloth sack—identified from a gesso cast—used to transport them. Among the items found were a pair of pearl earrings, a silver hand mirror, six silver

spoons, a silver medallion with an image of the goddess Fortuna, and an amber statuette of an Amorino wrapped in a cloak.[21]

According to the timetable, or sequence of events, presented in the *Giornale,* gesso was introduced into the impression of the first victim on 3 February, since it would have had to set at least overnight before the hardened ash could be cleaned off so that the cast could be seen on the following day. (Unfortunately, the process of casting destroyed the original negative impression that had been formed about the body.) The second and third victims were discovered and cast on 6 February and described the following day. The *Giornale* provided very specific information about the number of workmen engaged, the exact location of the excavation, and the objects recovered, classed according to their material and measured for purposes of identification. The entries are almost entirely lacking in a sense that history was being made. More unfortunate is the fact that no photographs seem to have been made at the time of the excavation, and the casts of this excavation—and many subsequent excavations—were only photographed after their removal to places of storage and display (figs. 5–12).

Against the very brief and objective reports in the *Giornale,* we can compare Fiorelli's first announcement of the discovery—which he most emphatically claims as his own—in the official *Giornale di Napoli* (12 February 1863):

> On the third of this month, while digging in the small street that begins opposite one of the secondary doors of the Stabian Baths and issues in the vicinity of the Building of Eumachia, were found, at the height of five meters above the soil, about a hundred silver coins, four earrings, and a small finger ring of gold, with two iron keys and some traces of cloth in which the coins had been wrapped. In a close search of the earth, lest any of this precious treasure be missed, we came to a place where the earth gave way under the trowel, revealing a hollow cavity deep enough to reach in at arm's length and remove some bones. I realized immediately that this was the impression of a human body, and I thought that by quickly pouring in scagliola, the cast of an entire person would be obtained. The result surpassed my every expectation. Af-

ter some days of difficult work, I had the pleasure to see arise the entire figure of a man, missing only a small portion of the right side, wrapped in a cloak, with long trousers and feet enclosed in a type of boots to which nails and the iron lasts of the soles still adhered. The open mouth and the swollen belly demonstrated quite clearly that he had died drowned by the waters and buried in the mud in which I found him enveloped.

Not far away from him lay two women, perhaps his wife and daughter, to whom belonged the gold items that I sent to the National Museum. They had fallen one next to the other, the first being of a mature age and the second a girl not yet twenty years of age, both of whose entire bodies were kept intact by means of the same scagliola, showing clearly the handiwork of the laces and ties that adorned their garments and their shoes.

If I shall be fortunate enough to encounter new bodies among the ashes, being better equipped with all the means necessary for obtaining good results in a work of such importance, my casts will come out more perfectly. For now it is a satisfactory compensation for the most exacting labors to have opened the way to obtaining an unknown class of monuments, through which archaeology will be pursued not in marbles or in bronzes but over the very bodies of the ancients, stolen from death, after eighteen centuries of oblivion. [See appendix for the Italian text.]

Fiorelli's newspaper account was written after he had made casts of the second and third bodies, that is, after 7 February. It is curious that he fails to mention the body of the fourth victim, which was reported in the *Giornale* entry for the same day.

In any case, Fiorelli's description and analysis of the excavation adds much valuable information to the very terse account found in the official record. His remark that "some days of difficult work" preceded the recovery of the cast of the first victim seems to contradict the sequence of events as it was represented in the *Giornale*. Fiorelli's account is the more likely. It is also interesting to read in his account that the

gold items were associated with the older of the two women (i.e., victim no. 2), since some have associated them with the man and since the order of the *Giornale* would seem to suggest this. However, the *Giornale* simply followed a conventional order, where Fiorelli wrote with the authority of an eyewitness commenting explicitly on this fact. On one particular, the truthfulness of Fiorelli's account has been challenged, and his account can be of no use in clearing the record. Later in Fiorelli's career and even after his death, some expressed doubt that he was personally responsible for the first casts of the Pompeian victims. They argued that one of his subordinates or a technician versed in the making of casts might have actually made the discovery for which Fiorelli took credit. It will be best to examine these charges in due course, but we can state that at this time in the life of the Pompeii excavations, Fiorelli was very actively involved in the excavations, and his own account is not improbable.

Other contemporary accounts help to fill in the details of this historic excavation and lend support to Fiorelli's claim to the discovery. A correspondent wrote from Naples in the journal *l'Italie* on 6 February:

> A very interesting discovery has been made by the learned inspector of the excavations at Pompeii, Signor Giuseppe Fiorelli. The day before yesterday, while digging at a depth of ten palmi, the pick struck a small heap of coins and jewelry. Sig. Fiorelli had the excavation continued with the greatest care, removing the nearly solidified earth grain by grain. After a few hours of work, an intact mould was found, made in the ashes, of a man lying on the ground. The flesh had been desiccated, but the skeleton was complete. Sig. Fiorelli had the happy idea of pouring plaster into the form of the Pompeian. The cast came out perfect, except for two sections of the arm and the leg, which lapilli had penetrated in place of the ashes and had not, in consequence, retained the impression.
>
> The man's features have been cast with amazing precision. The moustaches, the hair, the folds of the garment, the shoe are marvelously detailed. The famous question of the *Thesaurus* of Gronovius and Grae-

vius is settled: the Romans wore trousers! Archaeologists may finally be
able to agree on the manner in which the ancients tied their sandals, in
seeing a heel of a shoe completely nailed.[22]

This near contemporary account, which reveals great familiarity with
the first victim, supports Fiorelli's version of the timeline and also high-
lights the latter's role in the discovery. The finality with which (in the
opinion of the correspondent) the enigma of Roman dress has been re-
solved by the new discovery also demonstrates that a sense of histori-
cal awareness may have been shared by those who discussed the event.
This is to some extent confirmed by the report of a correspondent in
the *Times* of London for 10 February: "A great sensation has been cre-
ated here in the archaeological world by the discovery of the perfect
skeleton of a man under the ruins of Pompeii. A cast has been taken in
plaster of Paris."

Fiorelli's decision to announce his amazing discovery in the news-
paper might have been justified at the time by the fact that the *Giornale
di Napoli* was an official paper. It did, however, go against the custom of
making such an announcement first to his superiors and to an official
academy like the Accademia degli Ercolanesi. His superiors in Florence,
the administrative seat of the government at that time, were pleased
but were a little miffed to have learned about it in the papers. The Min-
ister of Public Instruction wrote a mild complaint to the principe di San
Giorgio, Fiorelli's direct superior in Naples, and learned that San Gior-
gio himself had only seen it in the papers.[23]

Although Fiorelli's *Giornale di Napoli* article must be taken as the
best evidence of his own state of mind and his hopes and expectations
for future discoveries, another letter written a few days later by the dis-
tinguished scholar and patriot Luigi Settembrini went even further in
promoting the fame of the discovery and the discoverer. Written on 13
February—the day after Fiorelli's letter had appeared—and published in
the same newspaper on the seventeenth, Settembrini's letter is both
more literary and more detailed in its narrative. Although it cannot
have been his original intention, Settembrini's letter ultimately dis-
placed Fiorelli's own account of the discovery, even though the author

had not been present when the first casts were made. It is quoted here in its entirety because it is not easy to find and deserves to be appreciated as a whole.

The Pompeians

I have just returned from Pompeii, and my mind is filled with sadness for the pitiable sight. Some friends who went with me and saw, as I had seen, those poor creatures, dozed peacefully on the way back, while I felt myself all inflamed with the thoughts whirling around in my head. At first I felt irritated that they could sleep. Then I took pleasure in it and lost myself in my fantasies.

But I must begin at the beginning. This morning, then, we went to Pompeii in a group to see the new miracle of our friend Fiorelli, who raises up the Pompeians and lets us see them as they were on 23 November AD 79, the last day of their unhappy town. He who goes about there collecting the final words scratched on the walls with nail, stylus, coal, or whatever, which after a time disappear because the plaster crumbles, and with these graffiti reconstructs the language spoken by the populace—now he makes us see the men themselves, with their shirts and with their sorrows.

Pompeii was buried first by a rain of cinders that left a coating more than three meters deep and then by another rain of ash and water. The ash quickly hardened, while the water filtered downward through the cinders, and whatever bodies of animals remained in the ash made a cavity there. Then the body wasted with time, and the cavity remained, containing the few remains of the decayed body. Previously, these cavities were hardly noticed. The spade broke through everything and recovered only the skull and the bones that were found amid the ash and that can be seen kept in some chests here and there. Fiorelli, with his acumen and his wonderful instinct for archaeological discovery, said to the superintendents of the excavations: "If you find any cavities, don't touch them, and bring them to my attention immediately." And lo and behold, a few days ago, while digging in a small street near the baths, and right in the middle of the street, there were found two pairs of gold earrings—one larger, one smaller—a gold ring, a hundred silver coins,

and two iron keys, all in the same spot near a hole that led into a cavity. Fiorelli rushed up and with long tongs dug out some bones from the hole and filled the cavity with liquid gesso. When the gesso had hardened and was scraped clean of the ash that adhered to it, it revealed the figure of a man lying on his back, with his mouth open, his chest and stomach swollen, as is usually seen in those who have drowned. The left arm was complete, extended, with the hand closed. At the tips of the fingers, the bones could be seen in the gesso. On the small finger, there was an iron ring. The right arm was missing because it was where the hole was through which the gesso had entered. On the left arm and on the chest is a certain accretion, which appears to be made by the clothing. The belly is bare. The trousers are rolled down over the thighs. On the feet were laced soles, and nails were visible on the bottoms. From the straps that wrapped the left foot, the large toe extended bare. He appeared to be a man of fifty years. The nose and the cheeks could be seen clearly. The eyes were missing, as was the hair. In the open mouth, he was missing some teeth. Here and there appears clothing material.

On the following day another cavity appeared. Fiorelli removed what bones he could from it, poured in the gesso, and, lo and behold, there emerged two figures of women, lying as though on the same bed, one at the head and the other at the foot. The larger one, fallen on her left side, appeared to be a mature woman. Her face could not be seen, but an arm was quite discernable, as were the legs and a band that bound the breast. The smaller woman, with her skull intact, into which the gesso had entered, lay face down. The lower parts of the body uncovered, she appears to be a girl not older than sixteen years. The attitude of this girl—all her limbs appear still convulsed—elicits real pity. That skull, hidden half in ash and half in cinders, that right hand that is held to the face and perhaps to the mouth, that left hand extended with hand contracted and, in the fingers, the little bones mixed with gesso display the final cruel agony of the poor creature. One sees the stuff of the garments, the stitching, the lacework, and the arms covered as far as the wrists; on the back, here and there, bare flesh, the little feet in laced sandals. Perhaps they were mother and daughter who fled and fell and

died next to one another, and perhaps the man was the father of the girl and carried in his hands the jewelry of the dear women and the small treasure of the family and the keys of the house to which he hoped to return. Perhaps in their house they had struggled against the rain of cinders, then, having left from there and fleeing through the street, they were overcome by the ash and water and fell and drowned.

It is impossible to see these three disfigured bodies and not to feel moved—especially the girl with that skull and that body of hers who, being less indistinct than the others, appears to have such grace that it breaks your heart. They have been dead for eighteen centuries, but they are human beings who are seen in their agony. There is nothing of art or of beauty, only bones, the remains of their flesh and their clothing mixed with the plaster. It is the pain of death that has conquered the body and the figure. I looked at the confused mass, I heard the shrill cry of the mother, and I saw her fall and struggle as she died. How many more human beings perished in the same torments and worse! Until now there have been discovered temples, houses, walls, paintings, writings, sculptures, vases, tools, implements, bones, and other objects that roused the curiosity of cultured persons, artists, and archaeologists. But now you, my friend Fiorelli, have discovered human pain, and whoever is human can feel it.

There is another figure of gesso, which certainly is of a man, but he is quite disfigured.

Fiorelli is weighing and searching for improvements in hardening the ash, in cleaning the cavities, and in obtaining precise figures, and from these figures, he promises to collect all the details about the clothing and the adornment of the men and women of Pompeii and to enrich archaeology once again by means of his new discoveries. I am certain that he will accomplish great things, because he has already accomplished great things, because he has great learning and the greatest love for his studies. The organization, the precision, the discipline with which he directs the excavations at Pompeii is astonishing in every respect: everything is preserved; everything is cherished; not even a cinder is carried away. Collapsed walls are put back in their places, where formerly they were carried away in order to show how much space had

been excavated and to collect more compensation. Thus the walls most recently excavated are quite a bit higher than the older walls. Where there were doors, an impression of the wood, now decayed, is taken in gesso. Broken vases of value are restored. Frescos are coated with wax, rendering them more alive and protecting them from the elements, and they are watched over scrupulously. Along the streets, there is not a blade of grass. Hundreds of boys, girls, and women transport the earth without making a commotion, discretely, cheerfully, most obediently. Everyone who enters pays two lire and nothing more to the guides, who are polite, well dressed, and salaried. On Sunday, entrance is free to all without payment. In sum, the city of the dead is kept better than that of the living.

Unfortunately, Settembrini does not say where the casts lay when he examined them—whether they had been removed from the site where they had been found to another location. He is also a bit vague on the precise timing of the initial discovery and is under the impression that the fourth body was that of a man, indicating that there was initial confusion in the description of this victim. He uses the occasion to praise Fiorelli's management of the excavations and mirrors the latter's concerns, expressed in his own newspaper letter, about improving the casting process. Above all, unlike Fiorelli, Settembrini professes to be moved by the victims' fate. At one point, he even seems to turn on the discoverer for having uncovered only human tragedy and nothing of artistic value. It is a rhetorical outburst, but Settembrini is aware that he is protesting against fate, against death itself. Both Settembrini and his friend Fiorelli are also aware that the outburst has been made in recognition of the passing of the classical ideal. After Fiorelli, the fate of the ancient Pompeians could no longer be romanticized. There could not be another Bulwer-Lytton. It was no longer possible to contemplate death in an intellectual way, in the presence of a tomb monument or even a skeleton as the Romantics had done. Heroic death, such as that imagined for the woman with her three children found at the Sepulchre of the Mammiae, must now give way to the more squalid reality

that was graphically revealed in Fiorelli's casts. No clearer statement of this sea change could have been made than by Ferdinand Gregorovius, who had written his poem *Euphorion*—a tale in the Romantic vein about a Greek artist working in the House of Diomedes—in 1858. After a visit with Fiorelli that included viewing the casts in 1864, he wrote:

> Wandered a long time about Pompeii, went to the house of Diomedes, and reflected on my own career, especially on the time when I wrote the poem of *Euphorion*. Even this, too, is covered, as it were, with ashes; the sensations I then experienced have passed away—the House of Diomedes and the sight of the ancient candelabra in the museum scarcely reawakening the faintest echo.[24]

As the excavation took place in the winter, the casts were moved to a place where they could be protected and also where they might be studied at leisure. A kind of museum was made in a house near the Herculaneum Gate that became known as the "House of the Cadavers of Gesso" (Casa dei Cadaveri di Gesso, VI *insula occidentalis* 27/28/29/30). Here they remained, comprising one of the high points in the itinerary of all visitors to Pompeii, advertised in countless photographs, as Overbeck noted as early as 1866. The museum consisted of two rooms entered from the street. The first room held the cast of the fourth victim, a woman in a contorted position, placed on a shelf. The second room contained two more shelves. One held the first victim, a man, lying on his back. The second held the second and third victims, two women, "lying with the heads at opposite extremities of the table, so that the lower portion of the one figure is parallel to the other."[25] Overbeck noted that while they fell far short of modern, artistic casts with respect to sharpness and detail, they were sufficiently exact to permit recognition of the cause of death, as well as general and particular observations of the bodily forms themselves, the garments, and other incidental ornaments.[26] Heinrich Brunn noted both the difficulty of making sense from the casts and the important role played by Fiorelli, who conducted a kind of coroner's inquest:

There are some things that are clear, some in doubt, some quite ob-
scure. Indeed, even by viewing these casts repeatedly, the eye is con-
fused, and one senses the need to seek the help of another, unpreju-
diced observer. And it is for this reason that I do not give a detailed
description here but must, rather, await the greater experience of
Fiorelli, who not only has examined these bodies more closely than
anyone but has also collected the observations made in his presence by
archaeologists and antiquaries, artists, anatomists, and others.[27]

Most viewers were, like Settembrini, struck by the pitiable sight of
the casts of victims in their last throes. Compare the reaction of the
young American consul William Dean Howells upon seeing the casts in
November 1864:

> The guide takes you aside from the street into the house where they lie
> and a dreadful shadow drops upon your heart as you enter their presence.
> Without, the hell-storms seem to fall again, and the whole sunny plain to
> be darkened with its ruin, the city to send up the tumult of her despair.[28]

With a bit more distance, G. Bascle de Lagrèze wrote:

> I experienced a strange and heartrending feeling at the sight of these
> beings who had lived in an era so distant from our own. It is a striking
> and pitiful spectacle that these white phantoms bear in their poses,
> their features, their attitudes of despair and of suffering in their final
> convulsions of frightful agony! That which was their body vanishes
> upon the first contact with the air. That which is left of man on earth is
> even more fragile than a piece of glass![29]

The removal of the casts from their archaeological context—a move
dictated by practical need but consistent with Fiorelli's mission to pre-
serve the antiquities—necessarily resulted in some confusion to those
who sought to understand the phenomena and to report them to the
rest of the world. Some contemporary accounts introduced (or perpet-
uated) factual errors. A report of the discoveries appearing in the *Mer-*

chants' Magazine in New York in June 1863, attributed to a correspondent of the London Atheneum, described the site of Fiorelli's discovery as a "house" and the first victim as "a Roman lady of the first century."[30] Such errors naturally had a tendency to reverberate in subsequent accounts, although Fiorelli was remarkably successful for his time in remaining in control of his story. When we compare the descriptions published within the first year or so of the initial discovery, we note an emerging consensus in the descriptions and interpretations of each of the four bodies. For example, the first victim, the man, is usually described as having died bravely and resigned to his fate, unlike the second, third, and fourth victims, women, who each demonstrated some manner of desperation. Howells reflected this consensus in his response to the sight of the casts in the little museum:

> The man in the last struggle has thrown himself upon his back, and taken his doom sturdily—there is a sublime calm in his rigid figure. The women lie upon their faces, their limbs tossed and distorted, their drapery tangled and heaped about them, and in every fibre you know how hard they died.[31]

Without doubt, later writers often drew on the language of earlier writers. Another reason for the consensus is that important visitors like Goldsmidt, Layard, and Beulé gained access to the casts through Fiorelli and naturally discussed the evidence with him. It is not surprising, therefore, that their published accounts reflected the opinion of Fiorelli. Probably, the most consequential observation first made by Fiorelli in his *Giornale di Napoli* letter and then often repeated was that the victims exhibited swollen stomachs precisely like those seen in drowning victims.

The First Victim (figs. 5–8 and 36)

The first victim was located on 3 February 1863 at what the *Giornale* recognized as the intersection of two alleys separating insulae 10, 11, 13,

and 14 of Region VII (see map). Subsequently, Fiorelli, in his public announcement of the discovery, stated that the body was found five meters above the ancient street level. It was found in the layer of compacted ash formed in the pyroclastic surge that swept this part of Pompeii in the early morning hours of the second day of the eruption. The initial discovery and the casting in gesso that followed took at least two days, with the results having been made clear by the end of the day on 4 February. Unfortunately, the exact position in which the body lay was not recorded at the time of excavation, and subsequently some confusion arose concerning which victim had been carrying the treasure. The man and possibly his companions had evidently emerged from shelter and been overcome by the surge while proceeding along one of the streets atop the fill of cinders (*lapillo*) that had been deposited during the earlier phase of the eruption. The man's body was discovered during a search for additional pieces of gold jewelry and silver coins, which seemed at first (cf. Settembrini's account) to be the contents of a purse carried by him.

A full description of the victim could not be made at the time of the discovery, and even when the gesso cast had set and been freed of the surrounding layer of ash. Settembrini's description, made within two weeks of the discovery and probably reflecting Fiorelli's preliminary theories as to cause of death and so on, set forth a pattern of description that many followed. The following descriptions made after the cast had been removed to the House of the Cadavers of Gesso provide additional details and analysis.

SETTEMBRINI (LETTER OF FEBRUARY 1863, CITED ABOVE)

. . . a man lying on his back, with his mouth open, his chest and stomach swollen, as is usually seen in those who have drowned. The left arm was complete, extended, with the hand closed. At the tips of the fingers, the bones could be seen in the gesso. On the small finger, there was an iron ring. The right arm was missing because it was where the hole was through which the gesso had entered. On the left arm and on the chest is a certain accretion, which appears to be made by the clothing. The belly is bare. The trousers are rolled down over the thighs. On

the feet were laced soles, and nails were visible on the bottoms. From the straps that wrapped the left foot, the large toe extended bare. He appeared to be a man of fifty years. The nose and the cheeks could be seen clearly. The eyes were missing, as was the hair. In the open mouth, he was missing some teeth. Here and there appears clothing material.

AUGUSTUS GOLDSMIDT (1863)

. . . the figure of a man lying on his back, with one hand grasping his garment, which he has pulled up to the chest, leaving the whole of the lower portion of the figure exposed, which is of very fine proportions; a curious peculiarity still distinctly traceable is that the hair of the *pubes* is shaved so as to leave it in a semi-circular form, such as may be observed in the statues, and which has, I believe, been generally supposed to be merely a sculptural conventionality. The other hand is extended and strongly clenched, and the limbs in an attitude of rigidity almost amounting to convulsion. These facts, as well as the expression of pain and horror distinctly traceable in the countenance, would seem to show that the unfortunate man died fully conscious of the dreadful fate which awaited him, and against which he vainly struggled. The bones of the feet are exposed.

AUSTEN HENRY LAYARD (1864 [1863])

. . . a man of the people, perhaps a common soldier. He is of almost colossal size. He lies on his back, his arms extended by his side and his feet stretched out as if, finding escape impossible, he had laid himself down to meet death like a brave man. His dress consists of a short coat or jerkin and tight-fitting breeches, of some coarse stuff, perhaps leather. Heavy sandals, with soles studded with nails, are laced tightly round his ankles. On one finger is seen his iron ring. His features are strongly marked; the mouth open as in death. Some of the teeth still remain, and even part of the moustache adheres to the plaster. (172)

OVERBECK (1866)

As the comparison with the Pompeian guide standing beside him in our illustration (cf. fig. 8) shows, the man is of gigantic proportions. He lies

upon his back, seemingly having been overcome in his struggle with death. He had convulsively drawn up his short garment. He seems to have died of a blow, in the opinion of the experts. A closer description of this victim seems unnecessary in the presence of the illustration. (32–34)

BRETON (1869)

The fourth body, placed to the left of the room, is that of a man of some height, probably a soldier, to judge by the traces of straps left on the lower abdomen. These seem to have formed the lower part of one of those cuirasses, or *loricae,* that were composed of strips of leather placed side by side. This man lies on his back; his arms and his legs, extended naturally, seem to indicate that he succumbed without convulsions. The entire right side of his body did not cast successfully, but the cast has generally well captured the left side. The hand, wearing an iron ring, is perfectly cast; the nose and the chin are well rendered, and the mouth, though pursed, leaves some of the teeth visible. The cheekbones are prominent and bony, and the hollow cheeks would seem to indicate a man of fifty years. The left leg seems weak compared to the right, which is enlarged by the impression of a coarse cloth. The feet are in stout shoes with soles trimmed with nails. (280–82)

BEULÉ (1872)

In the lead, acting as scout, marched an older man, perhaps the father of the young girls who followed him and who died together. He held in his hand the gold earrings of his two companions, some coins, and the house key. He was of low status, since he wore only an iron ring on his finger. A cut above usual height, he was not less than six feet. He had raised cheekbones and a pronounced brow. His mouth and the moustaches above it gave him the air of an old soldier. His lips seem to show his effort to breathe, his eyelids are intact, and his eyes open, as though he was still bearing up. Turned on his back, this giant sought to raise himself by supporting himself with his elbows. He had drawn up over his head the corner of his cloak in order to protect himself from either the ashes or the gas that choked him. The expression is that of suffoca-

tion, the same that killed Pliny. The cloak covers the chest and the right arm, while a bunch of material at his waist shows that he had lifted his clothing in order to be more mobile. On his legs, then, lean and vigorous, can be seen a type of pants adhering to his skin and shoes trimmed with large nails. (192–93)

NEVILLE-ROLFE (1888)

The third cast is a male body much less perfect than the others. The left hand has made an admirable cast, and had an iron ring on the little finger. The face is a man of fifty. He wore a moustache, but otherwise was clean shaven. (82–83)

As commercial photographs taken of the cast not long after it had been removed to the House of the Cadavers show, the stature of the first victim was great, possibly in excess of six feet. The inclusion of a modern custodian for size comparison makes this point clearly (fig. 8). The rigidity of the body, also evident in the photos, was interpreted by many observers as reflecting the moral character of the man, rather than as a physical symptom of his death. Noting that the man's stomach seemed to be bloated, Fiorelli and Settembrini initially favored drowning as the cause of death. Subsequently, Fiorelli was content to explain the swollen midriff as a flaw in the casting process.[32] Layard and Breton noted a certain resignation and death without convulsion. Goldsmidt and Beulé saw a more violent death struggle taking place. Beulé proposed an alternate hypothesis of death by suffocation.

Observations of the man's clothing demonstrate two important points. First, the cast presented more detailed evidence about clothing items already known to have been worn, such as shoes, with their laces and hobnails. Second, the trousers and underwear, unattested in classical sculpture, posed some problems of interpretation. Goldsmidt's observation about the man's trimmed pubic hair was delicately answered by Layard and Breton, who attributed the curious forms visible on the man's lower abdomen as the marks of tight-fitting underwear or, perhaps, a soldier's cuirass.

Some problems were not resolved. The man's iron ring would have

indicated slave status, difficult to reconcile with his identification as a soldier. His high cheekbones, prominent brows, and mustache, as well as his gigantic stature, all suggested a northern European origin.

The Second and Third Victims (figs. 9–11 and 40)

The presence of the cavities in the *fango* produced by the second and third victims was detected on 6 February, and the casts had been made and freed from the matrix by the end of 7 February. The exact location of the bodies with respect to that of the first victim is not recorded. The *Giornale* indicated the find spot as "10 palmi" (about 2.5 m) from the corner of insulae 10 and 13 of Region VII, but the notation is insufficient. Fiorelli, in his *Giornale di Napoli* letter, simply says that they were "not far from" where the first victim lay. Like the first victim, these were found five meters above the ancient street level, indicating that they had perished at the same time. Although it cannot be known for certain, it appeared that the three had belonged together as a group, because the gold earrings—a larger and a smaller pair—probably belonged to the women, as Fiorelli indicated. Settembrini, who suggested that the man may have been carrying the precious items for the women, speculated that the group might have been a family. Beulé suggested that a more complicated domestic relationship united the three.

SETTEMBRINI (1863)

. . . two figures of women, lying as though on the same bed, one at the head and the other at the foot. The larger one, fallen on her left side, appeared to be a mature woman. Her face could not be seen, but an arm was quite discernable, as were the legs and a band that bound the breast. The smaller woman, with her skull intact, into which the gesso had entered, lay face down. The lower parts of the body are uncovered, and she appears to be a girl not older than sixteen years. The attitude of this girl—all her limbs appear still convulsed—elicits real pity. That skull, hidden half in ash and half in cinders, that right hand that is held to the face and perhaps to the mouth, that left hand extended with hand contracted and, in the fingers, the little bones mixed with

gesso display the final cruel agony of the poor creature. One sees the stuff of the garments, the stitching, the lacework, and the arms covered as far as the wrists; on the back, here and there, bare flesh, the little feet in laced sandals. Perhaps they were mother and daughter who fled and fell and died next to one another, and perhaps the man was the father of the girl and carried in his hands the jewelry of the dear women and the small treasure of the family and the keys of the house to which he hoped to return. Perhaps in their house they had struggled against the rain of cinders, then, having left from there and fleeing through the street, they were overcome by the ash and water and fell and drowned.

GOLDSMIDT (1863)

These two are lying with the heads at opposite extremities of the table, so that the lower portion of the one figure is parallel to the other; they are the bodies of a woman apparently from 30 to 40 and a girl of 15 or 16. The woman is lying on the left side, with one arm slightly raised, and the other by her side, apparently in an easier position than the two figures before described, as if she had suffered less.

The younger is also lying on her left side, the head thus turned in a contrary direction to that of the elder; the face is supported on the left arm, which is placed so as to protect the eyes, and the arm and hand are in an attitude as if holding a cloth or handkerchief over the mouth, apparently protecting herself as much as possible from the falling ashes. The form of this figure is most beautiful, especially the loins and *nates,* which are perfectly modeled; the hand and arm are also very delicate, though both these figures would appear to have been of inferior rank to the first. The tissue of the dress is distinctly visible. I should have mentioned that, in the elder, traces of cloth leglets and the fastenings of a kind of ancle boots are distinctly visible.

The symmetry of the back and loins of this figure, as well as that of the younger already alluded to, are most remarkable, and, occurring as it does in the bodies taken by chance, would seem to go a long way to show that the ancients had actually before them individual specimens of that perfect symmetry which they have handed down to us in those magnificent statues which are still the world's wonder, and that they

were not an assemblage of the characteristics of different individuals into one imaginary form.

LAYARD (1864 [1863])

The most interesting of the casts is that of two women, probably mother and daughter, lying feet to feet. They appear from their garb to have been people of poor condition. The elder seems to lie tranquilly on her side. Overcome by the noxious gases, she probably fell and died without a struggle. Her limbs are extended, and her left arm drops loosely. On one finger is still seen her coarse iron ring. Her child was a girl of fifteen: she seems, poor thing! to have struggled hard for life. Her legs are drawn up convulsively. Her little hands are clenched in agony. In one she holds her veil, or part of her dress, with which she had covered her head, burying her face in her arm, to shield herself from the falling ashes and from the foul sulphurous smoke. The form of her head is perfectly preserved. The texture of her coarse linen garments may be traced, and even the fashion of her dress, with its long sleeves reaching to her wrists. Here and there it is torn, and the smooth young skin appears in the plaster like polished marble. On her tiny feet may still be seen her embroidered sandals. (172)

GREGOROVIUS (1911 [15 AUGUST 1864])

A few days ago went with Fiorelli, director of the excavations, to Pompeii. They are working with success on an improved system there. Many fresh excavations have been made—a two-storied house has been restored. The four figures—cast in plaster—of Pompeian fugitives, who were turned to stone while in the very act of flight, make an indescribable impression; life incarnate in its most awful tragedy. More especially is this the case with the young girl, who, in despair, has lain down to sleep the sleep of death; the figure as graceful as that of a slumbering Hermaphrodite.[33]

OVERBECK (1866)

A much more stirring picture is provided by the two women, and, indeed, the sight of the young girl of this group (on the right in the illustration), a tender creature of thirteen to fourteen years, produces a truly chilling effect in the original. She is clearly exhausted, and in the obvi-

ous impossibility of escaping, she has yielded to her bitter fate and has cast herself down headlong and half twisting, with her arms crossed under her head. And so she has died relatively calm; the peacefulness of her position shows it. She lies before us more asleep than dead, while the woman who accompanies her, to judge from the position of her head, the gesture of her left arm, the clenched fist, and the pose of the legs, has not resigned herself in a similar manner but has perished having collapsed in a hard struggle with death by suffocation. The clothing of all of these figures is very scanty. Naturally, the fugitives had cast off their larger garments and attempted to escape in close-fitting underclothing. These can be recognized with sufficient clearness. (32–34)

BRETON (1869)

Two bodies, however, formed a single group, composed of a woman and a young girl about fifteen years old. It is this group that one sees to the right upon entering into the small room from the Street of Domitian. The two women have fallen one next to the other, but in reverse direction. Their clothes, of coarse material, would seem to demonstrate that they did not belong to the wealthy class. For both women, the casts of the upper part of the body have not turned out well along the side they lay on, but fortunately the same was not the case for the upper portions.

The woman who one could assume to have been the mother appears to have been asphyxiated rapidly by some release of gas and to have died without convulsions. She lies upon her right side in a quiet and natural position. Her right arm falls freely, and the little finger bears the rusty impression of an iron ring.

The young girl seems, on the contrary, to have died in frightful convulsions. She lies flat on her stomach, her legs contracted and her face pressed against her left arm. Her hand grasps a fold of her garment, in which she has apparently tried to wrap her head. The form of this head is perfectly preserved, and a large portion of the cranium itself is exposed. The finger joints of her right hand are also evident. Through the tears in her clothing can be seen the youthful flesh, smooth as marble, and on a small foot an embroidered sandal is still recognizable. (280–82)

BEULÉ (1872)

But the most moving sight is that of the two sisters who ran a few steps behind this colossus, sustaining one another, breathing the same poison, struck down by the same blow, and dying with their feet entwined. The older one is lying on her side, as if sleeping. Two iron rings worn on her fingers attest to her poverty; her ear, large and prominent, shows her common origin. On the thighs can be seen pants of fine texture, contrasting with the coarseness of the rest of her clothing. This is torn in places but permits a view of firm and smooth flesh, of curves almost embarrassing, which recall those of the model in the studio. It is indeed a nude woman that one holds in one's view, and one well might blush had not the nudity been veiled in such misfortune, if indiscretion had not been purified by pity. The other young girl was not yet fourteen years of age: she has fallen on her stomach, stretching her arms out as protection or as support for her head. A clenched fist bears witness to her suffering. The other hand holds the tail of her robe or a kerchief close to her face, as if she was hoping to protect herself from the mephitic wind. Her two feet thrash in the air, caught in the folds of her tunic. One sees, however, that she has disengaged a shoe from the embroidered cloth, rent and torn on one side. Her small body, so tender, is already attractive: a beautiful back, straight and well-formed shoulders, a beauty in the making, calling to mind the *Joueuse d'Osselets* or the *Nymphe àla Coquille*. Her coiffure is that of Italian women of the mountains, a braid falling down the back of her neck. This pathetic tableau is a drama all by itself. No need to dream of mummies wrapped in their bandages and stuffed with bitumen, neither figures of wax formed with shocking exactitude. This is a group with realistic movement, of an immediate expression. Nature has been modeled on life, poised between suffering and death. The attitudes and unrehearsed freshness of composition bring to mind the greatest of artists. (193–95)

NEVILLE-ROLFE (1888)

The next case contains two female bodies, usually called "Mother and daughter." (83)

This group evoked more pity than either of the other victims. The fact that a single cast yielded two victims indicated that the two were in contact at the moment of their death. Commentators speculated on the relationship of the two women: were they mother and daughter or two sisters? All seem to have been in agreement that they were of humble status, noting the coarseness of their clothing and their features and the fact that elder one wore an iron ring.[34] This incongruity must have perplexed Fiorelli and others, leading, for example, to the difference of opinion over which body to associate the treasure with. (Fiorelli thought the older woman, while Settembrini suggested that the man carried the treasure.) Goldsmidt was especially taken with the beauty of the younger girl, taking her well-formed body to be an example of the ancient *belle nature* in the same spirit as Hippolyte Taine (cited above). It is not surprising, therefore, that this group drew the attention of the distinguished Neapolitan sculptor Tito Angelini, who was eager to reproduce it in marble.[35]

The Fourth Victim (figs. 12 and 39)

According to the *Giornale*, the fourth victim was found in the center of the alley, about one hundred *palmi napolitani* (about twenty-five meters) from the spot where the other three victims had been discovered. The direction is unspecified, but if insula II provided the outline of the excavation, it is likely that the fourth victim was found to the east of the intersection of the two alleys. It is impossible to determine whether this victim was part of the same group of fugitives as the three victims previously discussed.

SETTEMBRINI

There is another figure of gesso, which certainly is of a man, but he is quite disfigured.

GOLDSMIDT (1863)

In the first room is the figure of a female, apparently about thirty years old, or perhaps more, lying on the right side in a twisted and apparently

somewhat contorted position. The left hand is raised, and on the little finger is a ring much corroded, apparently of silver; the head is thrown back, and the hair, which appears to have been very plentiful, is still visible; the folds of the dress are quite distinct; the bones of the feet, which are stretched out, are protruding; the ankles and wrist joints and the extremities of the fingers are most delicately formed, and their slenderness and the great length and better proportions of the thumbs would seem to show that this female was of gentler blood than the two hereafter described.

LAYARD (1964 [1863])

At some distance from this group lay a third woman. She appears to have been about twenty-five years of age, and to have belonged to a better class than the other two. On one of her fingers were two silver rings, and her garments were of a finer texture. Her linen head-dress, falling over her shoulders like that of a matron in a roman statue, can still be distinguished. She had fallen on her side, overcome by the heat and gases; but a terrible struggle seems to have preceded her last agony. One arm is raised in despair; the hands are clenched convulsively. Her garments are gathered up on one side, leaving exposed a limb of beautiful shape. So perfect a mould of it has been formed by the soft and yielding mud, that the cast would seem to be taken from an exquisite work of greek art. She had fled with her little treasure, which lay scattered around her—two silver cups, a few jewels, and some dozen silver coins. Nor had she, like a good housewife, forgotten her keys, after having probably locked up her stores before seeking to escape. They were found by her side. (172)

BRETON (1869)

The third body, located at the back of the room, is also that of a woman, doubtless of the wealthy class. Near her, with a collection of keys, there were found two small silver vases, some gold jewelry, and quite a large number of silver coins. She lies on her back, and, although the cast is only a mediocre impression, her expression of despair is almost as poignant as that of the body conserved at the Archaeological School.

One arm is raised, the hands are clenched convulsively, and the cloth-
ing, thrown off in agonized movement, reveals the left leg, which is ad-
mirably shaped. The breasts have not turned out in the casting, and the
sex cannot be determined except by the coiffure, which seems to have
been curled, and especially by the size of the pelvis ("basin"), which is
such that one could suppose the unfortunate woman to have been
pregnant at the moment of the catastrophe that ended her life. (282)

BEULÉ (1872)

The first is that of a woman who has fallen upon her back. Although her
features are not very distinct, it can be seen that she has suffered and
been choked. Her face gasps for air, and her head seems to be lifted to-
ward the sky. She leans her right hand, clenched, on the ground. Her
left arm tries to repulse an invisible foe, both indications of suffocation.
A lock of her hair forms a crown about her head. Her chest is meager, or
rather it is flattened, as is natural in a person lying on her back and
whose breasts have been weighed down by a bed of ashes that became
heavier by the hour. The sleeves of the tunic are attached in graceful
curves, but the glass buttons that held each arc of the circle have fallen
off as the material decayed over time. The better to flee, the unfortunate
woman has lifted her garments, which form a bundle over her stomach
and make the waist and hips larger. One might even say, at first glance,
that she is pregnant. The thighs are covered by fine material that con-
stitutes proper pants. That which has been noted in the impressions in
the cellar of Diomedes [namely, that the women were clothed] has be-
come certain fact. In reflection, ancient costume was so transparent
among women, so short among men, so subject to the accidents of life
in the open air, that pants or some equivalent were necessary in order
that decency not be injured in each instance. Sculpture had no reason
to take notice of pants, which were invisible under the costumes.
Nonetheless, on the Column of Trajan, it has already been noticed that
the Roman soldiers wear them. At Pompeii, it has been established that
even slaves and public women wore these garments, which especially
then were indispensable.

To conclude the description of our Pompeian lady, we might add that

she was grand and elegant, that her left leg, better preserved by the cast, is well formed and charming, that the foot is admirably shaped. It is still covered in a boot with a firm sole, suited for going over the stones and the ruins. A silver ring is on her finger. Close to her were found some golden earrings, a mirror of silver, and an amber statuette representing a small cupid. This little cupid was wrapped in a cloak. His hair was arranged in three rows of curls over his forehead and fell in a braid over his back in a fashion that recalls nothing other than wigs à la Voltaire. A choice of objects so peculiar at a moment of extreme danger and the proximity of a house of prostitution may lead one to suppose that this woman, a coquette and a resident of a disreputable part of town, had been a courtesan. The proof is sketchy. Let us leave to rest in peace not the corpses, which we must always interrogate, but their memories. (188–91)

NEVILLE-ROLFE (1888)

The next cast represents a woman of middle age with very small hands. This cast is not a very perfect one. There is a silver serpentine ring on the finger of the left hand. This ring, and another consideration which will be obvious to those who look carefully at the figure, have led to the inference that she was a married woman. (83)

At first, because the body had been flattened, her sex could not be determined. Settembrini was sure the fourth victim was a man, even though the cast had been known for at least a week at the time he wrote his account. Breton and Beulé commented on the flattening of the breast, noting that the determination of sex has been made by observations of the woman's coiffure. Breton thought that the size of her swollen pelvis indicated that she was pregnant.[36] Beulé had a similar opinion but also observed that bunched-up garments might have added to this impression. All observers noted that she wore fine jewelry and carried a curious collection of bibelots. Noting the finer proportions of her limbs, including her exposed left leg, all agreed that she was a woman of a higher class than the others. Layard thought she might have been a *domina*, or proper housewife. Beulé suggested that

she might have been a prostitute, noting the proximity of the brothel. Neville-Rolfe, who knew the later "iconic" casts, was critical of the casting. He noted the woman's small, aristocratic hands and stated that the evidence of her pregnancy and her ring suggested that she was married.

From 1863 to 1875, these four victims, joined by a few more, were exhibited in the House of the Cadavers of Gesso, next door to the Archaeological School of Pompeii. From time to time, they may have been removed from their cases in order to be studied or photographed in the courtyard or on a nearby terrace. In 1875 they were carried to the new museum located in vaults adjacent to the Porta Marina.[37] Placed next to the technically superior, "iconic" casts of the 1870s, they suffered a marked decline in popularity. This is especially evident in the perfunctory descriptions accorded to them by Neville-Rolfe in his book of 1888.[38] They were all destroyed when the museum was bombed on 24 August 1943, the anniversary of the city's destruction.[39]

A number of different commercial photographers, mostly based in Naples, published images of the casts during the 1860s. The chief among them were Michele Amodio and Giorgio Sommer. Their photographs made of the first four casts about the time of their discovery or shortly afterward show a number of similarities due partly to limitations of the photographic technique and partly to practical necessity governing the handling of the casts. They made albumen prints on thin paper, which was usually mounted on a heavier card stock. The prints were produced in multiple formats, ranging from the small cartes de visite (ca. 2.5" × 3.5"), stereo cards (ca. 3" × 3" each), and cabinet prints (ca. 4.5" × 6.5") to larger prints (e.g., 7.5" × 9"). Most of the surviving photographic albums made by these studios employ cabinet prints, about the size of the postcards that eventually replaced them. The photographic process required that casts be displayed outdoors in direct sunlight. Since casts made in plaster of paris are both heavy and quite fragile, this procedure cannot have been repeated on very many occasions. Photos by Michele Amodio, among the earliest of the lot, show each of the casts arranged on a slab in front of a stone wall, with Vesuvius looming in the background (cf. figs. 5 and 12). At some point early on, each of the casts received its own custom-built table. In pho-

tographs taken by Sommer, the individual casts are supported on the tabletop by means of permanent struts. In order to take the photos outdoors, the photographer had to move the entire table. Presumably, the casts would not have traveled far from their home in the House of the Cadavers of Gesso, but one memorable photograph by Giorgio Sommer shows victims nos. 2 and 3 on a terrace near the Forum Baths, commanding a view of Region VI and Vesuvius.[40] The House of the Cadavers of Gesso is even visible in the background. Variety was achieved here by the photographer's control of the panoramic background. In other photos by Sommer, personnel connected with the excavations are introduced in order to show scale (as in the case of the "giant" victim no. 1) or possibly to denote technical or artistic connection with the cast. The man on the right in a Giorgio Sommer image of victims nos. 2 and 3 appears to be dressed as an artist (Vincenzo Bramante?).

These early photographic images of the first four casts display a mixture of curiosity and respect for the unfortunates whose pathetic images they transmit. The technical wonder of photography is as much a part of their intended meaning as is the technical wonder of Fiorelli's casting process. This historical mission gives the prints a kind of aura that is lacking in many, if not all, of the later photographs of Pompeian casts. All of the images are posed as artistic compositions. Michele Amodio located the casts in the foreground of his compositions, positioning the camera close in and slightly above the level of the victims. This produced a startling effect of intimacy between the viewer and the subject. Giorgio Sommer photographed the early casts from further back and from a higher vantage point. He achieved a more classical objectivity from this safer distance. Sommer sometimes achieved closer contact with the subject by including living persons in the act of examining the casts. Neither photographer attempted to show the corpses as objects, and both were completely indifferent to the archaeological context in which the bodies were found. It was, however, the technical shortcomings of the casts rather than of the photographs that kept this first generation of victims from becoming true Pompeian icons. The next generation, the casts made between 1873 and 1875, which included the famous watchdog, displaced the generation of 1863

due to a combination of intrinsic beauty, excellent casting technique, and improved photographic technique. The survival of Amodio's image of victim no. 4 on the cover of a locally printed guidebook of ca. 1900 is, under the circumstances, quite exceptional.[41]

The casts of 1863 were photographed under different conditions by the Brogi firm sometime between 1875 and 1882. In 1875 the casts had been moved to a new museum in Pompeii, where they were exhibited in a series of glass cases placed end to end in a long, barrel-vaulted room (fig. 20). The photographer positioned the camera directly above the casts for a series of individual photos (figs. 34–42). The casts were flooded with light, also from above, and the photographer attempted to record the texture of the white surfaces. The results were far more objective than the earlier photos of the same victims, but the new views did not succeed in capturing the pathos of the victims as well as the earlier photos. Consequently, the Brogi images of the casts of 1863 were rarely reproduced. By the time the casts of 1863 were destroyed by the bombs of World War II, their fame had been eclipsed by the brilliant series of casts and photographs made after them during the following decade.

CHAPTER 3

Second Thoughts

Fiorelli's Thoughts

When Fiorelli successfully cast the impressions of the first victims in 1863, he had every reason to believe that a new day was dawning for the Pompeian excavations. He wrote, rather sententiously, in his public announcement of the discovery of the first casts:

> For now it is a satisfactory compensation for the most exacting labors to have opened the way to obtaining an unknown class of monuments, through which archaeology will be pursued not in marbles or in bronzes, but over the very bodies of the ancients, stolen from death, after eighteen centuries of oblivion.

Fiorelli here addresses hypothetically those who may have considered the mission of the Pompeii excavations to be the recovery of the works of ancient culture, specifically masterpieces of marble and bronze sculpture (as well as painting).[1] He argues that the images of the actual Pompeians themselves—Pompeii's "living statues," in the words of Ferdinand Gregorovius—must take precedence over mere works of art. The conflict between works of art and the physical remains of the Pompeians thus belongs to the history of the conflict between "ancients" and "moderns," with the Pompeians (paradoxically) belonging to the "moderns."

Fiorelli's appreciation of the importance of his discovery had less-
ened not in the slightest when, four years later, he wrote:

> I consider the most striking results of these excavations [1846–66] to be
> the impressions of human bodies found in February 1863, from which
> have come those figures in gesso that are now admired as the most
> faithful reproductions of persons living eighteen centuries ago. Their
> forms have the same importance for the artist as for the archaeologist,
> the traces of the clothing in which their bodies were wrapped. Indeed,
> if this first discovery is to be followed by others like it, now that tech-
> nical difficulties have been reduced by this first experiment, much light
> will be cast by them over the vexed questions concerning the clothing
> of the ancients. The importance of such figures, however, detracts noth-
> ing from the importance of those masterpieces of art that have been dis-
> covered and especially those works of sculpture that, being cast in
> bronze, reproduce without doubt others of the most celebrated artists
> of Greece.[2]

On the other hand, he has clearly softened his attitude toward master-
pieces of sculpture. His statement seems intended to have a placating
effect on those interested in the fine arts, as he implies that better
knowledge of ancient clothing should affect our knowledge of sculp-
tural conventions.[3]

It is interesting to note that Fiorelli, at the time he wrote this, ap-
peared to value the evidence given by the casts as to the nature of an-
cient clothing as their most significant contribution to antiquarian and
artistic knowledge, even above the casts' value as forensic evidence. Be-
sides casting his lot with the "modern" camp, as opposed to the "an-
cient," because of his preference for archaeology over fine arts, Fiorelli
deserves to be called a "modern" because of his use of the antiquarian's
methodology: classification. Both his statement made at the time of
the discovery and the one made four years later reveal a conflict be-
tween the excavators' mission in advancing the history of art (and the
knowledge of classical antiquities) and their practice of what we would

now call forensic archaeology. By regarding the casts and, through them, the recovered images of the ancient victims as a previously "unknown class" of monuments, Fiorelli displayed the bias of an antiquarian accustomed to viewing artifacts categorically. Similarly antiquarian in nature is his expectation of gaining more knowledge of the clothing of the Pompeian victims and, through it, knowledge of the "ancient vestiary." An understanding of the victims' pathology would lead the way to a better understanding of the events of the eruption, but this concern seemed to be of lesser importance to Fiorelli at the time of the first casts.[4] Only later, when he published his *Descrizione di Pompei* (1875), did he add: "In the unpleasant labor of twelve years, if not many precious monuments were found, I had to confront on many occasions the diverse manner in which the Pompeians had died."[5]

Conflict between what we may refer to as the "antiquarian" and "historian" mentalities arose from the very moment the sources of treasure had been identified as the buried cities of AD 79.[6] The method of antiquarian studies, exemplified by the method of Monsignor Bernard Montfaucon, was to study the institutions and artifacts of ancient culture according to the catalogue raisonné.[7] The "battle of the academies" had already begun elsewhere, and it only remained to be seen in which direction the King of Naples was inclined before the lines of conflict would be drawn up. It happened that King Charles decided to become a collector—a virtuoso—leaving the more respectable field of letters open to his critics. To make a general characterization of the period preceding Fiorelli's, the Bourbon policy was to collect works of art, first for their palaces and later for their museum. Tourists regularly complained that the works of art had been ripped from their context, and the French regime of 1805–15 made a concentrated effort to exploit the context (even while they continued to collect). Often, the contest over the antiquities was a struggle between the foreigners, who desired to be educated and perhaps to gather a few souvenirs, and the locals, who desired to retain their possessions while impressing the foreigners. Pompeii and, to a lesser extent, Herculaneum might be considered either as sources for objects to be displayed in a collection or as sites where objects might be seen in their original context. The latter course

required extensive restoration and entailed great expense, but Chateaubriand had floated it as a serious idea, and it was brought up from time to time over the course of the nineteenth century.[8]

In a way, Fiorelli belonged to both camps, though he was by nature a collector, as his early career as a numismatist shows. A love of objects and classification remained his driving passion despite his busy career as an educator and administrator. Fortunately for his own peace of mind, the course of history made him director simultaneously of both the Naples Museum and the Pompeii excavations, and he was able to placate foreigners while protecting the national patrimony. The fact that, even as director in Naples, he continued to receive visitors with the coin trays on the desk in front of him is a revealing anecdote related by Felice Barnabei.[9] It was only consistent with this aspect of Fiorelli's nature that the casts of the victims would be treated as a collection intended for a museum.

The regulations that governed the excavations at Pompeii, dating back to the early years of the century, were designed to assure that the finer works of painting and sculpture found their way to the Naples Museum. Lesser artifacts might remain in Pompeii. Before Fiorelli's time, this practice had led inevitably to the corruption of the staff in Pompeii, since they were able to sell off sequestered trinkets to foreigners. Nevertheless, there was a serious inventory problem that developed over the course of time, as the museum was unable to absorb everything sent from Pompeii and the other archaeological sites.[10] A solution was found at Pompeii by creating secured storage depots, first in the Tempio di Mercurio (fig. 13) and later in the Small Museum and its successors. Objects unsuited for the Naples Museum but still worthy of preservation, such as terracotta amphorae, roof tiles, decorative marble fragments, pieces of colored marble, and, after 1855, skeletal remains were regularly sent to the Tempio di Mercurio from 1837 onward.[11] By necessity, there developed two distinct collections of artifacts from Pompeii, one of which remained at the site in a lockup. Wall paintings and mosaics whose artistic value justified their removal, all sculpture except for broken marbles, items of jewelry, coins, and utilitarian objects were regularly invoiced and sent to Naples, where they were ab-

sorbed into their respective collections.[12] Other odds and ends, princi-
pally terracottas, remained at Pompeii, where they received very little
attention before the institution of the site museum.

The decision to keep human remains in the Tempio di Mercurio
most likely stimulated some thoughts on the subject of nonartistic ob-
jects in Pompeii. The old conflict between archaeology and the history
of art can be seen in Charles Beulé's judgment published in his *Drame
du Vesuve* of 1872:

> If a hundred years of the predecessors of Sig. Fiorelli had similarly cast
> the bodies that were found in favorable conditions, if they had probed
> the cavities and filled them with plaster before destroying them, there
> might have been an anthropological museum that would reveal all that
> one might desire to know concerning the race, the beauty, the cos-
> tumes, and the social classes of the inhabitants of Pompeii. By compar-
> ing the circumstances that caused or accompanied their death, one
> might reconstruct the history of this disaster that shocked the world.[13]

Beulé's use of the word *anthropological* points to the source of the trou-
ble. In what sense were the excavations of Pompeii anthropological? To
the extent that the excavations were a scientific enterprise, Fiorelli
would have styled himself an anthropologist. The circle of men that
surrounded the Count of Syracuse in the 1850s had been a virtual cult
of the founder of anthropology, G.-B. Vico. The count himself had
sculpted Vico's statue, which stands today in the Villa Communale in
Naples.[14] Fiorelli had convinced Leopold to support a journal devoted
to science and letters, published under the title *Giambattista Vico*.[15]

An anthropological response to Fiorelli's discoveries was registered
at the time by the French journalist G. B. de Lagrèze:

> This apparition of beings from the distant past is moving. It gives birth
> to deeper thoughts. It is instructive for science. It provides us with de-
> tails concerning the progress of the eruption and is a matter of study
> concerning ancient man. The clothing of the victims is reproduced in
> the lava with such fidelity that different fabrics can be distinguished,

and one even seems to behold the fine embroideries opening over the nakedness of the flesh. Some skulls have been recovered, some human remains, some bits of animals. These have been examined scientifically, notably by a distinguished naturalist, Stefano delle Chiaje. The skulls seem to present three different forms, indicating different races. The stature of man and of animals has not changed at all after so many centuries.

Has physical beauty diminished? This subject has not been treated yet, so far as I know. The chevalier Hamilton, ambassador of England at the end of the last century, maintained that the teeth of the Pompeians were more beautiful than those of our own women. He attributed the decadence of dental beauty to the use of sugars, which had been unknown to the ancients.[16]

Fiorelli was ideologically tied to the science of anthropology (which was an alternative to the official Bourbon ideology of religion), but ideology did not prevent him from being practical—never to the extent that the collection of monuments (i.e., *collezionismo*) was outweighed as the primary reason behind the excavations. As far as the government that funded them was concerned, the excavations had, from the beginning, been undertaken to add to the king's collections. Even in his remarks of 1867 (above), Fiorelli had to agree defensively: the casts could not in any sense be considered works of art, and works of art would continue to flow from the excavations. Although a few of the earliest reports had assumed that the discoveries would enrich the collections of the Naples Museum, none of the casts was ever sent there to be seen before the exhibition of 2003.[17]

Fiorelli's willingness to leave in situ some monuments (e.g., marbles in the houses of Holconius and Cornelius Rufus) that would certainly have been sent to the museum in Naples in earlier administrations has already been noted.[18] In some cases, preservation of the decorative or archaeological context prevailed over the advantages of adding a given object to a typological series represented in the museum. In individual decisions, Fiorelli showed himself to be pragmatic, weighing his ability to protect a given object from theft or from the elements against the

relative advantage to be gained either by leaving it in place or by send-
ing it to Naples. By encouraging mechanical reproduction of works of
art through the media of engraving, photography, and bronze casting,
Fiorelli was able to make the decision to send a work to Naples or keep
it in Pompeii less consequential. As the monuments from Pompeii,
both those that had been newly discovered and those already in the
Naples Museum, now became the property of the state rather than of
the monarch, Fiorelli's encouragement of making reproductions was an
intentionally democratizing process. While he continued to anticipate
the discovery of monuments of art in the ruins of Pompeii, Fiorelli
looked forward to amassing a collection that included specimens re-
lated to all aspects of human life and culture.

The casts of 1863 raised expectations that more would soon be on
their way. Fiorelli's archaeological prowess and his newly acquired
technical expertise were justly praised. Furthermore, as everyone knew,
a great portion of the ancient city remained to be explored. Johannes
Overbeck stated the case for optimism in 1866:

> There is good reason to expect that still more victims will be discovered
> in similar situations and in the same layer of ashes, and there can be no
> doubt that if this should occur, Fiorelli's industry and expertise will find
> the means of making more complete casts that will offer the antiquar-
> ian-scientific interest yet more interesting details than these first ef-
> forts.[19]

Heinrich Brunn, representing the Instituto di Corrispondenza Archeo-
logica, voiced high expectations that Fiorelli's study of the first casts,
augmented by still further discoveries, had yet to be fully digested:

> Indeed, even by viewing these casts repeatedly, the eye is confused, and
> one senses the need to seek the help of another, unprejudiced observer.
> And it is for this reason that I do not give a detailed description here but
> must, rather, await the greater experience of Fiorelli, who not only has
> examined these bodies more closely than anyone but has also collected
> the observations made in his presence by archaeologists and antiquar-

ies, artists, anatomists, and others. And so we can be certain that nothing will be overlooked by him that might serve to improve the method of making the casts and securing scientific evidence. We may hope that with the progress of the excavations, there will be recovered a series of facts and observations sufficient to shape a well-stabilized system.[20]

The New Victims

In 1873, Fiorelli published a comprehensive report on the excavations from 1861 to 1872.[21] Despite his best efforts, he was only able to add two partially successful casts to the initial four. An indication of the difficulties he encountered can be seen in the unsuccessful attempt to cast a victim on 2 March 1866:

> The bones of a human skeleton were uncovered in the corridor located between the second and third cubicula on the left of the atrium of the above-mentioned house [IX.1.20/30], at the height of about one meter above the ground in the stratum of the compacted material, for which reason liquid gesso was introduced into the cavity that the body had left in the earth in order to recover the impression.

The 3 March entry reports:

> The skeleton uncovered yesterday did not yield a true impression because the earth had adhered to the bones in such a way that no cavity remained, and thus the gesso that was introduced was not able to set properly.[22]

The Fifth Victim (1868) (figs. 14–17)

In March 1868, more than five years after the first casts, a fifth cast was made. The victim was among a group of seven victims uncovered in the House of Gavius Rufus (VII.2.16).[23] The cast was only partially success-

ful, since the cavity had been infiltrated by lapilli, leaving the skull and the left leg exposed. Since there was no room to exhibit it in with the others in the House of the Cadavers of Gesso, it was placed in the Archaeological School next door. It was there that Ernest Breton saw and described it in the year of its discovery. As we shall see, special arrangements were being made for its exhibition in the new museum in 1873. It is, however, best known from Sommer's photographs made during its stay at the Archaeological School.

BRETON (1869)

A fifth dates from 1868, and has not yet been exposed to the curiosity of visitors. This one is kept in one of the rooms of the Archaeological School of Pompeii, and I have reproduced it here [fig. 17].

This unfortunate was discovered lying on his stomach in a room to the left of the atrium in the House of Gavius Rufus. Six other skeletons were near him. This cast came out best of all, with the exception of the left leg, which could not be reproduced, and further that his expression is the most terrifying. He is the embodiment of despair, driven to his final paroxysm. (272–73)

BEULÉ (1872)

Later, in 1868, Sig. Fiorelli was able to repeat this operation on a body found in a room to the left of the atrium of the House of Gavius Rufus. It was a man. Unfortunately, he lay upon the layer of pumice, whose roughness and sponginess had prevented a good impression. Fallen on his face, he displays today but a ghastly and forbidding head, almost entirely stripped of its flesh, its teeth clenched. His two clenched hands seem still to grasp the soil and sink into it during his final convulsion. His death agony has been painful; it has a cruel eloquence, as we can witness. The body is for the most part in the nude. At least, the tunic was hitched up during the last struggle and has been wound over the back. The right leg, the only one reproduced in the cast, is tense, extended, well developed. A ring of copper is still worn on the little finger of the hand. (187–88)

FIORELLI (1875)

> In the House of M. Gavius Rufus, Reg. VII, Ins. II, a tablinum is lacking, and in its place, there is a spacious door that enters into the garden peristyle, where a triclinium and an oecus attach. . . . Seven human skeletons were found in this place, one of which was face down and in the process of making his last effort to emit his breath choked by volcanic fumes. He was clothed by me in his bodily forms by obtaining them from the impression that remained in the ashes. (187)

NEVILLE-ROLFE (1888)

> The next [case] contains the body of an old man lying on his face. His left leg had been amputated at the knee, which accounts for his inability to escape. (83)

The Sixth Victim (1872) (figs. 18–19 and 35)

The sixth victim was found in the street at the northeast corner of insula 3 of Region IX on 4 March 1871:

Giornale

> In the lane to the north of the House of M. Lucretius, right where it intersects with the other lane parallel to the Strada Stabiana, there was found a human skeleton, of which an impression was made in gesso. Near it was found a small star in *gold*, composed of six rays ending in pomegranates, one of which was missing. The star was mm 22 in diameter.[24]

The sixth cast was more successful than the fifth, though neither lived up to the hopes and expectations voiced in Fiorelli's statements made at the time of the first casts. Depending on what angle it was photographed from, the cast of the sixth victim seemed either natural (cf. Sommer [fig. 18] and Rive [fig. 19]) or bizarre (cf. Brogi [fig. 35]).[25] Views

of the second room of the Pompeii Museum made after 1875 show the sixth victim in a glass case in the center of the long, vaulted room. In the description he wrote for his *Guida di Pompei*, published not long after the museum was first opened, Fiorelli described this victim as an African, judging from the features of his face.[26]

NEVILLE-ROLFE (1888)

The next cast is also of a man, and probably of a slave, from the low type of his face and his receding forehead. If the raised band encircling his body is a belt, it would be a further indication of his servile condition. Some have conjectured that this elevation is not a belt, but was caused by the bursting of the corpse. The right hand is firmly clasped and the expression of the mouth is one of extreme agony. The left hand is on the belt, and the legs are extended. (82)

The fate of the four original casts of 1863 and the dozen added to their number in the course of the three decades that followed was determined by Fiorelli's decision to treat them as a collection. The earlier site museums—namely, the House of the Cadavers of Gesso (1863) and the Small Museum (1859), located in the crypt of the Temple of Fortuna Augusta—together lacked the spaces necessary to display the collections of artifacts kept at the site of Pompeii. With the expansion of the workforce and the increase in tempo of the excavations after 1860, Fiorelli anticipated the need for more storage space and for better exhibition space. In 1862, in clearing the mountain of fill from earlier excavations that had accumulated along the western edge of the city, Fiorelli came upon the Porta Marina and a series of subterranean vaults that may have been part of Pompeii's port facilities. The gate itself was strategically located near the Taverna del Lapillo, later the Hotel of Diomede, a place where visitors to the site often stayed or dined. Fiorelli made the Porta Marina the principal entrance to the excavations, famously installing his indiscriminating turnstile in order to collect an entrance fee of two lire per head.[27] It took some time to convert the vaults, entered by a door under the gate's arch, into a museum.

The museum utilized a long, barrel-vaulted chamber, an ancient

structure underlying the terrace of what must have been Pompeii's grandest temple.[28] As can be seen from old photographs, the setting was quite grim (fig. 20). The casts became the main attraction of the site museum of Pompeii, which opened in its new premises in 1875. Niccola Pagano described it in a finished or near-finished state, as yet not open for business, in the 1873 edition of his guide to Pompeii. When it came to the arrangement of the individual bodies, however, Pagano was obliged to equivocate. The author makes specific mention only of the four original casts of 1863 and of the two additional casts of 1868 and 1872. Still unknown at the time were the four great casts made between 1873 and 1875. It is interesting to note that the stairs used for viewing from underneath were originally intended for the "grotesque" cast from the House of Gavius Rufus, found in 1868. It is unlikely that this cast was ever actually placed above the stairs, because a more attractive candidate, the young woman from the Strada Stabiana (victim no. 10, discovered in 1875), emerged from the ashes just before the museum opened.

A. NICCOLA PAGANO: NEW MUSEUM (1873)

[Fiorelli] has had the clever idea to locate near the entrance a collection of ancient objects found in these excavations in order to demonstrate to the public not only the city [itself] but also the domestic utensils used by the ancients. To these he has added various models in gesso and in wood of doors with their respective locks. But the greatest praise that is owed to Soprintendente comm. Fiorelli for the tireless care that he has shown on a daily basis ever to improve the condition of the Excavations of Pompeii is that which he deserves for discovering a successful manner of making visible those unfortunate citizens . . .

These real models that we admire here today might be of a mother and daughter, the two women opposed and united in their position, while the other two are separate. One was a woman of nobility, with delicate limbs; the other of a man of lower status, perhaps related to the two, who, lying nearby, seemed to belong to the same family.

In other, later excavations were similarly encountered another two skeletons. One of them lies face down and can be seen from under-

neath, being placed above some stairs so that, by descending, one can see his face. On the following bench, the other is seen, lying on his back.

A great number of amphorae are to be seen on the shelves along the walls. They served to hold wine, grain, dried fruits, and salted fish. They are pointed at one end so they can be stuck in the ground in order to preserve their contents better.

In the same room may be seen terracotta gutters that the ancients used not only to drain away water but also to beautify the roofs of their buildings.

The shelves of the third room hold domestic and sacred utensils of bronze and of glass, as well as a collection of human skulls found in the same excavations.

Finally, there are diverse skeletons of animals skillfully reassembled—horses, dogs, cats, and even the deformed body of a crippled person. (15–18)

Unanticipated when Pagano wrote his prospective guide to the new museum was the discovery and successful casting of four victims well deserving of the term *iconic*.

The Iconic Victims (figs. 21–33)

While the fifth and sixth casts added to the collection were unsuccessful from an artistic or technical point of view, the period beginning in 1873 saw a series of spectacular successes that may legitimately claim to be called icons. The technical expertise of the cast makers had also increased, so that unlike the first six casts, the next four survive today. Moreover, their popularity as photographic subjects was such that they almost immediately displaced the original casts as images or icons representative of the entire class. By strange coincidence, the arrival of the iconic casts came at the very end of Fiorelli's career in Naples and Pompeii. In 1875 he was promoted to the position of director general of antiquities and the fine arts in the Ministry of Public Instruction in Rome.

Before he left Pompeii, he was able to see the opening of the new museum (1875) and the publication of his authoritative *Descrizione di Pompei* (1875), which employed the new system of region, insula, and entryway numbers to organize a detailed description of the entire city that had been excavated to that time. Very appropriately, Fiorelli concluded his book with a mention of the wonderful cast of the "sick man" (victim no. 7), which had been made just before he consigned his manuscript to print.

The Seventh Victim: The Sick Man ("Ammalato") (figs. 21–24 and 41)

The seventh cast, made in June 1873, was immediately recognized as a masterpiece. The body of a man who had seemed to resign himself to his fate had been found in a shop leading to an area identified as a tannery at the southern end of the Strada Stabiana, just inside the city gate.[29] Cast no. 7 was technically superior to any previous cast. The envelope of ash that encased the man was at no point broken by contact with the lapilli. The pose of the victim was classically serene—he seemed to swoon rather than to struggle with death. He died in such a passive manner that it was assumed he was already stricken, earning him the name "Ammalato" (the "sick man").[30] Fiorelli noted that the man appeared to have succumbed peacefully and without the paroxysms or violent struggle shown by other victims. Curiously, contemporary writers do not seem to have made many comparisons of this victim with classical sculpture, as Gregorovius and Beulé had made earlier in the case of the young girl (victim no. 3), although Dyer's likening of the head to a terracotta may imply comparison with the verisimilitude of Roman or Italian Renaissance portraits. Perhaps the new reliance on photographic illustration struck some authors of the period as rendering verbal description less necessary. Overbeck, who reproduces a full-page photolithograph (fig. 24), is uncharacteristically terse in his description of this cast, which he holds in high esteem. Between the mid-1860s and the mid-1870s, photographers like Giorgio Sommer suc-

ceeded in increasing the contrast in their prints, making better mechanical reproductions possible. Overbeck's photolithographic plate was a vast improvement over any of the earlier cast reproductions that had appeared in printed books.

The near perfection of the cast of the "sick man" as a "sculptural expression," to use Gregorovius's term, brings to mind the self-contained quality of a work of art.[31] To Fiorelli and his contemporaries, the piece must have justified their efforts to treat it and to display it and the rest of the casts as museum pieces rather than as part of an archaeological context. The immediate removal of the cast from the tannery where it was found to the museum was a blatant act of *collezionismo*. As the new museum was not yet ready to receive exhibits in 1873, the cast of the "sick man" must have been taken to the Archaeological School or to another place nearby for temporary viewing. It was photographed repeatedly in what appears to be the school's courtyard. When the new museum was opened in 1875, the cast seems to have been placed in the third room (i.e., Herchenbach's second room) so that it could be appreciated in the round and in isolation. An old photograph shows it in the presence of the animal skeletons with which it shared the space (fig. 23).

FIORELLI (1875)

[At number 3], there is a door that leads into a place that had been in ruins in antiquity. Here was found the impression of the body of a man who had been attempting to save himself by fleeing. Sensing that he was being suffocated by the volcanic gases and that he was losing his strength, he lay down on the ground and there fell calmly into his eternal sleep. (452–53)

DYER (1875)

Descending the Street of Stabiae . . . , on the left-hand side of that street, and on the right-hand side of the last *vicoletto* before reaching the Porta Stabiana, was discovered a tannery, the only one hitherto found at Pompeii. In the back part of the premises are fifteen large circular stone

vats used in the trade. In a shop near this was found, towards the end of 1873, the impress or mould of a body by far the most perfect that has yet been discovered. The head of the cast that has been taken from it has all the appearance of a *terra-cotta* bust, so sharply are the features defined. We have given an engraving of it at page 476. (577)

OVERBECK (1875)

The best, indeed, almost perfectly preserved and magnificently cast, found in June 1873, is the almost entirely naked body of a man that is shown here in the accompanying lithographic reproduction from a photograph [fig. 22]. (30 and facing page)

RUGGIERO (1879)

The man found in the courtyard near the tannery is the finest impression. (30–31)

NEVILLE-ROLFE (1888)

The next case contains the cast of an old man (evidently a Roman) who seems to have died quite peacefully, and looks as if he were asleep. (87)

The Eighth Victim: The Watchdog of Vesonius Primus (figs. 25 and 42)

If the story of the sentinel who died at his post was proved eventually to be a fabrication, at least one of Pompeii's victims did indeed die at his station. The watchdog chained to the doorpost in the House of Vesonius Primus (VI.14.20) struggled to keep above the lapilli as they filled the vestibule, only to die in the surge layer.[32] The cast of the dog with his slender legs seeming to flail in midair has never failed to evoke pity in those who see it, and it is justly admired as a masterpiece of casting. The dog wore a broad leather collar with two bronze rings, still visible in the cast. He appears to have been exhibited in the last room of the new museum until the discovery of the emaciated child (victim no.

11) in 1882, when the two pathetic creatures were placed on either side of the door in the principal room. The dog is perhaps Pompeii's best-known victim, thanks to the work of photographers and postcard makers for more than a century. The cast of the watchdog and that of the young woman found in the Strada Stabiana (victim no. 10) were exhibited in the exhibition Pompeii A.D. 79 that was shown worldwide in 1978–80.[33]

RUGGIERO (1879)

Finally, not to be passed over in silence is the pitiful fate of the dog, whose fineness of limbs and contorted body position required exacting excavation and perhaps even more difficult casting. The unfortunate animal had been tied behind the front door of the House of Vesonius Primus (Reg. VI.14.20). As the cinders raining down through the compluvium accumulated in the passageway, he climbed atop them, twisting himself with his back to the ground and his legs raised upwards, wrenching his neck and his head to get free from the rope fastened to a ring of bronze which can still be seen attached to his collar. In the act of such extreme contortions was he overcome and choked by the ashes. (30–31)

PRESUHN (1882)

We step now into the entrance of the house, called the *ostium* or *vestibule*. Here, at his post, five feet above the ground in the layer of ash, the real watchman of the house, the dog, found his death in the destruction of Pompeii. We get a truly moving illustration of the death-struggle of this animal from the plaster cast . . . which is now preserved in the local museum at Pompeii. It is known that the skeletons of the bodies have been preserved beneath the destruction debris, while a cavity has been left by the deterioration of the other parts, which have been revealed in the plaster. Thus has this dog been preserved down to the smallest detail, even to the rings of his collar, seen as green oxidized matter in the cast.—In life, he lay before the porter's room, to the right of the entrance (*g*), on his chain, and thus has he been portrayed in mosaic on the floor of this room. (part 3, 3–4)

NEVILLE-ROLFE (1888)

> Cast of a dog found tied to his kennel, behind the door of the house of Vesonius Primus. The poor brute had contrived to mount up upon the falling ashes till the length of his chain prevented his getting any further, when he died on his back in great agony. (87)

MORLICCHIO [1901]

> Region VI—Island XIV—Cardo.
> 20.) HOUSE OF ORPHEUS, OR VESONII PRIMI—On the threshold of the door the 20th November 1874 was found the skeleton of a dog bound with a collar who had not been able to free himself at the time of the catastrophe. A model in plaster was made of it and is now to be seen in the Pompeian Museum. (76)

The Ninth Victim (figs. 26–29 and 34)

Unlike the "sick man," the ninth victim appears to have suffered a painful death. His body was found together with that of the next victim in the Strada Stabiana, about one block from the Vesuvian (north) Gate.[34] The discovery of the two victims and the making of their casts was noted very briefly in the *Giornale:*

> 23 [April 1875.] Reg. VI, Insula 14, near the northeast corner, in the middle of the street, at the height of about four meters from the ground, two human skeletons were discovered, of which forms were made in gesso: the first is of a man lying on his back, with arms and legs drawn up; the other is of a young girl lying face down, with her head resting on her right arm. (*Giornale degli scavi di Pompei*, n.s., IV [1875], 173)

These victims were in the layer of ash, several meters above the ancient street level. Having exited, probably together, from a house nearby, they must have been in the act of fleeing when overcome by the surge. The man held an iron bar, which was probably the means of

their escape from the place where they had been sheltering. He was found lying on his back. Ruggiero thought that he might have been using the iron bar in a vain effort to shield himself at the time of his death. The bar can be seen lying next to his cast in the case in the foreground of figure 20. The author of an article in the journal *L'Illustration* believed that the victim was an African from his features. Presuhn commented also on the man's facial features but made no judgment of his ethnicity. The supposed African identity, however, is probably based on a confusion of this victim with victim no. 6, who lay next to him in the museum and who was described as an African by Fiorelli in his guidebook of 1877 (see below).

l'Illustration (1875)

The man was a Moor, to judge by certain characteristic features of his face, reproduced in the smallest detail by the cast. Anonymous (1875)

RUGGIERO (1879)

The relaxation of death is not to be seen in their bodies, but the alertness of living persons, and among these there is one who by the resolute action of his arm and his closed fists, and by the iron bar with traces of wood which was found alongside him, it could be said that he was intent upon fanning off or repulsing the ashes or cloud of vapor which were overcoming him. (30–31)

PRESUHN (1882)

On 23 April 1875, in the Strada Stabiana, at *p* on the plan, at four meters above the ground in the layer of ash, two skeletons were encountered and cast in plaster, by which means an impression was taken of the empty cavities that enveloped them.

How harsh a death-struggle . . . does the man show! The legs are drawn up; the hands clench the garment and draw it upward in thick folds. The face is wide; the skull is high; the lips are thick and curled: in no way is he a model of beauty. The straps of his sandals are impressed on his feet. Alongside him lies an iron bar, eaten away by rust.

Who knows in which house on the Strada Stabiana 1800 years ago

lived these unfortunates, who in their tragic fate lived on into another world? (Part 4, 67)

NEVILLE-ROLFE (1888)

Cast of the body of a slave, apparently a North African—The nose and lips are decidedly of the negro type, and the imprint of the woolly hair can be readily seen near the right ear. The folds of his clothes have come out with remarkable clearness. At his side is an iron instrument shaped like a walking stick, but having a pivot in the middle, which makes us think that it was a part of the apparatus for closing a large door. (82)

The Tenth Victim: The Young Woman (figs. 30–33 and 37–38, 49)

The cast of a young woman found together with the "Moor" in the northern part of the Strada Stabiana has been greatly admired ever since her discovery. The successful casting of her face and the rest of her body must have made her a last-minute substitution for the man from the House of Gavius Rufus (victim no. 5) in the case positioned above the stairs in the museum. The figure has often been admired for the beauty of her form, which is sometimes eroticized.[35]

PRESUHN (1882)

The woman rests peacefully in death, with her face buried in her right arm. The plaster cast is so well executed that one still marvels at the beautiful shape of her limbs. At the back of her head one sees the large lock into which her hair was made up; a similar one is on her forehead. Her light clothing covers only the upper part of her body. Her body has been almost completely cast even on the underside. It lies in a glass case which one can view as well from underneath. (Part 4, 6)

NEVILLE-ROLFE (1888)

The next cast stands over a staircase to allow of its being examined from below as well as from above. It is the figure of a young girl, and is the most pathetic of all the casts in the collection. Her hair is gathered in a

knot upon the top of her head, and her left hand seems to be in the act of brushing the ashes away from her mouth, while her right arm supports her forehead. She appears to have drawn her clothes up round her neck. That she was young is certain, but the size of her hands and the absence of any jewelry, lead us to think that she did not belong to the wealthier classes. (83)

SOGLIANO (1899)

. . . [the impression of] a young woman who competes with Venus for the epithet Kallipygos . . . (7)

MORLICCHIO (1901)

The third [case] placed over a small staircase to enable the face also to be seen contains the model of a woman fallen on her face, of which one sees the arrangement of the hair and the folds of the drapery. (10)

The definitive arrangement of the new museum when it opened in 1875 can be found in Fiorelli's own guide to the museum, published in 1877. Fiorelli assigned a number to each exhibit, corresponding with the order of the exhibit in the single file of cadavers beginning with the case closest to the museum's entrance. In Fiorelli's arrangement, the sequence opens with a cast of inferior quality, made interesting by the excavator's observation that the man appeared to be an African. This was to cause some confusion when another cast, the male companion of the young woman from the Strada Stabiana, was added at the beginning of the series—and inherited the "African" identity. The second case in Fiorelli's arrangement of 1875 was occupied by the first cast to be made, the "soldier" of 1863. He now lay separated from the rest of his party and with only the sketchiest of archaeological contexts. Fiorelli was, in fact, somewhat disappointed with this cast, not only since it lacked the right arm but because the bloated body no longer supported his theory that the victims showed evidence of having perished by drowning. In his guidebook, Fiorelli attributes the swelling of the stomach to a fault in the casting process. The third place was occupied by

the victim in the case located above the staircase, a feature of the gallery that suggested the visitor might want to linger over this exhibit. The cast of the young woman fallen face downward discovered in 1875, proved to be the ideal exhibit for this case. After her, the last two cases in the long gallery held the three women of 1863, still celebrated for their costume and for their pathos. In the next room, cases held the casts of the peacefully sleeping man of 1873, the male companion of the young woman of 1875 (sharing the same number with the grotesque, face-down man of 1868), and the watchdog of 1875. Fiorelli's inaugural arrangement, like all subsequent arrangements, preferred technical quality and exhibition value to the preservation of archaeological context or the order in which the casts were made.

B. GIUSEPPE FIORELLI (1877)

POMPEIAN MUSEUM
I. Plaster Casts
c) Human and animal Remains
37. Man [no. 6] lying on his back, with his legs spread apart, his right arm extended, and his left hand near his belt, with sandals on his feet and a ring on his finger. From his face, he would appear to be an African (Reg. IX. insula iii. *via secunda*).[36]

38. Man [no. 1] fallen in the lapilli, which do not preserve the impression of the back or of the right arm. The swelling of the stomach is due to a piece of ash having broken off at the time when the gesso was formed (Reg. VII. insula xi. *via quarta*).

39. Young woman [no. 10], face down, with her head resting on her arm. She is denuded in part of her clothing, save for some traces on her shoulders, and her tresses are still visible, with hair knotted behind her head (Reg. VI. insula xiv. *cardo*).

40. Young woman [no. 4] with a ring on her finger and a boot on one foot, whose leg is admirable (Reg. VII. insula xiv. *via quarta*).

41. Two women [nos. 2–3], one next to the other. The older resting on her side; the younger face down, with her face in her arm (Reg. VII. insula xiv. *via quarta*).

42. Beautiful figure of a drowsing man [no. 7], who lies on his left side, resting his head on his arm and with legs drawn up (Reg. I. insula v. number 3).

43. Man [no. 5] face down, with his hands extended (Reg. VII. insula ii, number 18).

Another man [no. 9] on his back, with legs and arms drawn up, protected by a cloak and sandals (Reg. VI. insula xiv. *via nona*).

44. Large dog [no. 8] tied to the threshold of the door of a house in which he stood guard. Two bronze rings are preserved in the impression of the leather collar (Reg. VI. insula xiv. number 20). (Fiorelli, *Guida di Pompei* [Rome, 1877], 88–89)

In the description of a visit made in August 1876, not published until several years later, the distinguished journalist Cesira Pozzolini-Siciliani relies on Fiorelli's guide for her remarks on the individual bodies but concludes with a heartfelt thought:

There is no doubt that the skeletons filled out in gesso are the most singular, the most affecting, and altogether the most curious objects of the Pompeii Museum. Although cold and petrified like statues, in the midst of all these dead things, one might say that they impart some motion and a certain feeling of life. They are really human bodies, human remains clothed in gesso, and they preserve the contractions and contortions of a painful death. Look at them, lying still as they were eighteen centuries ago. Look at them, holding the same poses as when the ashes buried them! The more they attempt to shield their head with their arm, the more they hide their face; it seems that they hold their breath in order to avoid drawing in those fatal blasts; they struggle with the life that escapes them; they struggle with the death that draws inexorably

near, and they are left completely asphyxiated! . . . I no longer have the will to see any more.[37]

It seems that sensitive visitors were not infrequently left with a feeling of surfeit, though capacities varied, as the account of Wilhelm Herchenbach, who visited Pompeii in 1877, demonstrates:

> Our first visit is to the newly constructed museum, which is found on the left as one enters.[38]
>
> The first room contains several bronze doors with locks, which would have served to close off the Pompeian houses. Far more important, however, are the plaster casts, for in these can one observe the last moments of life of those who died. . . . an incomparable collection of once living and real Pompeians. The second room contains finds of vases, clay masks, herms, gutter spouts, and the like. The most gripping, however, are the real bodies that are found in the glass cases of the third room. There they lie as they were found, with face turned to the floor, still covered with ashes. Huber seems to find special pleasure in representing to us in very dramatic terms the last moments in the life of these unfortunates, but I shuddered, and I was not inclined to busy myself any longer with the numerous skulls, seashells, and miscellaneous things.
>
> I breathed freely again as we got through the gate into the first street of the city of the dead.[39]

After leaving the museum, Signora Pozzolini-Siciliani had a similarly uplifting experience, one that demonstrated just how quickly Fiorelli's discovery had made an impact on Neapolitan society. Taken by her guides to the top of the mound of earth overlooking the site, she was ideally placed to witness, as the sun set, the arrival of a special train from Naples, bringing fifty couples in festive dress. The train discharged its happy revelers at the station, which had been festooned with myrtle and laurel and illuminated by electric lights. The happy couples proceeded to the similarly electrified Forum, where a wedding was reenacted in the Temple of Jupiter. Following a musical interlude,

the emperor Nero (a patron of the colony) reprised his coronation of the Armenian king Tiridates, and the pageant concluded with the destruction of the city.

In juxtaposing the Pompeian victims in the museum with the modern reenactors, Pozzolini emphasizes a point that had been made explicitly by Settembrini, Brunn, and others. The ancient Pompeians could be seen as bourgeois; they could be likened to and impersonated by modern Neapolitans. Although it would have been impossible a mere twenty years earlier, Neapolitans could now even reenact a pagan ritual in the Temple of Jupiter. That the very proper Florentine lady was inclined to be amused rather than to be scandalized by the behavior of her fellow Italians was clearly a sign that times had changed. One can only imagine how this pagan ceremony was received by the growing number of devotees who, earlier in that same year, had begun flocking to the nearby Sanctuary of the Madonna of Pompeii and its miraculous image.[40]

The Photographic Medium

The introduction of collodion, "wet-plate" negatives, which enabled photographers to print multiple paper prints from their original exposures, resulted in lowered prices. Photographs began to compete with, if not entirely to replace, lithographs and wood engravings, and photographic shops appeared in Florence, Rome, Naples, and other major Italian cities. From the point of view of commerce, these shops satisfied a market for artistic views and reproductions of well-known artworks and were eagerly sought out by tourists. Curators and custodians at museums and archaeological sites had been permitted to supplement their income by the sale of guides and prints. Photographers like Giorgio Sommer soon found a ready market in scenes, such as Neapolitan "macaroni-eaters" and similar genre subjects. The new medium of photography profoundly tested social convention during the decade of the 1860s. Among the genres that attracted the public's curiosity were

scenes of the dead. Photographs of the American Civil War dead at the Battle of Antietam had first been exhibited for sale in New York in November 1862. Unlike photographs of dead soldiers, the images of Pompeian casts did not invade the privacy of the deceased and were therefore somewhat more acceptable as commodities for trade.[41] Consequently, there developed a lively commerce in these images, especially in the popular "trading card" (carte de visite) format (figs. 15–16, 33).

It was the Amodio and Sommer photographs more than any other medium that spread the fame of the first casts throughout Europe and the Americas. Responding to these images, a contributor to the *Photographic News* (September 1868) observed:

> That [photography] should be the historian of the life and manners of the present period more fully and faithfully than any written account is not so much a matter of surprise. Appealing, as it does, to the vanity and affections of the people, it is at once a recorder of the changes of fashion, a registrar of marriages, births, and deaths, and a truthful illustrator of the times in which we live.[42]

As familiar as he no doubt was with arguments such as this, Fiorelli could not have anticipated the role that this new medium was destined to play in spreading the fame of the Pompeian victims. The writer goes on to note:

> Photography has been made the cheap and easy means of informing the present generation of the manner in which the ancients behaved, suffered, and died in the midst of one of the most appalling catastrophes that ever overtook the inhabitants of any part of the world, ancient or modern, as vividly and undeniably as if the calamity had occurred but yesterday. . . . The photographs alluded to reveal with a fearful fidelity the dreadful agonies of some of those who perished at Pompeii, and while looking at the pictures, it is difficult to divest the mind of the idea that they are not the works of some ancient photogra-

pher who plied his lens and camera after the eruption had ceased, so forcibly do they carry the mind back to the time and place of the awful immurement of both a town and its people.[43]

The Brogi Photographs (figs. 34–42)

The Brogi photographic firm (Stabilimento G. Brogi) of Florence made a superior set of photographs of the casts in the interior of the Pompeii Museum not long after the museum was opened.[44] In order to obtain the desired view, each cast was photographed from directly above through the top of the glass case. This process entailed the construction of elaborate scaffolding, partly visible in one of the photographs.[45] The photographs in this series were extremely clinical and "objective" views of each of the exhibits, emphasizing the removal of each cast from its archaeological context. The photographs permitted better knowledge of some of the casts, particularly those in the group of 1863, but they did not always present the individual casts to their best artistic advantage. One exception was the superior view of the cast of the "sick man" (Brogi 5579; fig. 41), which contributed a new, eminently reproducible view to the iconography of that superb cast.[46]

The Eleventh Victim: The Emaciated Child (figs. 43–44)

The eleventh victim represented a type that had been encountered previously in skeletal remains, such as those of the victims from the Villa of Diomedes, but one that the collection of casts still lacked: a mother and child.[47] Unfortunately, the group found in 1882 was incomplete, since, except for her jewelry-laden arm, the child's mother could not be cast successfully. The child, however, was cast perfectly, though the little boy appeared to be chronically ill or deformed. Contemporary accounts describe a complicated archaeological context associating the victims with the House of Acceptus and Euhodia (VIII.5.39), from

Watchdog No. 8	Brogi 5580	44
		[43]
Sick Man No. 7	Brogi 5579	42

Room III

Two Women Nos. 2-3	Brogi 5578	41
Woman No. 4	Brogi 5577	40
Woman No. 10	Brogi 5576	39
Man No. 1	Brogi 5575	38
Man No. 6	Brogi 5574	37
Man No. 9	Brogi 5573	43 [bis]

Room II

which the mother seems to have been passing the child into the street in an attempt to escape when the surge hit. Without any trace of the mother, the cast of the boy took on a different significance when photographed and when exhibited in the museum. Contemporary accounts such as that in the *Illustrated London News* or that in Russell Forbes's *Rambles in Naples* stressed the context and the role of the mother while the memory of this touching scene was still fresh. To judge from the language of the respective accounts, it appears that these authors had access to the official journal.

First, from the journal itself:

> In the street that borders insula 7 [now insula 6], Region VIII, on the north side, at a height of about four meters from the street pavement, have been recovered two human skeletons, one of a woman and the other of a boy. It was not possible to obtain a cast in gesso of the first, because it was found in the stones [i.e., lapilli]. The cavity of the body of the second offering the probability of enclosing the form, an attempt was made, and a somewhat satisfactory, if not a perfect, result obtained. It is a boy of about twelve years of age, lying on his left side, with his legs and arms drawn up. The face is without any form; part of the left leg is missing, and the right hand is missing. The emaciated body suggests that the boy had been infirm. The skeleton of the woman was next to the boy, so that one of her arms touched his legs. It would appear that she was the mother, who was carrying her own son in her arms because he was infirm. On the arm of the woman were found the following objects:—Gold. A plain, laminated bracelet, diameter mill. 84. Another similar, of the same diameter. A finger ring set with an emerald with an incised horn of plenty, diameter mill. 21. Another ring set with an amethyst, with the incision of a seated Mercury, diameter mill. 19.— Bronze. A measuring cup with a handle, height mill. 130. A sewing needle, somewhat bent, length mill. 140. A coin of medium size.[48]

The following account is from the *Illustrated London News:*

A Child of Pompeii

We now and then hear of some interesting discovery, but seldom of one more affecting to the sense of humanity than that which was made three weeks ago. In one of the narrow streets were found signs of human remains in the dried mud lying on the top of the strata of lapilli reaching to the second floor of the houses; and when the usual process of pouring plaster of Paris into the hollow left by the impression of a body had been accomplished, there came to light the form of a little boy, seemingly about twelve years old. Within the house, opposite to the second floor window of which this infantile form lay, were found a gold bracelet and the skeleton of a woman, the arms stretched towards the child. The plaster form of this woman could not be obtained, the impression being too much destroyed. It is evident that the mother, when the fiery mass descended, had put her little boy out of the window in the hope of saving him, and he must, no doubt have been overwhelmed. The position of the left leg, indeed, seems to show that the child had lost one foot, or that it had been hurt or lamed, which may have been done by the burning substance that quickly overspread the floors of the house and the pavement of the street. Some think the boy was actually being raised and carried in his mother's arms, at the moment when both finally perished. His left arm is close to the chest, as though wrapped in his toga or mantle, while the right arm (which has been broken off above the wrist, in digging out the figure) was somewhat uplifted. There is a protuberance on the face, which seems to have been caused by his putting a finger to his mouth, to clear off the suffocating matter that pressed upon him in his last moments of life. . . . We are indebted to Mr. J. Boyd, of Naples, for the photograph we have engraved.[49]

This account was written by August Mau, giving somewhat more information as to the archaeological context:

In this street was found at a height of four meters above the pavement the skeletons of a woman and a boy. That of the boy was cast in gesso

and appeared to be about twelve years of age and of a sickly aspect. To-
gether with these were found two bracelets and two rings of gold. Of
these last, one had a cornucopia incised in an emerald and the other a
seated Mercury in amethyst. Also found were a small measuring cup, a
sewing needle, and a coin, all of bronze.[50]

Finally, there is the vivid account of S. Russell Forbes:

The skeleton of a woman with a child was discovered at Pompeii in the
narrow street which bounds on the north Insula 7 of Regione 8, *about
twelve feet* above the level of the ancient pavement—that is to say,
where the layers of lava end and those of ashes begin. It is well known
that the catastrophe of 79 A.D. commenced with a thick shower of
small pumice-stones, by which the streets and open squares of Pompeii
were covered up to the roofs of the houses. Stones were succeeded by
ashes, which became solid owing to the action of successive showers of
boiling water, and these ashes now form the top layer of the materials
which now covered the ruins of Pompeii. Most of the unhappy beings
who remained in the houses after the eruption first reached the town,
and who found, when the shower of stones was over, that no deliver-
ance was possible except in flight, made their escape through the win-
dows, the doors having been blocked by the stones and lava. But, so far
as we can judge from the excavations, the greater part of these fugitives
could have taken but few steps, and must have been quickly suffocated
by the poisonous fumes. The hot ashes and water covered their bodies
in such a way as to make an exact cast; and after the flesh had shrunk
away, the impression made by the corpses still remains as they fell
struck down by death. The Senatore Fiorelli conceived the happy idea
of taking plaster casts of the impressions, and thus reproduced the
figures to be seen in the Pompeii Museum, which have been copied into
most of the books that describe the antiquities of the buried city. It was
not always possible to obtain a perfect cast, because in many instances
a portion of the body was resting on the stones, where of course it left
no impression. Unfortunately this is the case with the two skeletons
lately discovered, the larger of which, that of the woman, is almost en-

tirely embedded in the layer of stones. One arm only has left an impression on the ashes, and with this arm she was clasping the legs of the child, the greater portion of whose body has been modeled, showing considerable contraction in the arms and legs, and a great emaciation; which lead us to suppose that the child must have been very ill. It is believed that it was a little boy about ten years of age. Doubtless the woman was the mother of the child, and we can hardly suppose that she would have carried him had he not been unable to walk. Some jewels found on the female skeleton indicate a person of condition. Two bracelets of gold encircled the arm which held the boy, and on the hand were two gold rings, the one set with an emerald, on which is engraved a horn of plenty, and the other with an amethyst bearing a head of Mercury cut in *intaglio*.[51]

The last case contains the emaciated body of a child of about six years of age.—This child must probably have been ill at the time of the catastrophe and consequently unable to escape.[52]

The Twelfth Victim: The Man with Two Keys (fig. 45)

The body of a man was found in the southwest corner of the garden that occupied the western end of the small insula 6 of Region VIII (i.e., VIII.6.5).[53] Found at a level of four meters above the ground, he had been fleeing atop the cinders at the time of the surge, probably without knowledge of what was beneath him. At the time of his flight, he was carrying two keys. No other objects are recorded. The excavator, Luigi Fulvio, reported his success in making the cast to his superior, Michele Ruggiero, in Naples:

> The conditions were ideal for making a gesso cast according to the method discovered by our illustrious director general, and yesterday I was able to free the cast, which had come out perfectly. It reveals a human form, probably masculine (not having been able to ascertain this because the surrounding ash has not been entirely removed). [The

figure] is supine, with the left hand pressed to the chest, near which were found two iron keys, and the right hand near the loins. The back and the buttocks are perfect, and the legs are bent so that the knees are lifted somewhat off the ground.[54]

Unfortunately, despite the fact that the victim's entire body came out in the cast, the end result is disappointing.[55] The detail of the man's belt is clear, but his body appears, on the whole, to be rather amorphous, with the surface marked by the chisel used to remove the ash covering. As the *Giornale* noted, the sex of the victim is determined not from primary or secondary sexual characteristics but only by inference from his general bearing.

> Insula 7, region VIII. Inside and to the right of the fourth entrance on the north side, counting from the northwest, and at a height of about four meters from the soil, there appeared a human skeleton, of which was cast a model in gesso. Although the genitals do not appear, because they did not turn out, it seems from the features to be a man who, having fallen on his back, lies with his legs drawn up, his right hand to his breast, and his left arm raised somewhat. Near him were found two small iron keys, poorly preserved.[56]

Despite the poor surface quality of the cast, this victim was exhibited in the museum and often photographed.

Finally, Russell Forbes:

> In the vicinity [of the new excavation in Region VIII] a garden has been laid bare. There are indications of the flower-beds and walks, but the most interesting find was the form of a man encased with what was at the time of his death liquid mud. Plaster of Paris was poured into the space once occupied by the body, and on taking away the volcanic mould it was seen that the man was in the act of fleeing when overtaken in the current. Two keys which he was carrying fell from his hand as it relaxed in the death-throes. He had the usual girdle round his waist, and his loins were girded up to facilitate his flight.[57]

Despite the poor quality of this cast (which still can be seen in Pompei), it made an affecting exhibit for the museum.

> The following case contains the cast of an old man who died in great agony. He was probably a slave.[58]

The Gift for Kaiser Wilhelm II

Long before Fiorelli was appointed Inspector-Director of the Pompeii excavations, he was known to be sympathetic and useful to German scholars in Naples. This personal association continued to be advantageous to both parties during the period 1860–75, when Fiorelli directed the Naples Museum and the archaeological excavations in southern Italy, and from 1875 to 1891, when he was Director General for Archaeology and the Fine Arts for all of Italy.[59] In August 1888, when he learned of the upcoming state visit of the newly crowned Kaiser Wilhelm II, Fiorelli wrote an urgent letter to Ruggiero asking him to invite the sculptor Achille d'Orsi to make reduced copies in gesso of the casts from Pompeii and to have them ready by the end of September. When it became clear that the Kaiser would visit Pompeii, Fiorelli wrote again to Ruggiero, telling him to keep the copies in Pompeii so the Kaiser could examine them next to the originals. Apparently, the exhibition was satisfactory to the Kaiser, who accepted the gift and promised that the copies would be sent to the Royal Museum in Berlin.[60] The copies were, accordingly, installed in the Neues Museum in glass cases on the second floor at the head of the stairs, where they would be seen by everyone who visited the museum's collection of prints and drawings in the renowned Kupferstich-Kabinet.[61]

The entire incident is interesting, not only for its indication of what was considered an appropriate gift for the Kaiser, but also for what it says about the casts in general at this time. From a diplomatic point of view, the visit represented the first official visit by a head of state to the Kingdom of Italy since its foundation in 1870. It was known that Wilhelm took a personal interest in the classics and in archaeology and the

fine arts and that, as Kaiser, he represented the state that continued its support of the old Instituto di Corrispondenza Archeologica, now re-constituted as the Roman branch of the German Archaeological Society. On Fiorelli's part, the gesture was, of course, self-promoting for the discoverer of the casts, and it provided a lucrative commission for an old friend. The project is most interesting in the way it presents the casts as a museum collection, reproducing the originals in the Pompeii Museum but completely removed from their archaeological context.[62]

Victims 13–15, from outside Porta Stabiana (1889) (figs. 46–47)

Between August and October 1889, three human cadavers and a tree were found and cast in gesso just outside the Porta Stabiana at the southern edge of the city. The man resting on his left side (victim no. 13) was found first, on 12 August. A cast was made by the *capo d'opera* Alfonso D'Avino and the restorer Vincenzo Bramante, who were praised highly for their work by Ruggiero.[63] A photograph by Sommer was sent to Rome.[64] The supine man (victim no. 14) and the face-down woman (victim no. 15) were found on 11 October. Their casts were made under the supervision of Ruggiero and the engineer Cozzi.

> The first one uncovered is that of a man lying supine and wrapped in a cloak, with his head to the northwest and with his hands held in as if to protect his chest. The legs are slightly bent, and on the sole of his right foot can be seen a kind of circular projection. The other [victim no. 15] is a woman of mature age, who lies face down and is half-clothed. Her head is to the south, and her arms appear to strain. Near them were found the impressions of some trees, one of which it has been possible to cast. Its height is m 3.40, and the diameter of the trunk is about m 0.40.[65]

As in the previous case, photographs, including one of the trunk of the tree, were sent to Fiorelli in Rome.[66] The tree proved to be of some interest. Ruggiero submitted it to a botanist, and it proved to be of the

species *Laurus notabilis,* of the variety that bears round fruit in the autumn. Fiorelli, who was convinced that Pompeii had been destroyed by the volcano not on 24 August AD 79 but on 23 November of the same year, agreed with Ruggiero's determination.[67] Moreover, he was able to chalk up yet another contribution made by the casts to the knowledge of Pompeii. As in the case of victims previously cast in gesso, these casts, including the tree, were added to the museum exhibitions.[68] Ruggiero himself summed up the discovery in the official publication:

> In the last months, while digging at Pompeii in the bastion to the right as one leaves the city by the Porta Stabiana, were seen in the layer of ash the impressions of three human bodies, two men and a woman, and a tree a little distance from them. Liquid gesso was poured in in the usual fashion, and the four casts turned out successfully. After they had been cleaned and examined in good light, they were recorded in photography. Of the two men, one lay resting on his left side, and the other stretched supine on the ground. The woman died on her stomach with her arms stretched before her. *The most important point of this discovery seems to me to be the tree, of which, besides the impression of the trunk, the castings recovered the remains of leaves and berries* [emphasis mine]. The cast did not preserve the entire length of this tree. The lower extremity was lost in the pumice [i.e., lapilli], and that part toward the top that rose above the ash was consumed over time.[69]

The Sixteenth Victim: The Heavily Clothed Man (1890) (fig. 48)

It is impossible to escape the conclusion that the attempt to include elements of the archaeological context, such as casts of tree trunks and branches laden with fruit, offered a challenge to the traditions of *collezionismo,* or the antiquarians' method. Simply adding new casts of human victims as they were uncovered and fabricated in the process of excavating Pompeii threatened to overload the museum's capacity to receive them and exhibit them. Yet some additions could not be turned away. The sixteenth victim, the heavily clothed man, yielded technically

perhaps the best cast ever made and was no less important for his con-
tribution to a favorite subject of the antiquarian, the ancient vestiary.

According to the *Notizie degli scavi*, the body of a man wrapped in
his cloak and lying on his left side was encountered on 12 March 1890
in the excavations outside of the Porta Stabiana.[70] The cast was recog-
nized as being among the best made up until that time:

> It represented a young man, of slender figure, who lay on his left side,
> wound up in his cloak and wearing short pants which exposed his legs
> from above the knee. On his right foot could been seen clearly the san-
> dal in which he was shod.[71]

Nothing could be made out of the left leg or arm, as they did not turn
out.

Since a proper catalogue raisonné of the casts was never published,
it was inevitable that errors would eventually begin to affect the collec-
tion and even to influence the way individual casts were interpreted. As
more casts entered the museum, it was necessary to rearrange the cases.
Writers of authoritative guidebooks, meant to go through multiple edi-
tions, accordingly refused to describe the casts because "the objects are
often rearranged in the three rooms."[72] Even when one did offer de-
scriptions of the individual victims—with the admonition that the
arrangement should be regarded as "provisional"—information as to
the provenance of each was not provided.[73] Commercial photogra-
phers of the time rarely took the trouble to be accurate in the captions
that they added to their prints. The superb Brogi photograph (fig. 40)
of the two women from 1863 (victims nos. 2 and 3) bears the caption
"Cadavere d' uomo e di ragazzo" (Cadaver of man and of boy).[74] Au-
thors who attempted to connect the casts in the museum with their
provenance found themselves at the mercy of tour guides, mislabeled
photographs and postcards, and an interested but uncritical audience.

An attempt at a comprehensive survey of the victims, most of them
represented by casts to be seen at that time in the Pompeii Museum,
was attempted at the turn of the century by Pierre Gusman (1862–

1942).[75] Gusman, who had already achieved a considerable reputation as an artist and publisher, devoted a separate chapter to the victims in his book on Pompeii. He reproduced eight of the victims in his own drawings printed in linecuts interspersed in the text. The book was quite splendidly produced for its time, but unfortunately the author was not careful with details. Among his other mistakes, Gusman illustrated a figure of the woman identified as victim no. 15 in a supine position—as it is indeed to be seen in many photographs and even in the museum—with the caption "A Man (Museum of Pompei)."[76] The drawing itself appears to be taken from a photograph, perhaps the very one included in the present study as figure 47. In his drawing (fig. 49) of the young woman from the Strada Stabiana (victim no. 10), he copied the drawing in *L'Illustration* (fig. 27), itself a copy after Amodio's photograph (fig. 30).[77] A more serious error of Gusman's, however, was to confuse his description and drawing of this victim with one of the four victims found by Fiorelli in 1863 (victims nos. 1–4). Aware that he had one more woman to account for, he added a detailed description of the woman (victim no. 4), referring to her simply as "another charming female."[78] An essay that was meant to be informed and informative thus contributed to the separation of the victims (i.e., the objects) from their archaeological context and even from their museological context.

Even guidebooks devoted to the excavations had begun to show the effects of memory loss. In its description of the contents of the second room, Morlicchio's guidebook of 1901, intended for English visitors, passes quickly over the first two cases in order to focus momentarily on the woman above the stairs.[79] It then proceeds to the next victim (no. 4), misidentifying the woman, once celebrated for her beauty by Beulé and others, as a man. In the description of the third room, the presence of the dog alerts us to the fact that the guidebook's description is nearly twenty years out of date, since the unfortunate canine had long before been moved to the second room, where it was paired on either side of the door with the newly arrived emaciated child. In fact, the turn of the century found the Pompeii Museum in need of renovation, as the following excerpt will attest:

FRANCESCO MORLICCHIO (?), *GUIDE TO POMPEI,
ILLUSTRATED* [1901]

In this Museum, the formation of which is owing to the Director of the
excavations, the illustrious Commendatore Fiorelli, the visitor will ob-
serve a great number of excavated objects, showing the material condi-
tions and domestic utensils of the Pompeians.

The site where this museum is located was perhaps destined to the
deposit of goods coming from the sea.

FIRST ROOM.—Entering the first room is seen on the right the im-
pression in plaster of a door of two folds, having united with it the locks
and all the ancient ironwork: at the [back] of this room is a new door of
wood in imitation of the antique.

SECOND ROOM—On the right is seen a painting representing Nar-
cissus looking at himself in the fountain.—The walls of this room are
covered with presses and there are six cases in the middle which con-
tain numerous objects.—In the presses at the sides are amphorae of var-
ious forms, monopods, tubes, shells, bottles, cups, small altars, por-
ringers, lamps, pots, vases, money-boxes, *paterae,* plates, masks for
fountains, tiles, waterspouts, and other objects in terra-cotta.

The cases contain, the first and second on entering the room, the
models of some men: the third placed over a small staircase to enable
the face also to be seen contains the model of a woman fallen on her
face, of which one sees the arrangement of the hair and the folds of the
drapery: the fourth case preserves another skeleton of a man: the fifth
two skeletons of women, probably mother and daughter: in the sixth
case are some burnt pieces of tissue and of hemp rope.

THIRD ROOM—In the presses at the sides on the right are shells, hu-
man skulls, amongst which one that preserves some hairs, diverse
pieces of bread, dried fruits, unguents, lamps, lanterns, door-latches,
locks, nails, bolts, colours, bottles, glasses, pins, small bells, horses' bri-
dles, copper-pans, different colours, various eatables, eggshells, horns,
strigils, pincers, trowels, snails, tortoises, candle-sticks, ladles, buckets,

scales, compass, hooks, needles, baskets, funnels, braziers, measures of capacity, etc.

In the presses on the left are the skeletons of horses, rats, dogs, cats, a sea-shell of bronze with a little suckling pig and fowl bones.

In this room are seen the statues in marble of Venus, and of a beardless youth and a Satyr.

In the first case is seen the skeleton of a man, found in September, 1873, in the Region of the Stabian Gate: In the second two, other models of men: in the third a dog found in 1874 upon the threshold of the house, called of Orpheus, which preserves in the impression of the collar the two rings of bronze.[80]

At the beginning of this section, it was noted that even Fiorelli took some time to come around to a realization of the casts' value as evidence for the nature of the destruction that overtook Pompeii, namely, for their value as forensic evidence. At the end of the period surveyed in this book, August Mau had little to say about the casts in his great study of Pompeian art and topography.[81] What he did say, however, was very significant to our understanding of the conditions at the time of the final destruction and was based on and could not have been said without the evidence of the casts:

> The extraordinary freshness of these figures, without any suggestion of the wasting away after death, is explicable only on the supposition that the enveloping dust was damp, and so commenced immediately to harden into a permanent shape. If the dust had been dry and had packed down and hardened afterwards, we should be able to trace at least the beginnings of decay.[82]

Recent studies of the bodies from Pompeii have tended more toward the forensic than toward the antiquarian. The casts of 1863–90 have been supplemented by a new collection, somewhat closer to the archaeological context, a collection that promises to add a few iconic ones to the older series.

The total number of casts made over the period 1863–90 was

small—on the average of one every twenty-one months. In retrospect, Beulé's vision of an anthropological museum seems overly optimistic. In addition to their value as forensic evidence, the casts have provided a modest amount of data for the antiquarian. More should still be asked of them. (For example, was the thick band worn by several of the victims an article of clothing, or might it have signified the status of a slave?)[83] The casts' relation to art was mentioned by many contemporary observers, some of whom were artists themselves. What effects may they have had on sculptors of the period? Achille d'Orsi, the modeler of the copies for Kaiser Wilhelm, was also the creator of such realistic masterpieces as *I Parassiti* (1877, Florence, Galleria d'Arte Moderna) and *Proximus Tuus* (1880, Rome, Galleria d'Arte Moderna), both of which betray ancient inspiration while they advance the realist current in modern sculpture. The exhibition of the casts made a unique contribution to the history of museums, particularly archaeological site museums, in yet another way. Nineteenth-century museums were as apt to be chambers of horror as they were bastions of culture. The Pompeii Museum belongs to both traditions.

The Life of a Collection

The decision to conclude this survey of the initial collection of casts with the year 1900 is not completely arbitrary. By the end of the century, a site museum had been well established at Pompeii. It had been accepted by the writers of guidebooks and by the public itself as an important or even a necessary introduction to a proper tour of the excavations, but by the end of the century, it had begun to show its age and was in need of refurbishing. Housed in vaults beneath the Temple of Venus, it was not easily expanded beyond the rooms that had been filled at its opening in 1875. The dozen casts seen by Kaiser Wilhelm in 1888 stretched the capacity of the place, and the addition of four more casts during the next decade necessitated doubling some of the displays. The museum was increasingly taking on the appearance of a catacomb. Moreover, some of the facts were being scrambled, as we can

see from the descriptions of Gusman (1900) and Morlicchio (1901). Plainly, a limit had been reached, and the time was ripe for renovation. That this need coincided with the arrival of a new boss in Naples, unsympathetic to the legacy of Fiorelli and ambitious to impose his own stamp on the institutions, signaled that a change was imminent for Pompeii (see discussion of Ettore Pais in the epilogue).

In the life of a collection, there are four distinct yet interrelated stages: discovery, conservation, illustration, and dispersal. In the collection of casts as it was envisioned by Fiorelli—and as his continuing interest demonstrated by his role in commissioning the copies for Kaiser Wilhelm showed—these four stages had been fully played out by the end of the century. Fiorelli's initial discovery of the cast-making process had led seamlessly to the conservation of the casts as objects: namely, the appropriation of a space to house them, the construction of individual glass cases, and so on. Fiorelli may once have intended an official publication as a way of illustrating the items in his collection. When the collection failed to grow at the rate he had anticipated, and feeling disappointed with what he realized were flaws in his original casts, he settled for exhibiting the casts in a site museum. Perhaps, too, he was surprised and satisfied with the entrepreneurial success of the commercial photographers of Naples. At any rate, Fiorelli cannot have been disappointed with the way the casts' fame was spread.

When Fiorelli died in Naples in 1896, having been called to Rome in 1875 for more important work, it was the end of an era in Italian archaeology. I suggested earlier that his excavations at Pompeii—including his success at resurrecting Pompeians—could be considered to some extent an artifact of the Risorgimento. During the year preceding his death, perhaps the greatest archaeological treasure ever discovered in Italy, the silver treasure from Boscoreale, had been spirited out of the country by Neapolitan art dealers (acting on behalf of the owners on whose land the treasure had been discovered) and sold in Paris. With the inevitable calls for reform that were issued by the press, the era of Fiorelli and the successors he had left in charge of Pompeii was coming to an end.

Epilogue

Amedeo Maiuri, who became General Superintendent of Antiquities and Director of the Naples Museum in 1924 (and effective director of the excavations at Pompeii), had the fortune of seeing the Pompeii Museum in its original state, of supervising its renovation, of seeing it totally destroyed during World War II, and of rebuilding it from scratch:

> When I came to Pompeii for the first time [ca. 1910], I found it with its old cases painted in white, with coarse wooden doors and poor lighting, with rows of vases and bronzes crowded and dirty behind the spiderweb of a metal screen. I had the impression of certain old pharmacies in the country, where jars painted with letters of gold are barely visible in the cases, so the groping hand of the pharmacist must laboriously feel for the desired drug.[1]

Despite his initial negative impression, Maiuri recognized the importance of Fiorelli's museum:

> But ancient and rustic as it was, it was the passion of the visitors, who found it at the entrance to the city, as preface and preamble of what they would have seen in the abandoned and empty houses. It was the humble, simple, and human life of Pompeii: plain, ordinary earthenware table service and bronze cups dented with use, traces of cooking on the bottom of a pot and fishhooks, pigments and foodstuffs, locks and keys, balances and scales, and models of villas and farmhouses where any rus-

tic might recognize the cellar, the winepress, and the olive mill. And what rendered this first contact with the uncovered city most lively and immediate were the inhabitants of Pompeii, those bodies distributed in the cases, on their backs and on their stomachs, those marvelous impressions of life and death that Fiorelli had taken from the cavities of those buried in the *cenere* and that, in a people who revered death, excited piety and compassion; and there at the door, that guard dog tied by a chain, dead also in his convulsions, as if to express the common tragic fate, in that disaster of long ago, of every living creature.[2]

Dilapidated as it was when Maiuri first saw it, the Pompeii Museum had enjoyed one major addition since the time of Fiorelli, and this is reflected in Maiuri's description. In 1893–94, a working farmhouse, a so-called *villa rustica,* had been found on private land in Boscoreale, a town bordering the archaeological zone of Pompeii on the north. The organization of the villa was so clear and its preservation so good that a scale model was made, and the villa's bath complex, boiler, and all, were moved to the third room of the museum. The same excavation also produced for the museum a cast of the upper portion of a man with his face wrapped in a scarf and reaching out in his agony, which was "eerily moving," in Mau's words.[3] The model, the bath, and the cast were added to the contents of room 3 by 1899.[4] Important as they were, the items from the *villa rustica* represented an attempt on the part of the owner to assuage public (and state) opinion, since the major discovery of the excavation had been the famous silver treasure of Boscoreale. Loyalty to the Kingdom of Italy had been sacrificed when the treasure, the greatest in modern times, was put on the auction block and sold to Baron Edmond de Rothschild, who presented it to the Louvre.

If the Pompeian casts were, to some extent, artifacts of the unification of Italy, their fate was also linked to that of the state that brought them into being. The government that had appointed Fiorelli and had generously funded his enterprise in 1860 encountered social, economic, and political crises as the century came to an end. To a certain extent, the casts and their museum mirrored the fortunes of the Kingdom of Italy. Despite the fact that the process of cast making had at-

tained a high degree of perfection by 1890, the museum had run out of exhibition space, and an infinite series of plaster casts no longer seemed like an exciting idea from a museological point of view.[5] While visitors to Pompeii continued to find the casts fascinating—at least in small doses—the Pompeii Museum had begun to show signs of wear. The administration of the excavations was in the hands of the next generation. Ruggiero had been replaced by Antonio Sogliano, and a new Pompeii was emerging, typified by the House of the Vettii excavations. By 1893 Fiorelli had lost his sight and retired to Naples, where he died at the beginning of 1896. Although there was no shortage of memorials to him, the world of Neapolitan archaeology soon erupted in turmoil.[6] This was due, in part, to an unhappy turn in foreign affairs.[7] Sales to foreign buyers of great treasures from the region were criticized by prominent voices that appeared in Italy's newspapers in defense of the country's patrimony.[8] The silver treasure of Boscoreale was soon joined by bronzes from the same villa, bought for Berlin, and frescoes from another villa in the same town, bought for New York's Metropolitan Museum of Art, upsetting the balance between national and foreign interests that Fiorelli had sought hard to establish during his administration in Naples and in Rome. Because of the public outcry, Giulio de Petra, Fiorelli's protégé and successor as Director of the Naples Museum and Superintendent of Antiquities, was relieved of his position. He was replaced first by Paolo Orsi and then, almost immediately, by a brilliant and dynamic scholar who very shortly brought Naples to a state of "perpetual earthquake," in the words of Benedetto Croce.[9] The economic situation in the South and in Naples had deteriorated, but the greatest humiliation that the city had to endure was to see a non-Neapolitan, Ettore Pais, appointed as Director of the Naples Museum, General Superintendent of Antiquities, and Professor of Archaeology at the University of Naples.[10]

Pais served as Director of the Naples Museum and excavations from 1901 until 1904, when pressure from de Petra and Sogliano, as well as from leading intellectuals like Croce, induced the Roman government that had appointed him to remove him. Earlier in his career, Pais had been assigned by Theodor Mommsen the task of publishing the Latin

inscriptions of northern Italy for the German-sponsored *Corpus of Latin Inscriptions*.[11] In his struggles in Naples, he was actively supported by German and by French scholars. Writing in the *Revue Archéologique,* Salomon Reinach described the fall of Pais as the victory of the Camorra over science. Croce responded in a letter published in *Napoli Nobilissima* that such foreigners spoke from ignorance of internal matters such as justice and finance.[12] Although a confidential report commissioned by Rome excused Pais of any wrongdoing, his attempt to purge the Naples Museum of any vestiges of Fiorelli's antiquarian system by reorganizing the collections chronologically brought a chorus of complaints. Had Pais remained in power, he might have constructed a new museum that he had envisioned for Pompeii. His fall and the hostility to the Roman administration that it entailed promised to be problematic for Naples and for Pompeii.[13]

Another affair that soured relations between many foreign scholars and the Neapolitans at that time was the effort of the Anglo-American scholar Charles Waldstein to revive the excavations of Herculaneum. Apparently acting from the best intention and without any knowledge or concern for the turmoil in Naples, Waldstein published a newspaper appeal for an international effort to excavate Herculaneum, arguing, as Beulé had earlier, for the superiority of that site to Pompeii. He quickly won the support of such figures as President Roosevelt and Kaiser Wilhelm, but Italy was cool to the idea, and the official line was that the task should be accomplished as a national effort. Waldstein did not relinquish his cause gracefully but continued to urge his plan in newspapers throughout the world.

By the time yet another foreigner, Arnold Ruesch, attempted to exercise his patronage in Neapolitan affairs, it seemed as if things could not get any worse. The Swiss Ruesch's project was to support the publication of a comprehensive, illustrated guide to the Naples Museum. Sections of the guide were to be written by distinguished Neapolitan scholars like de Petra and Sogliano—those who had survived and triumphed in the Pais affair. The guide itself was a monumental scholarly achievement, but nearly the whole of the first edition was destroyed in a suspicious warehouse fire in 1908.

After Pais's fall, the position of Soprintendente Generale and Director of the Naples Museum was given back to Giulio de Petra, who held them until 1910. Vittorio Spinazzola, who had been waiting in the wings as Director of the Museum of the Certosa di San Martino in Naples during Pais's regime, was appointed Soprintendente Generale and Director of the Naples Museum in 1910. His principal achievement during his administration, which spanned the war years, was to complete the excavation of the Via dell' Abbondanza in Pompeii. This main artery, which led from the Forum to the Amphitheater (including the stretch with Fiorelli's first excavations in the House of Holconius), was at the time of Spinazzola's excavation spectacularly preserved, with its shop fronts, paintings, and inscriptions directed toward the street. Unfortunately, much of the street was destroyed by bombing during World War II. Spinazzola's excavations did much to re-create the daily life of the Pompeians, and his work with the human remains was similarly directed to preserving them as groups, rather than as individual "sculptures."

One of the changes in the method used in excavating Pompeii under the new, post-Fiorelli regimes was to excavate larger sectors of the *cenere* during the winter months, leaving the more loosely packed layer of the lapilli for the summer. It was thought that, in addition to saving money, this procedure would protect newly exposed walls from erosion by winter rains.[14] At the beginning of the twentieth century, excavators were apt to think of the layer of the *cenere* as surface debris deposited upon the underlying city and thus as irrelevant to their idea of the "archaeological context." While this policy may have benefited plaster walls, it was not good for objects deposited in the *cenere*. As far as future casts were concerned, a mixed result of the new policy was that more bodies might be uncovered at the same time. Spinazzola's excavation in the garden of the House of the Cryptoporticus (I.6.2) in 1914 uncovered a group of nine skeletons in the *cenere*.[15] As a photograph published in the *Notizie degli scavi* showed, the new excavating technique, in combination with improved site photography, recorded the context and the relationships that existed among the members of the group. In his account of this excavation, Spinazzola articulated the principles that had guided the excavation and the casting of the victims:

The orders from the director's office concerning these forms in gesso of Pompeian cadavers were as follows: since we already have splendid examples of individual impressions presented under favorable conditions, we must take every care and use our utmost patience to improve the method of the new casts, seeking to obtain even those that may present themselves under less favorable conditions, whether by making partial casts of the forms or by cleaning as much as possible the bones from the cavities, by making tools specially adapted for this purpose when necessary. The principal goal should be that of capturing the final moment not of individual persons but of groups of persons and to obtain, for the first time, impressions of such groups—and thereby to add not only to the pathos of the Pompeian disaster but what such groups may be able to tell of the manner in which it occurred and, moreover, of the character, the costumes, and the spirit of these people.

Spinazzola went on to offer due praise to the inspector (unnamed) and the workmen Umberto Borelli and Armando Mancini who assisted in the excavation.[16]

Spinazzola's decision to use the casting process to gain evidence of the archaeological context rather than to create individual masterpieces suitable for exhibition explains why casts of this period are not represented in the Pompeii Museum. As the casts eventually had to be removed from their context in order for the excavation to continue, it appears that the publication in the *Notizie degli scavi* of a photographic record, supplemented by a narrative reconstruction, was to be considered the authoritative documentation of the human remains. Comparing the fate of the victims in the House of the Cryptoporticus with that of the victims found 140 years earlier in the cellar of the Villa of Diomedes, Spinazzola wrote:

As in the previous case, so here the family had to look for a sturdier shelter against the earthquakes and the fall of heavy lapilli and pumice and the burning rain in the solid vault of the wine cellar, which had, in fact, so well withstood the great weight upon it. But, contrary to that which befell the inhabitants of the Villa of Diomedes, these were sud-

denly driven out by the lapilli, which, building upon the already high level of the garden (the level of which came up the level of the windows), easily penetrated and quickly began to build up in the crypt. In any case, they remained there as long as they could. Then, they ascended the stairs that had brought them to the crypt and looked to escape to the shore through the garden, wandering among the falling ashes. They equipped themselves with large tiles, with which they covered their heads, as Pliny the Younger told his uncle and the family of his friend Pomponianus had with cushions, in order to protect themselves from the falling lapilli and stones. But being quickly surprised, overcome, and suffocated by the rain of ashes, they fell, just as we found them there, each with a tile near his head that protected him and accompanied him in his fall, and they all fell asleep forever covered by the heavy blanket, until our search freed them and brought them to light, with their beautiful forms, the agony of their final hour, and the affection that accompanied and eased it.[17]

By focusing on the archaeological context rather than on the individual form, Spinazzola effectively brought to a close the chapter that Fiorelli had begun. The discovery of a body surrounded by a cavity amenable to casting was no longer qualitatively different from the discovery of any other skeleton. Casting was simply one more tool in the archaeologist's repertory of technical skills. Some of the bodies uncovered in the garden of the House of the Cryptoporticus were cast in plaster, and some were left as skeletal remains. Even though Spinazzola's methods may have signaled an end to Fiorelli's antiquarian-inspired collection of casts, the new system might equally well be regarded as a tribute to the man who initiated the *Notizie degli scavi.*

With the advent of Mussolini, Spinazzola was replaced by Maiuri, who had served under him but was unscathed in the latter's battles and enjoyed strong support in Rome. Despite an early attempt to intimidate him through an act of vandalism to the Naples Museum's most valuable object, Maiuri gained control over his subordinates through a combination of administrative vigor, archaeological good fortune, and personal magnetism.[18] His excavations in Pompeii produced the fa-

mous lamp-bearing ephebe from the Via dell'Abbondanza in 1925. He reopened the excavations in Herculaneum in 1927. In Pompeii, he finished the excavation of the Villa of the Mysteries (1929–30) and, shortly afterward, the House of the Menander, with its silver treasure (December 1930), rivaling the one that had been lost to the Louvre.

In 1926 he refurbished the Pompeii Museum, only to see it totally destroyed by an Allied bomb in 1943. Maiuri described the morning of that day and the state of the museum:

> When, at dawn, the painful task of recovery was begun, there was the full vision of disaster. Of the long, vaulted gallery from the time of Fiorelli, of the ancient walls of the city's warehouse, nothing remained standing but the tottering walls of the first room. The rest was rubble and abyss. Among the rubble there surfaced broken fragments of the cases and, lying in ruin, contorted, and mutilated, like the victims of the recent catastrophe, the casts of the dead of two millennia ago, the victims that the lapilli and the *cenere* of the eruption of 79 had reverently contained and that a more inhuman violence had mutilated and dishonored in violating their sacred peace of the dead.[19]

Most of the contents of the museum were beyond repair. Fiorelli's original casts of 1863 were destroyed. Miraculously, some of the "iconic" casts—those of the "sick man," the young woman from the Strada Stabiana, the watchdog, the man with two keys, the heavily clothed man, and man from the "Villa della Pisanella"—survived the bombing. They returned to their museum when Maiuri rededicated it in 1948 under the new name "Pompeii Antiquarium."[20]

Aside from conserving those of the earlier casts that could be salvaged, Maiuri added to the museum only one of the casts made during his long superintendency: the cast of a muleteer who had died wrapped in his cloak, squatting against the wall in the portico of the Grand Palestra.[21] His greatest trove of casts, however, was in open country, in the "Grove of the Fugitives." He was fortunate to discover and to cast successfully a remarkable group of thirteen fugitives in an area just outside the city gate known as the Porta Nocera. Faithful to the precepts of

modern archaeology, he gave careful attention to the archaeological context. In his description of the victims, however, he allowed his admiration for individual specimens to show, in the fashion of earlier antiquarians. In a moving essay, "The Victims of Porta Nocera," he described the first two bodies—"vigorosi corpi"—with the eye of a sculptor. The man, with his powerful musculature and contracted limbs, might be a wrestler in the defensive position; the woman, identified by her voluptuous forms, might under other circumstances appear as a model in a sculptor's studio: "We often stand in admiration before statues and portraits in stone or in marble, and I found myself in the presence of two marvelous bodies modeled and sculpted by the softest and most ductile clay one could ever desire: the ashes of Vesuvius."[22] Next to them was an old man with thin legs and a bent spine, who died trying to pull his garment over his face, "so weak and alone that he seemed to me," wrote Maiuri, "to have died more tragically than the others."[23] Maiuri identified him as a beggar, with his stick and his pack, comparing him with Ulysses returned to Ithaca. Here, too, was a type well known from the wall paintings.

Maiuri was more fortunate than Spinazzola in his attempt to envision just how the Pompeian victims had perished. Whereas Spinazzola described the death of the victims in the garden of the House of the Cryptoporticus as though they had been buried by falling pumice, we know now that, like the rest of the victims found in the *cenere,* they were overcome by a surge traveling over the land surface—probably the first or the second surge to hit the city—before they were buried in the final surge.[24] Although the tiles carried by the fugitives showed that they had tried to protect themselves from falling pumice, these would have been of no use in a pyroclastic flow.

Since Maiuri's time, archaeologists have learned much more about the destruction of Herculaneum and Pompeii. It is enough to say here that casts of the Pompeian type cannot be made of the victims at Herculaneum. The ancient town of Oplontis, closer to Pompeii, offers a more comparable archaeological context. Between 1982 and 1985, the conservator Amedeo Cicchitti made an innovative, "transparent" cast of one of the Oplontis victims, using multiple stages to produce a final

cast in polymer resin.[25] The result compares favorably with the traditional gesso casts in being lighter and more durable and in permitting examination of the skeleton. However, the new procedure requires considerably more expense in labor and in materials.

In 2003 the exhibition Tales from an Eruption: Pompeii, Herculaneum, Oplontis opened at the Naples Archaeological Museum. It has subsequently traveled to other cities throughout the world.[26] The exhibition has attempted to combine the viewing of objects in a museum setting with the presentation of information about their specific archaeological context. Among the contexts from Pompeii that have contributed objects to this exhibition, the "Alley of the Skeletons" (Vicolo degli Scheletri), the site of Fiorelli's first casts, is represented by an amber statuette, a silver medallion with an image of the goddess Fortune, and a silver hand mirror, all of which were found in the vicinity of the body of the woman denoted in this study as victim no. 4.[27] It is consoling and no small wonder to see that the little treasure that the woman struggled to preserve at the time of the destruction survives today.

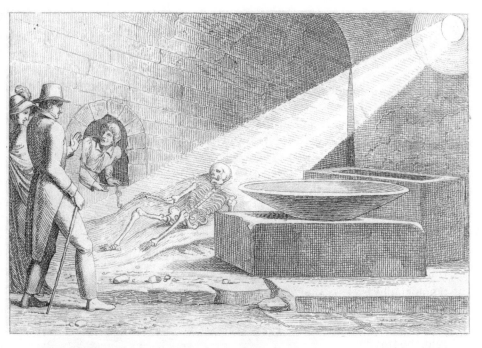

Fig. 1. Visitors viewing skeleton in a cellar. Engraving (image 3 1/2 x 5 1/2). (Henry Wilkins, *Suite de Vues Pittoresques des Ruines de Pompeii* [Rome, 1819], text to Plate 1. Collection of the author.)

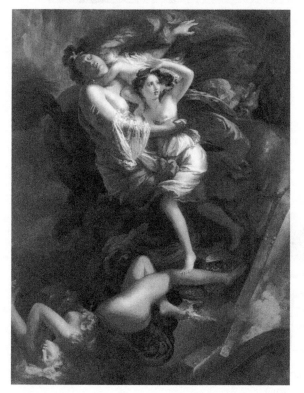

Fig. 2. Joseph Franque, *Scene during the Eruption of Vesuvius.* Oil on canvas. (Courtesy of the Philadelphia Museum of Art: Purchased with the George W. Elkins Fund, 1972.)

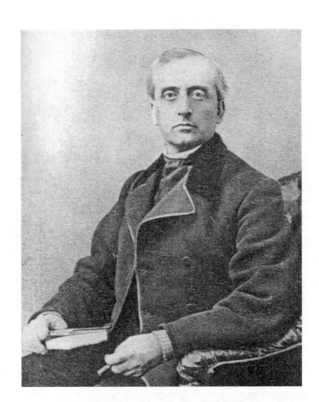

Fig. 3. Giuseppe Fiorelli in 1863. (Photography by Grillet and Co., Naples. After Palumbo [1913].)

Fig. 4. House of Holconius excavated in 1861. (Photography by Michele Amodio. Collection of the author.)

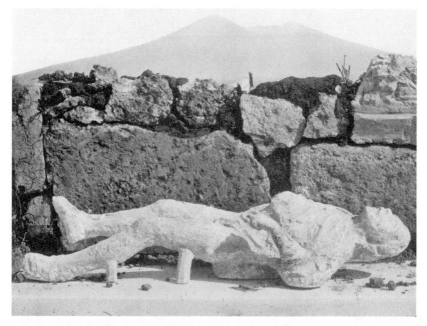

Fig. 5. Victim No. 1. (Photography by Michele Amodio. Courtesy of the Kelsey Museum of Archaeology.)

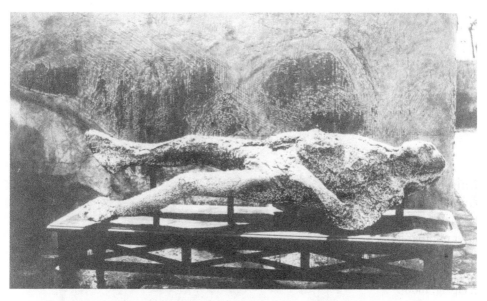

Fig. 6. Victim No. 1. (Photography by Giorgio Sommer. Collection of the author.)

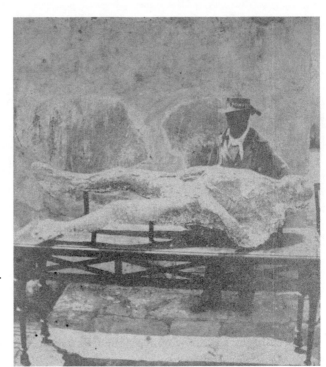

Fig. 7. Victim No. 1, with Pompeii Guide. (Photography by Giorgio Sommer. Collection of the author.)

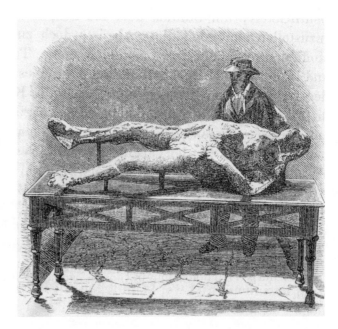

Fig. 8. Victim No. 1, with Pompeii Guide. Metal-cut book illustration after photograph. (From J. Overbeck, *Pompeji,* 2nd ed. [Leipzig, 1866]. Collection of the author.)

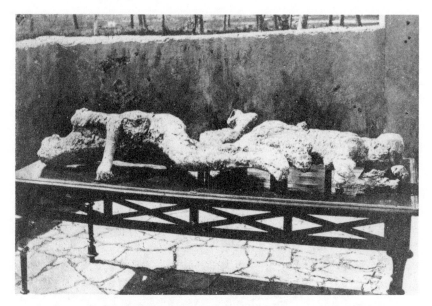

Fig. 9. Victims Nos. 2 and 3. (Photography by Giorgio Sommer. Collection of the author.)

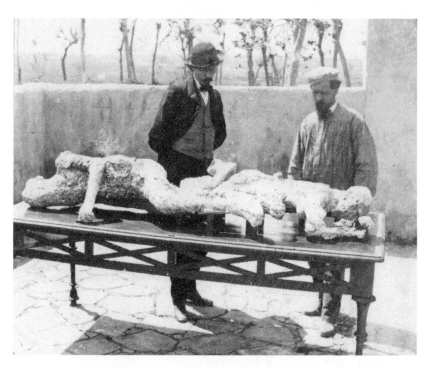

Fig. 10. Victims Nos. 2 and 3, with Pompeii personnel. (Stereo card photograph by Giorgio Sommer. Collection of the author.)

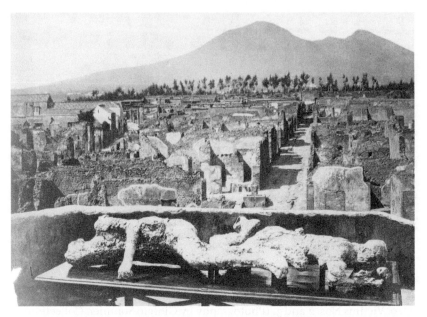

Fig. 11. Victims Nos. 2 and 3, on terrace overlooking Region VI. (Photography by Giorgio Sommer. Collection of the author.)

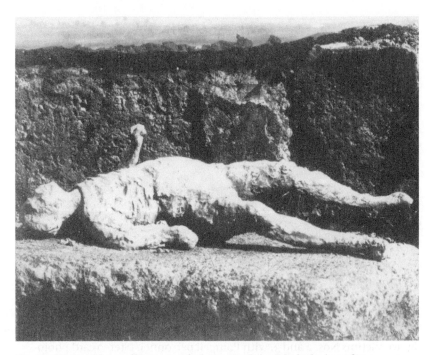

Fig. 12. Victim No. 4. (Stereo card photograph by Michele Amodio. Collection of the author.)

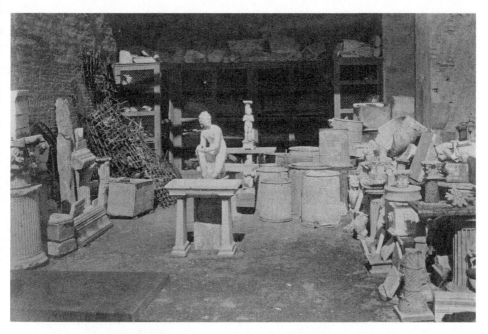

Fig. 13. "Tempio di Mercurio," ca. 1870. (Photography by Giacomo Bragi. Collection of the author.)

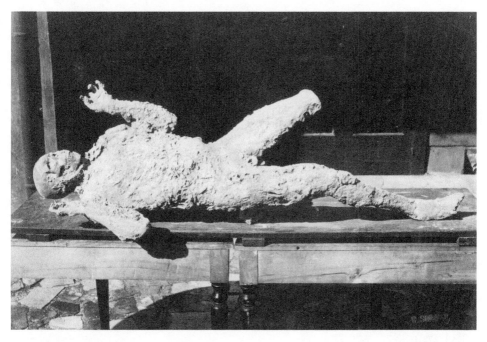

Fig. 14. Victim No. 5. (Photography by Giorgio Sommer. Collection of the author.)

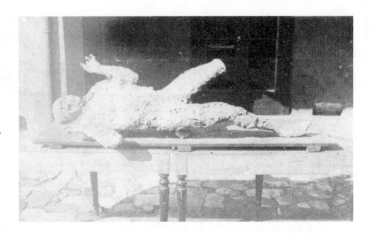

Fig. 15. Victim No. 5. (Photography by Giorgio Sommer. Collection of the author.)

Fig. 16. Reverse of carte de visite in figure 15.

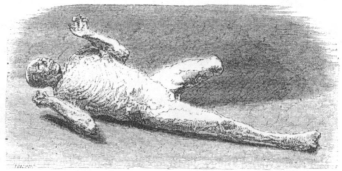

Fig. 17. Victim No. 5. (After Ernest Breton, *Pompeia,* 3rd ed. [1869], 272.)

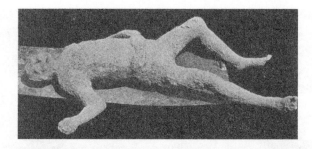

Fig. 18. Victim No. 6. (Photography by Giorgio Sommer.) (Collection of the author.)

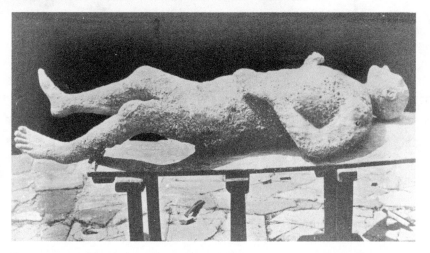

Fig. 19. Victim No. 6. (Photography by Roberto Rive. Collection of the author.)

Fig. 20. Interior of Pompeii Museum. (Photography by Roberto Rive. Collection of the author.)

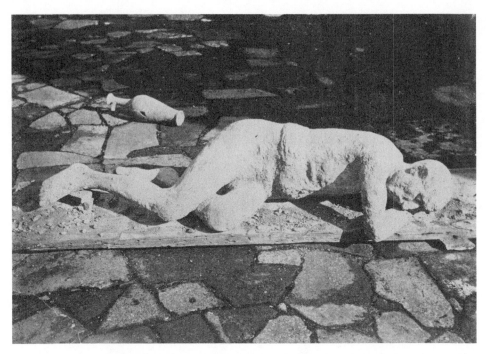

Fig. 21. Victim No. 7 (the Sick Man). (Photography by Michele Amodio. Collection of the author.)

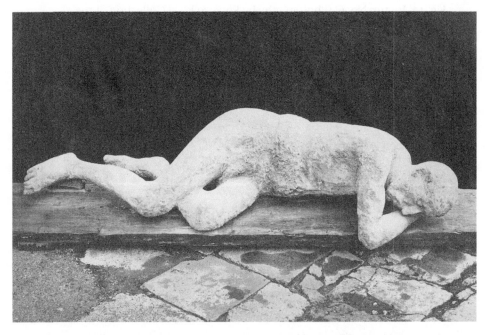

Fig. 22. Victim No. 7. (Photograph by Roberto Rive. Collection of the author.)

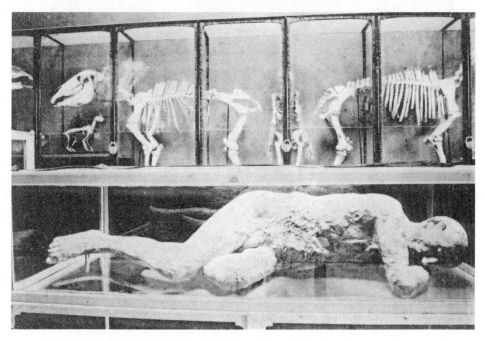

Fig. 23. Victim No. 7, in museum case, Room III. (Postcard by Carlo Cotini. Collection of the author.)

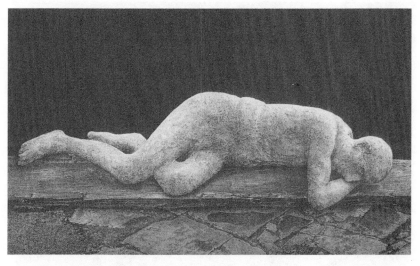

Fig. 24. Victim No. 7. Photo-engraved book illustration. (After J. Overbeck, *Pompeji,* 3rd ed. [Leipzig 1875].)

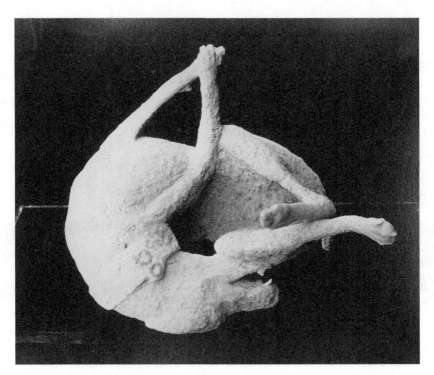

Fig. 25. Victim No. 8 (the Watchdog). (Photography by Giorgio Sommer. Collection of the author.)

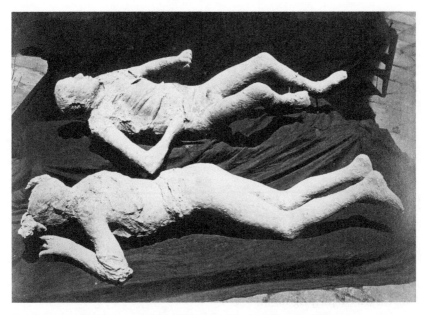

Fig. 26. Victims Nos. 9 and 10. (Photography by Giorgio Sommer. Collection of the author.)

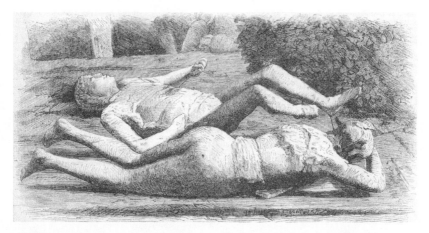

Fig. 27. Victims Nos. 9 and 10. Linecut illustration after *L'Illustration*. (Collection of the author.)

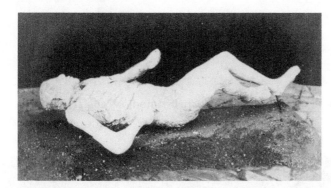

Fig. 28. Victim No. 9. (Photography by Giorgio Sommer. Courtesy of the Kelsey Museum of Archaeology.)

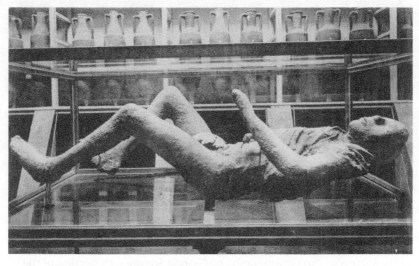

Fig. 29. Victim No. 9, in museum case (ca. 1900).(Note that a fig leaf has been applied to the cast.) (Photographer unknown.)

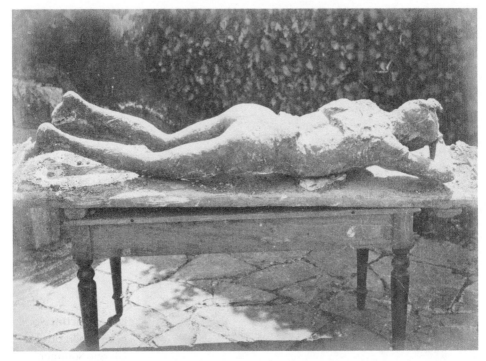

Fig. 30. Victim No. 10. (Photography by Michele Amodio. Collection of the author.)

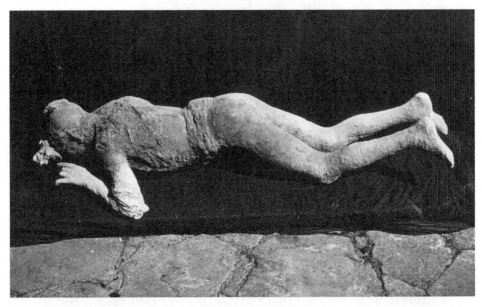

Fig. 31. Victim No. 10 (Photography by Giorgio Sommer. Collection of the author.)

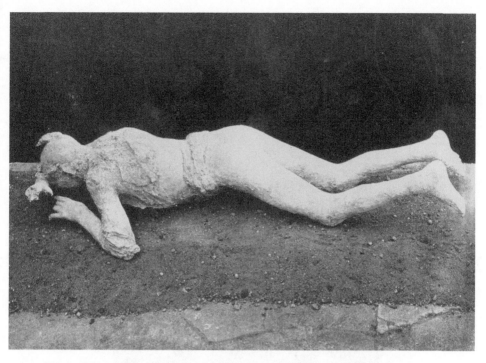

Fig. 32. Victim No. 10. (Photography by Roberto Rive. Collection of the author.)

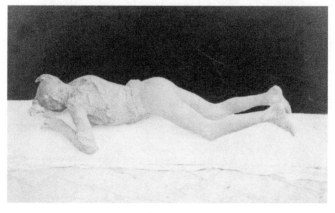

Fig. 33. Victim No. 10. (Carte de visite photograph by Roberto Rive.)

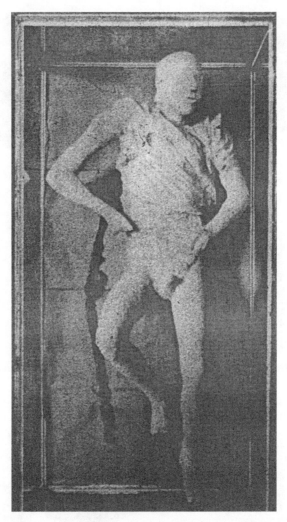

Fig. 34. Brogi 5573. Victim No. 9, in museum case.

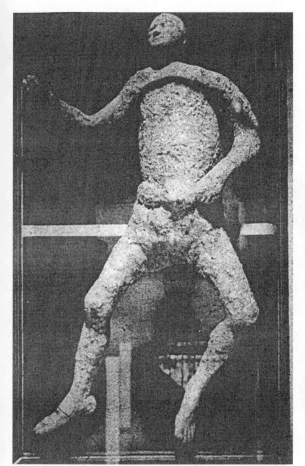

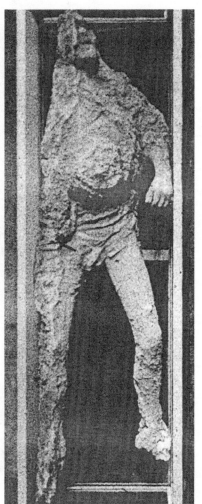

Fig. 35. Brogi 5574. Victim
No. 6, in museum case.

Fig. 36. Brogi 5575. Victim No. 1,
in museum case.

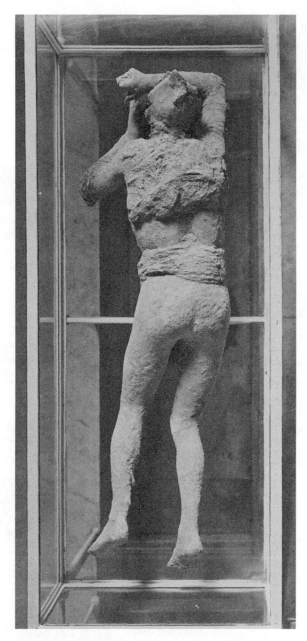

Fig. 37. Brogi 5576. Victim No. 10, in museum case.
(Collection of the author.)

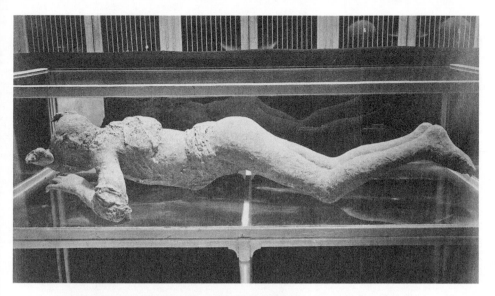

Fig. 38. Brogi 5576a. Victim No. 10, in museum case. (Side view.) (Collection of the author.)

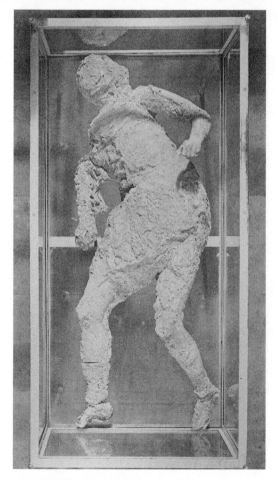

Fig. 39. Brogi 5577. Victim No. 4 ("The Pregnant Woman"). (Collection of the author.)

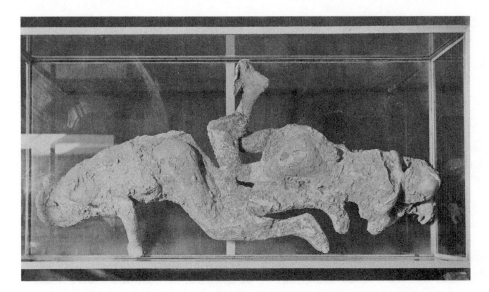

Fig. 40. Brogi 5578.
Victims Nos. 2 and
3, in museum case.
(Collection of the
author.)

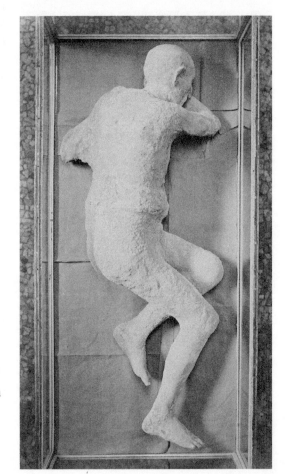

Fig. 41. Brogi 5579.
Victim No. 7, in museum
case. (Collection of the
author.)

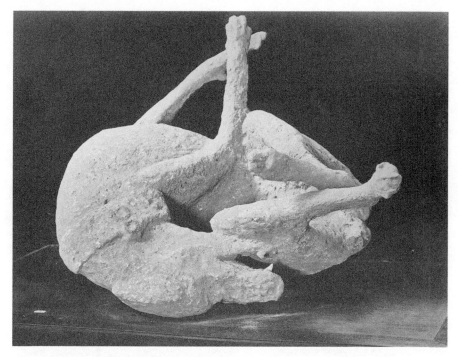

Fig. 42. Brogi 5580. Watchdog from the Casa di Orfeo (Victim No. 8), in museum case. (Collection of the author.)

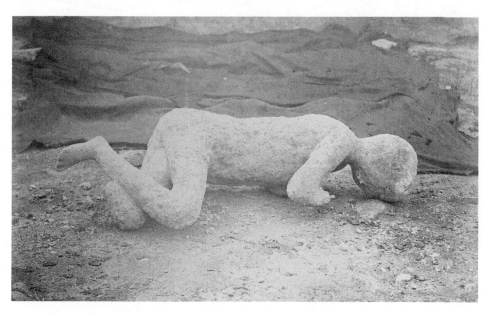

Fig. 43. Victim No. 11 (the Emaciated Child). (Photography by Giorgio Sommer. Collection of the author.)

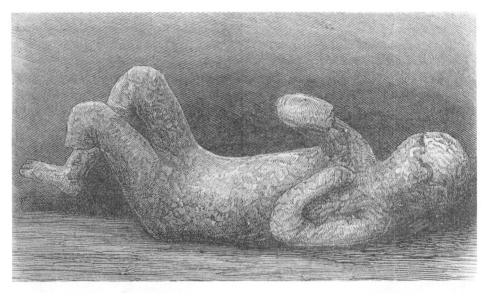

Fig. 44. Victim No. 11. Metal-cut illustration. (After *Illustrated London News.*)

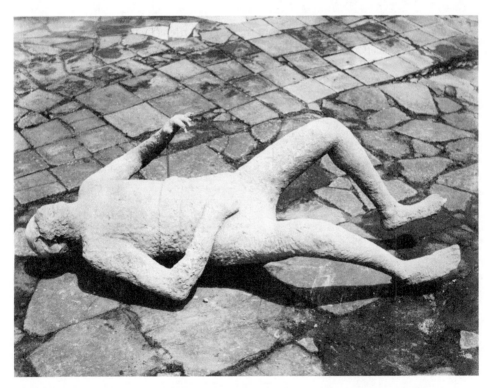

Fig. 45. Victim No. 12. (Photography by Giorgio Sommer. Collection of the author.)

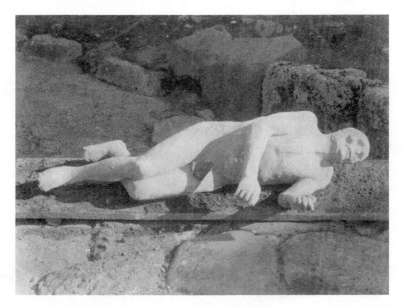

Fig. 46. Victim No. 13. (Photography by Fratelli Esposito. Courtesy of the Kelsey Museum of Archaeology.)

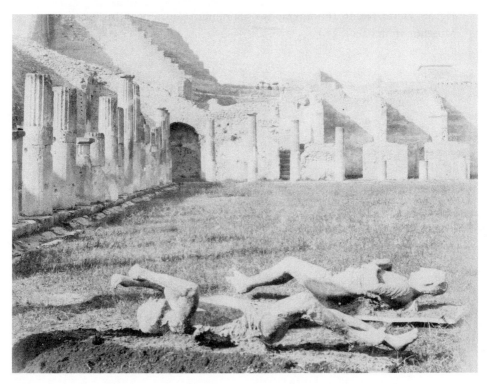

Fig. 47. Victims No. 15 (woman in foreground) and 14 (supine man).

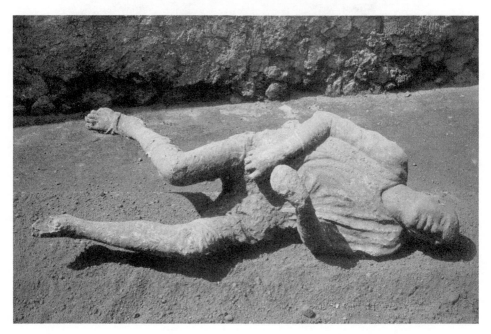

Fig. 48. Victim No. 16. (Photography by Sommer.) Courtesy of the Kelsey Museum of Archaeology.)

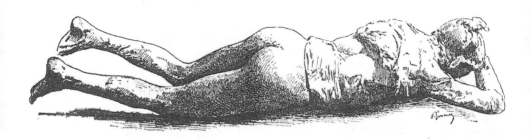

Fig. 49. Victim No. 10. (Drawing by Gusman [after L'Illustration, after Amodio].)

Appendix

Letter of Giuseppe Fiorelli to the *Giornale di Napoli* (12 February 1863, 3):

Scoverta Pompejana—Il Cav. *Fiorelli* ci comunica le seguenti interessanti notizie:

Il 3 corr., scavandosi nel vico che ha cominciamento di fronte ad una delle porte minori delle *Terme Stabiane,* e riesce presso l' edifizio di Eumachia, furono rinvenute all' altezza di cinque metri dal suolo, circa un centinaio di monete d' argento, quattro orecchini ed un piccolo anello di oro, con due chiavi di ferro ed alcuni avanzi del tessuto dentro cui erano involte le monete. Ricercando quella terra accuratamente perchè nulla sfuggisse di quel prezioso tesoretto, si giunse ad un punto dove la terra sfondando sotto la cazzuola, mostrò una cavità vuota e profonda tanto, da potervi introdurre un braccio e cavarne fuora delle ossa. Mi avvidi allora ch' era quella l' impressione di un corpo umano, e pensai che colandovi dentro prontamente la scagliola, si sarebbe ottenuto il rilievo della intiera persona. L' esito ha superato ogni mia aspettazione. Dopo alcuni giorni di arduo lavoro, ho avuto il contento di veder sorgere la intiera figura di un uomo, mancante solo di picciola parte del lato destro, involto in un mantello, con lunghi calzoni, ed i piedi chiusi in una specie di coturni, cui sono ancora aderenti i chiodi ed i ferri delle suole; la bocca aperta ed il ventre gonfio oltrè misura mostrano com' egli fosse morto soffocato dalle acque, e sepolto nel fango di cui lo trovai circondato.

Poco discosto da lui giacevano due donne, la sposa forse e la figliola, cui già appartennero quegli ori che ho depositati nel Museo Nazionale, cadute l' una accanto all' altra, la prima di età matura e la seconda giovanetta che non avea oltrepassati venti anni, le cui intiere persone serbate intatte con lo stesso mezzo della scagliola, offrono tuttavia visibili i lavori di trine e di lacci che ne ornavano le vesti e le scarpe.

Se avrò la sorte d' incontrare nuovi corpi fra le ceneri, meglio fornito di tutti i mezzi occorrenti alla buona riuscita di un' opera cotanto importante, i miei getti riusciranno più perfetti. Per ora mi è di grato compenso a gravissime fatiche, l' avere aperta la via ad ottenere una ignota classe di monumenti, per i quali l' archeologia non sarà più studiata nei marmi o nei bronzi, ma sopra i corpi stessi degli antichi, rapiti alla morte, dopo 18 secoli di oblio.

Notes

Preface

1. Moormann 2005; Fucini 1878, 57–58.

2. The terms *presence* and *inherence* were introduced by Freedberg 1989 and further developed by Maniura and Shepherd 2006 to denote viewers' perception of the thing represented within the representation. An "auto-icon" is, of course, Jeremy Bentham's term for his own statue, composed of his own body: a thing rather similar to one of Fiorelli's casts.

Chapter 1

1. A report, dated 10 February, was published in the *Times* of London on 19 February. The *Revue Archéologique,* published twice annually, carried an item from a correspondent in Naples dated 6 February citing a notice in the journal *l'Italie.*

2. Vasari credited Andrea Verrocchio with being the first to cast human body parts in plaster.

3. Settembrini 1863, 1.

4. De Franciscis 1975, 24: "The meeting of the great German archaeologist with the world of Neapolitan culture brought new nourishment to the latter and lifted the awareness and the appreciation of our antiquities to a more sophisticated level. It is precisely for this that Naples ought to be thankful to Winckelmann" (my translation). The other foreigner whose visit at about the same time was to have important consequences for Neapolitan archaeology and for the ruins of Pompeii in particular was the Austrian emperor Joseph II. See Corti 1951, 146–51.

5. The dead were even less evident in Herculaneum, as was known to Winckelmann for reasons that have only become apparent in our own time.

6. Winckelmann 1969, 1:55.

7. Winckelmann 1997, 75 (=ed. Eiselein, §22).

8. Ibid., 75 (= ed. Eiselein, §23).

9. Ibid., 74–75 (= ed. Eiselein, §19–22).

10. For a recent study of the human remains from the city of Pompeii, see De Carolis and Ciarallo 1998.

11. De Caro 1992, 3–21, "La scoperta, il santuario, la fortuna."

12. *PAH* 1.1.188–89 (10 May 1766): "Vicino alla mensa vi era uno scheletro di uomo, e sotto alla medesima varie ossa di pollo." (I omit the two skulls noted in the *Giornale* for 28 June 1765 [*PAH* 1.1.174].) From the circumstances of the discovery, it has usually been inferred that the priest had been dining on the chicken. The *Giornale degli* (or *dei*) *soprastanti*, or excavators' journal, was a brief account written daily at Pompeii and at the other excavation sites for the Interior Ministry in Naples. The reports for the period 1748–1860 were edited by Giuseppe Fiorelli in *PAH* and are the most authoritative record of the excavations for this period.

13. Latapie 1953, 232: "Dans une autre chambre voisine du principal lavoir on a trouvé un squelette avec une hache de cuivre et comme le mur d'à côté avait une brèche commencée, il n'est pas invraisemblable que c'étoit quelque sacrificateur qui n'ayant pu sortir du côté de la cour où les matières volcaniques étoient en trop grande abondance, avoit tenté de se faire jour du côté opposé."

14. For a summary of the controversy that developed, see Descoeudres 1993,165–78.

15. *PAH* 1.1.197 (20 December). The device is described in considerable detail.

16. Fiorelli 1875, 352, usually cautious and reliable, mentions two skeletons held in the stock.

17. Compare Gray 1830, 218, on objects to be seen in the Naples Museum, including "a pair of stocks, in which skeletons were found detained by the leg." Breton 1869, 159, notes that [at some point] a wooden copy of the stock had been made for exhibition at the site in Pompeii.

18. For the drawing, see Thomas 1952–55, 24. Marguerite Yourcenar, with due credit to Victor Hugo, analyzed Piranesi's taste for the bizarre in an essay, "The Dark Brain of Piranesi," written in 1959–61 and republished in English in a volume of essays under that title in 1984.

19. *PAH* 1.1.208 (20 June 1767): "nel mezzo della stanza . . . uno scheletro di uomo tutto intero, che resta rannicchiato a terra, cosa molto curiosa a vedersi."

20. *PAH* 1.1.211 (5 September 1767): "in questo sito fra il lapillo e la cenere si è trovato uno scheletro." The stratigraphy is typical for a *fuggiasco* who had survived until the final pyroclastic surge destroyed all remaining life in the city.

21. Leppmann 1970, 182–83.

22. *PAH* 1.1.217 (9 January 1767). It is not clear from the *Giornale* whether the thirty-four skeletons noted, ibid., 218 (16 April 1767), include this group of eighteen. It is clear, however, that a large number of persons had sought shelter in the immediate area.

23. Ciarallo and De Carolis 1999, 153 (no. 155). Ironically, the much despised Monsignor Ottavio Bajardi had correctly identified one of these *ghiri* from Herculaneum. See Bajardi 1755, 282–83 (DCCCLXIX). See also Lalande 1790, 6:105.

24. *PAH* 1.1.199 (20 December 1766). See also *PAH* 1.2.151 (30 December 1766).

25. Layard 1864, 165.

26. *PAH* 1.1.230: "Al che dicendogli che a poco a poco tutto si sarebbe fatto, l'Imperatore soggiunse, che questo era un lavoro da mettervisi tremila uomini."

27. *PAH* 1.1.230 (7 April 1768): "Dopo i Sovrani passarono ad osservare alcune stanze sottoposte, dove ancora si conserva uno scheletro intatto." The event is described by Corti 1951, 148, using the *Giornale* and a letter from the Emperor to the Empress Maria Theresa (Florence, 21 April 1769) in the Vienna State Archives as sources. Richardson 1988, 234–40, gives a careful description of the house, including the bakery-bath suite on the lowest level.

28. Bergeret de Grancourt 1948, 110–11, as cited by Caroselli and Rossen 1982, 2:279–80 (99). A drawing by Fragonard recorded the scene and was subsequently published by Saint-Non 1781–86. See *Pompei: Pitture e Mosaici* [vol. 1] 1995, 5–6 and 9 (fig. 9). The drawing is now in Lyons (Musée Lyonnais des Arts Décoratifs, no. 429). The engraving by Claude Fessard after Fragonard's drawing is reproduced in Trevelyan 1976, 48, fig. 29. Another drawing, by Pietro Fabris dated 1774, is in the collection of the Society of Antiquaries, London. See Jenkins and Sloan 1996, 43, fig. 16.

29. Mazois' version of the scene, which appeared as plate 34 of the second volume of *Les Ruines de Pompei*, departed somewhat from Fragonard's. In turn, Mazois served as model for later, less ambitious versions such as J. Overbeck 1856, 28, fig. 3; and Mau 1907, 346, fig. 177. Wilkins copied Fragonard more faithfully in details of the scene, costumes excepted.

30. Dupaty 1788, 383.

31. *Giornale degli scavi di Pompei* (12 December 1772). The text was published in *PAH* 1.3.268–69.

32. Beulé 1872, 180.

33. Dupaty 1788, 385.

34. Dupaty 1788, 320. The object—the other fifteen pieces having disappeared—was exhibited in the third room of the "Cumaean Collection" in the Naples Museum as recently as 1893. See Monaco 1893, 110–11. Maiuri, *Pompei ed Ercolano,* tried to solve the mystery of its disappearance during his time in the museum 1910–63. "For the last time, I searched for the breast of Arria Marcella in the cases, on the shelves, and in the ancient storerooms of the museum, . . . but every search was in vain. I found no notice of its disappearance in the old papers in the museum archives. Perhaps the registrar of the time did not think that the poor ashen form was worth filling out a de-acquisition form, as the regulations governing the inventories of the state's patrimony require for objects that have been worn out and are no longer of any use."

35. Lalande, *Voyage d'un Français en Italie* (edition of 1786) 7:556, cited in Grell 1982, 112. Chateaubriand's statement is from his *Oeuvres romanesques et voyages* 1969, 2:1783, 1474, and is cited by Hall 1999, 95 (n. 70, 318–21).

36. Bonucci 1827.

37. Moormann 2003, 20–25.

38. Gell 1852, 63. According to Moormann 2003, Gell was telling this story to English travelers as early as 1823.

39. Silliman 1853, 1:371. For an engraving of this strange object, see Gusman 1900, 19, fig.

40. D'Aloe 1853, 140, no. 2907.

41. Monaco 1893, 97, no. 5636.

42. See, for example, De Carolis and Patricelli 2003.

43. Something like this did happen to the watchdog in the House of Orpheus, who was, in fact, chained to his post.

44. Arditi's plan, or program, for the excavations was published by Fiorelli in *PAH* 1.2.177–87.

45. *PAH* 1.3.76 (11 January 1812): "Si è lavorato pure alla strada, che dalla porta della città deve condurre alla casa di campagna. In questa si è incontrato uno scheletro umano, da 4 in 5 pal. superiori al lastricato della medesima, e per quante diligenze siensi usate si è riconosciuto non aver cosa alcuna." For the precise location, 71.5 m from the Herculaneum Gate, see Kockel 1983, 47 (no. 4).

46. *PAH* 1.3.78–79 (1 February 1812).

47. *PAH* 1.3.81 (29 February 1812).

48. *PAH* 1.3.89 (18 July 1812): "Sopra lo strato del lapillo, per la medesima strada, si sono incontrati tre scheletri umani, ma accosto a questi nulla si è trovato."

49. At the end of October two skeletons, one a woman "of aristocratic proportions" ("di statura molto vantaggiata"), were found in the level above the lapilli in the escarpment in the Street of the Tombs. See *PAH* 1.3.97 (31 October 1812). From the *Giornale,* it appears that their excavation was deferred in anticipation of an approaching visit of Queen Caroline. When the excavation was eventually held in her presence on 21 November, the woman was found to be accompanied by several victims, one of whom was an infant. See *PAH* 1.3.98 (21 November): "Di seguito l'ho condotta all'altro scheletro, che le partecipai, ed in vece di uno se ne sono trovati quattro o cinque, fra'quali uno di fanciullo. Fra i medesimi si sono trovate pure delle monete di argento e bronzo, due pendenti con due perle per ciascuno, e tre anelli anche d'oro, due con pietre intagliate, ed altro formato da serpe." Rosenthal 1979 shows that the figures wear corresponding jewelry. Queen Caroline, who took great delight in such finds, took the jewelry with her when she left Pompeii. An addendum published by Fiorelli, *PAH* 1.3.258 (21 November), identifies the location of the discovery as "precisely under the porch of the 'osterie,' along the south side of the Street of Tombs." The site corresponds with Street of Tombs, "North" (or "East") 16–29a. See *CTP* V, 223. From the jewelry found with them, it was concluded that they were persons of quality.

50. Rosenthal 1979.

51. Ibid., 9.

52. Paris, Salon, 1827, no. 1823. The translation is by Rosenthal 1979, 3.

53. Franque was professor of painting from 1822 until his death in 1833. Bonucci was Architect-Director of excavations at Pompeii from 1827. The translation from Bonucci 1827, 67–68, is adapted from Gray 1830, 183. Cf. Overbeck 1856, 27.

54. Bechi in *RMB* II, "Relazione degli scavi di Pompei da febbraio 1824 a tutto dicembre 1826," 3.

55. Bonucci 1827, 102–3.

56. That there may have been some truth to this judgment, or at least a practical lesson to be taught in condemning the effort to retrieve valuables, may be read in the warning expressed in the admonitory inscription known as the "Epitaffio di Portici" affixed to the wall of a palazzo near Herculaneum following the disastrous eruption of 1631. A similar story is told of four female skeletons from the House of Pansa. See *PAH* 3.12 (19 May 1817). See also Gell 1824, 1:186; Etienne 1973, 56; Varone 2000, 302.

57. Such was the opinion of Etienne 1973, 56.

58. Bechi in *RMB* 2:4 (at end of volume). There is, of course, no way of knowing whether he was correct in his assessment of where the greatest danger lay.

59. Lippi 1816.

60. Fiorelli 1875, 118. Cf. *PAH* 2.218 (January–March 1829). The same finds were associated with a shop facing the House of the Dioscuri on the Street of Mercury, excavated on 22 January 1829. See *PAH* 3.94. See also Varone 2000, 302.

61. Gray 1830, 182.

62. *PAH* 1.3.203 (5 May 1818). See also *PAH* 3.14. Bonucci 1827, 151, claimed that here lay "the remains of two soldiers who had not been willing to abandon the post where they were perhaps standing guard. One had been crushed by the unforeseen collapse of a column." He then proceeded to create another fable, namely, that in the small prison in the same part of the Forum, its door closed by an iron gate, had been found the skeletal remains left behind by the flood that had afflicted Pompeii. This was debunked as a "poetic fiction" by Fiorelli 1875, 251.

63. Bulmer-Lytton 1834. This passage is from the afterword to the final chapter.

64. Supposedly, "Bulwer took away the skull with the permission of the authorities, and on his return to England placed it under a glass case in his study." See Clemens 1902–3, 490. See also Leppmann 1968, 129–36, and pl. 14a.

65. This statement, which is dated to 1834, can be found in the "Notes to Book V" reprinted in many editions of the novel.

66. Thus, Bulwer's heroes, Glaucus and Ione, find a ship with the help of the blind girl Nydia, and the principals in Gregorovius' *Euphorion* (1858) are saved by an Alexandrian merchant who had been lying in port. Gray's heroes, Lucius and Lucilla, die in the eruption.

67. Maiuri 1949, 33: "Nel 1881 si scavò un complesso di edifice, in cui si rinvennero degli scheletri di fuggiaschi, che colà si erano rifugiati nella vana speranza di trovar scampo sulle navi."

68. Gell was a corresponding member of the London Society of the Dilettanti and the Rome-based Instituto di Corrispondenza Archeologica. This did not, however, keep him from being out of touch with more progressive currents in European scholarship.

69. For example, Lippi's theory of the destruction of Pompeii by water, published in 1816, was "refuted" by Archangelo Scacchi in 1843 in an open letter addressed to another Neapolitan scholar. See Humboldt 1858, 429.

70. Cf., e.g., Gigante 1987; Ciarallo 2006.

71. For a concise history of the Neapolitan academies, see McIlwaine 1988, 1:507–10.

72. See Buttà 1877, 1:49–50, for the famous episode in which Charles discovered his Pompeian signet ring with his own hands.

73. Work was suspended from January through June in 1821 for lack of funds. See *PAH* 2.29–32; 3.26.

74. Cf., e.g., *PAH* 2.155–56.

75. For January–July 1821, see *PAH* 2.29–32. Work was suspended from July 1848 until 15 October 1849, when it was resumed in anticipation of the visit of Pope Pius IX on 22 October. Work was again suspended between 25 October 1849 and 26 September 1850. See *PAH* 2.482–85. Work was again suspended from the beginning of December 1859 until 15 December 1860, when it began again under Fiorelli's direction.

76. For a concise summary history of the papyri, see McIlwaine 1988, 1:64–81 and 2:751–99. For *Le Antichità di Ercolano*, see McIlwaine 1988, no. 8.31.

77. McIlwaine 1988, no. 4.99.

78. The second edition of Overbeck 1866 bears a dedication to Giuseppe Fiorelli.

79. Helbig 1868. The author dedicated his work to Giuseppe Fiorelli.

80. Wickert 1959–80, 2:136.

81. A good biography of Fiorelli does not exist. Brief autobiographical notes were published in Fiorelli 1994 and in his own legal defense argument, "Sulle imputazioni addebitate a Giuseppe Fiorelli, Ispettore degli Scavi di Pompei (arrestato a'24 aprile 1849)." It has been photostatically reprinted in Vander Poel and Poli Capri 1994, 1:XLVIII–XCVI. Fiorelli's writings have been collected in Palumbo 1913 and García y García 1998, 1:493–504. See also De Caro and Guzzo 1999.

82. Fiorelli, "Sulle imputazioni addebitate," 1 (see note 81 to this chap.).

83. This information, which may be biased, comes from Fiorelli, "Sulle imputazioni addebitate" (see n. 81 to this chap.)

84. Fiorelli 1850. See García y García 1998, 1:494–96, no. 5266.

85. Part of Leopold's (i.e., Fiorelli's) letter to Francis is quoted in Acton 1961, 475–77.

86. Fiorelli 1994, 92.

87. See Acton 1961, 175–78.

88. For this period, see Pagano 1991–92, 188–89.

89. This fact is announced and the principle explained by Giovambattista Finati, *RMB* XV, "Relazione degli scavi di Pompei da marzo 1852 a dicembre 1855," 1–2 ("lodevole metodo adottato dall'attuale amministrazione"). Typical of those who credited Fiorelli with this innovation is Lagrèze 1872, 68.

90. Two systems were apparently in use at the same time, namely, the French system under which the hours began at midnight and run through noon before

repeating themselves and the Italian system under which the hours began at sunset and ran through twenty-four until sunset of the next day. Cf. the *Giornale* entries for 5 May 1845 ("di Francia" *PAH* 2: 439) and 12 March 1847 ("italiane" *PAH* 2.458). According to the latter entry, they worked an eleven-hour day, beginning at sunrise.

91. Fiorelli 1858. For an appreciation of this work, see De Angelis 1993, 6–16. Fiorelli's system was probably prompted by an earlier attempt to introduce an entry-numbering system by Domenico Spinelli, Principe di Sangiorgio, who was Soprintendente Generale from 1850 to 1863. See Vander Poel, *CTP* V, 505–10.

92. See Snowden 1995.

93. Pagano 1994, 412.

94. "Cenno notomico patologico sulle ossa umane scavate in Pompei" in Minervini 1854.

95. *PAH* 2.620 (16 October 1855).

96. Ivanoff 1859.

97. Ivanoff must be referring to the same "Small Museum" (Piccolo Museo) that is described by Pagano 1873, 77–80, though the cast was no longer there when Pagano described its contents. The museum had been made in the crypt of the Temple of Fortuna Augusta, cleared in January 1859. (See *PAH* 2.675.) It was entered by means of a stairway originating in one of three small rooms adjacent to the temple on its south flank. See Fiorelli 1875, 212 (VII.4.2: "Area privata M. Tulli").

98. Fiorelli 1861, 9–12 and pl. II.

99. *PAH* 2:688. The entry concludes: "—Fiorelli."

100. VIII iv 1, according to his own system.

101. Breton 1869, 467: "Fiorelli a pu faire mouler la partie inférieure de l'une de ces portes sur l'empreinte qu'elle avait laisée et nous la reproduisons plus loin d'après le dessin dont il a accompagné la savante description de la taberna offectoris." Brunn, who correctly noted Ivanoff's publication, stated simply that the observation of the cavities left in the layer of solidified ash by organic matter that had decayed had been made "some years back" and the experiment with casting some wooden shop doors had turned out well. See Brunn 1863, 88.

102. Fiorelli's effort to denote the precise location makes it clear why he considered the new referencing system necessary.

103. *PAH* 2.678.

104. Pagano 1991–92, 189.

105. Pagano 1991–92, n. 65, cites the letter, dated 25 November 1856, in the

"Archivio di stato di Napoli, Min. Pubblica Istruzione, FS. 317/1." On the ceramicist Carlo De Simone, see Barnabei 1991, 165, n. 42.

106. Cf. *PAH* 2.641–42. Work was concentrated in the court of the "new" Stabian Baths, just across the street from the "Taberna Offectoris."

107. He remained Soprintendente generale degli Scavi until his death in April 1863. This is not, however, the last time that Fiorelli was to ignore him. He neglected to inform his superior of the discovery that forms the material of the next chapter until he had announced it to the world.

108. Fiorelli 1875, 331–32.

Chapter 2

1. Layard 1864, 175.

2. In his topographical analysis of the excavation, Giuseppe Fiorelli 1861, 17, wrote: "In the tablinum, about a meter from the floor level, was the skeleton of a woman caught in her flight with as much of her precious possessions as she was able to gather up from the darkness of that unforeseen night, among which were her *mundus muliebris,* encased in a wooden chest," including a necklace made up of amulets, a lamp, and some other small things.

3. *PAH* 2.248 (Jan.–June 1831).

4. Taine 1872, 54.

5. The *Giornale degli scavi* begins to record the discovery of human bones as a separate category of finds toward the end of the 1850s. Beginning in September 1858 and continuing into 1859, the recorded human bones, esp. skulls, are each said to have been sent to the secure storage in the so-called "Temple of Mercury."

6. Fiorelli 1861, 8.

7. Previously, the excavations had been conducted locally under an Architect-Director, often with interventions from Soprantendente Generale and by the Minister of the Interior himself. The custom of conducting special excavations for the benefit of visiting dignitaries was still very much alive. Under Fiorelli the excavations followed a more organic plan.

8. *PAH* 2:688.

9. In an 1858 paper, Fiorelli divided Pompeii into nine zones or "Regions," based on a quincunx diagram.

10. Dyer 1875, 447.

11. Breton 1869, 461.

12. Overbeck 1866, 268.

13. It would be interesting to know when the use of plaster of paris (and gesso, which involves the addition of glue) became a standard tool of the excavators at Pompeii. The English architect Edward Falkener (1860, 49) used plaster of paris to cast the impressions of glass bottles in wicker matrices in his excavations in the House of Marcus Lucretius in March 1847.

14. The index was never completed, but its function was at least partially fulfilled by Fiorelli's *Descrizione di Pompei* (Naples 1875).

15. For a number of reasons, some obvious and some not so obvious, Fiorelli's rise in the world of Italian scholarship was not so meteoric. Envy was, of course, one factor, but other, more legitimate, factors must be considered.

16. Fiorelli published the contracts, which run forty pages, in his new publication *Giornale degli scavi di Pompei* I (1861): 121–60.

17. Strangely enough, an Italian wishing to study the topography of Pompeii as late as 1872 was advised to read foreign authors. Antonio Sogliano, preparing to visit Pompeii, was so advised by Giulio de Petra himself. See Sogliano 1939, 334.

18. Fiorelli 1994, 95.

19. Fiorelli identified the subject of the statuette (now in the Naples Archaeological Museum) as Narcissus, whence its popular nickname "Il Narciso." A lithographic plate of the statuette was used by Overbeck (1866, 1875) as frontispiece.

20. Brunn 1863, 87–90.

21. Three items appeared as a group in a recent exhibition organized by the Soprintendenza Archeologica di Pompei. See Guzzo 2003, 103–5, figs. 1–3.

22. "Nouvelles Archéologique," *Revue Archéologique,* 2nd ser., 7–8 (1863): 210–11.

23. This amusing exchange of letters from the archives of the Ministero della Pubblica Istruzione can be found in Poli Capri 1996, 2:129 and 134–35.

24. Gregorovius 1911, 211–12 (15 August 1864).

25. Goldsmidt 1863, 286–88.

26. Overbeck 1866, 32–34.

27. Brunn 1863, 87–90.

28. Howells 1988, 67–68.

29. Bascle de Lagrèze 1872, 1:68–69.

30. Dana 1863.

31. Howells 1988, 67.

32. See Fiorelli 1877, 89, no. 38.

33. Gregorovius 1911, 211–12 (15 August 1864).

34. Or two iron rings, according to Beulé.

35. Angelini made his proposal in a letter addressed to the Minister of Public Instruction (16 January 1865) and now in the Archivio dello stato in Rome. A transcription of Angelini's letter, which details his plans for copying the figures in clay in Pompeii before completing the work in marble in his studio in Naples, has been published in Vander Poel and Poli Capri 1994, 7:X–XIV.

36. Whence, "donna gravida," as she was sometimes referred to by the writers of guidebooks and the makers of postcards.

37. As a student, Luca Beltrami assisted in transporting the casts from the House of the Cadavers of Gesso to their new home in the museum at the Porta Marina. See Beltrami 1927. The article has been reprinted in Fiorelli 1994, 161–72.

38. Neville-Rolfe 1888, 82–87.

39. See Maiuri *Pompei ed Ercolano,* 195–203 ("Pompei e la Guerra").

40. Overbeck (1875), plate facing p. 44 ("Ansicht des Modells eines Theiles der Stadt"), shows the location in which this photograph and those of victims nos. 1–4 by Amodio were made to have been an elevated terrace commanding a view north along the Vicolo Modesto, with Vesuvius in the background. Most likely, this series of photographs was made before the casts were installed in cases in the House of the Cadavers of Gesso.

41. Francesco Morlicchio [1901]. See García y García 1998, 2:839, nos. 9627–28.

Chapter 3

1. Fiorelli's thoughts on the purpose of the excavations at Pompeii, offered in numerous passages throughout his works, have been eloquently condensed and summarized in Boissier 1896, 337–38.

2. Fiorelli 1867, 57.

3. Compare, for example, the observations of Augustus Goldsmidt (1863).

4. De Angelis 1993, 6–16, has argued that Fiorelli in effect changed from an antiquarian into a historian in the course of his career, but the "antiquarian perspective" never completely absented itself from Fiorelli's projects.

5. Fiorelli 1875, 23. This passage is cited by De Angelis 1993, 13.

6. Paradigmatic, if not diametric, opposition of the two modes of classical studies was traced by Momigliano 1950, 285–315. Where history was considered

a literary pursuit and its advocates self-identified as "Ancients," antiquarian studies and collectors of "curiosities"generally were more in the emerging scientific vein and are, therefore, described as "Moderns." See Vallet 1998, 11–28.

7. Bernard de Montfaucon's *Antiquité expliquée et representée en figures*, published in 1719 in ten folio volumes, quickly became a standard work among antiquarians. See Stark 1880, 143–46. Monsignor Ottavio Antonio Bajardi readily acknowledged his indebtedness to Montfaucon's method in his own unsuccessful attempt to catalog King Charles's collection, *Catalogo degli antichi monumenti dissotterrati dalla discoperta città di Ercolano* (Naples 1754, 1755), xxi.

8. Curti 1872, 1:161, and 3:371–82, recalls Chateaubriand's plan. The renewal of open-air excavations in Herculaneum, finally achieved in 1927 under Amedeo Maiuri after several earlier false starts, had been proposed as a conservation measure by Fiorelli and his colleagues, as well as by the foreigners Beulé and Waldstein. See Waldstein, 1910, 218.

9. "Fiorelli passed the greater part of his life organizing the coins of the National Museum in Naples." See Barnabei 1991, 102 and 140 (this passage).

10. Many decorative marble sculptures shipped to the Naples Museum from Pompeii were stored in the Cabinet of Venus Callipygia, which had been closed under King Francis I in 1828 on moral grounds.

11. This building, located on the east side of the Forum, appears to have been used as a deposit as early as 3 May 1837. See *PAH* 2.336.

12. The collections of the Royal Bourbonic Museum (and later the National Archaeological Museum) were separately administered by curators, who had the power to admit visitors and to charge an admission fee.

13. Beulé 1872, 195–96.

14. For the attribution of Vico's statue to Leopold, see Barnabei 1991, 41 and n. 21.

15. Fiorelli 1994, 80–81.

16. Bascle de Lagrèze 1872, 1:68–69.

17. Some observers assumed incorrectly that the casts would be sent to Naples. Compare the early report in the journal *Il Diritto* (not cited here) and Davenport Adams 1873, 265 ("You may see them now in the Museum at Naples [*sic*]").

18. An interesting precedent for this practice was the House of Marcus Lucretius, excavated in 1847. In that case, credit for the idea was claimed by the English architect Edward Falkener, though the decision must have been made higher up. See Falkener 1860, 38.

19. Overbeck 1866, 34. Overbeck had little use for sentimentality in his own

history, as he added cattily: "Sentimental observations and descriptions, for which the present corpse-forms provide adequate opportunity, I leave to the choice of the reader, who might find support in the work of Marc Monnier."

20. Brunn 1863, 87–90.

21. Fiorelli 1873, 172: "Avanzi organici."

22. Vander Poel and Poli Capri 1994, 8:17–18.

23. *Giornale degli scavi di Pompei*, n.s., 1 (1868): 20. De Carolis-Patricelli-Ciarallo 1998, 105, "Rinvenimenti nella cenere," no. 153.

24. Giornale degli scavi, n.s., 2 (4 March 1871): 281.

25. A plate made after Sommer's photograph represented the victims of Pompeii in Engelmann's sixth edition of Guhl and Koner 1893, fig. 881.

26. Fiorelli's description may be found below in his guide to the Pompeian Museum (no. 37).

27. Davenport Adams 1873, 263: "The ruins of Pompeii are now entered at two points, by the Street of the Tombs, and by the gate leading to the Forum [i.e., by the Porta Marina]. Every visitor pays a fee of two francs, and, in return, is furnished with a plan of the excavations and a guide."

28. Excavation of the vaults utilized by the new museum began in March 1863, which suggests that Fiorelli may have envisioned their use for that purpose at that early date. See Vander Poel and Poli Capri 1994, IV, 55–56.

29. The area (I.5.2/3), which seems to have been used as a tannery, has been called the "Conceria" or the "Officina coriarum of M. Vesonius Primus." See Della Corte 1965, nos. 563–64; De Carolis-Patricelli-Ciarallo 1998, 99, "Rinvenimenti nella cenere," no. 47.

30. I have taken the title from the caption of a contemporary photograph by Amodio.

31. Gregorovius, *Euphorion: Eine Dichtung aus Pompeji*, 2nd ed. (Leipzig: F. A. Brockhaus, 1884), 100 ("Anmerkungen"): "Thus he captured the unfortunates and the moment, even the expression of death as sculptural expression. Whoever beholds these most noteworthy of all statues that the world possesses considers them not without deep emotion. For what once only the fantasy that a poet might have conjured up, he has in full-blown reality in front of him, and as evidence of the moment itself."

32. Evidence for the use of watchdogs at the front door of the house is abundant in Pompeii, ranging from floor mosaics to skeletal remains. For the bones of a dog found in House of Siricus, see Dyer 1875, 463, top of page. A dog may have been the only victim to have survived the eruption, if the story told about the victims in the House of the Vestals is correct. See, e.g., Bascle de Lagrèze

1872, 68. For a Bowdlerized version (which was used by Bulwer-Lytton), see Bonucci 1827.

33. The casts were represented in the exhibition by copies. See Ward-Perkins and Claridge 1976, catalog nos. 21 (the watchdog) and 22 (the woman). According to the catalog authors, the originals remained in the Pompeii Antiquarium.

34. De Carolis-Patricelli-Ciarallo 1998, 105, "Rinvenimenti nella cenere," no. 148.

35. E.g., Yusef Komunyakaa, "Body of a Woman (*Cadavere di Donna*)," in *Talking Dirty to the Gods* 2000, 42. I am grateful to Angela Salas for bringing this poem to my attention. Komunyakaa also included "Body of a Dog" (*Cadavere di un Cane*) in the same collection (8).

36. The findspot here and in the other entries refer to the map of Pompeii published in Fiorelli 1875.

37. Cesira Pozzolini-Siciliani 1879, 60–87, esp. 80–81.

38. Actually, on the right.

39. Herchenbach 1877, 82–83. Cf. also the reaction of the young artist and traveler, Marie Bashkirtseff: "The skeletons are frightful; the poor things are in shocking attitudes." See Bashkirtseff 1889, pt. 1, 116 (entry for 18 April 1876).

40. Bartolo Longo, a Neapolitan lawyer, the founder of this extraordinary cult, which has now spread throughout the world, had been by his own admission "a priest of Satan."

41. Pompeii was also able to satisfy another category that bordered on bad taste, namely, the risqué. Perhaps unsurprisingly, Fiorelli at first championed the opening of previously "reserved" collections such as the "Pornographic Collection" in the Naples Archaeological Museum.

42. Werge 1868, 427–28.

43. Ibid.

44. According to the Brogi numbering system, at the time the photographs were made, the cast of the watchdog appears to have been in its original position in Room III. With the discovery of the emaciated child in 1882 and the entry of that cast into the museum, the watchdog took up its new position flanking the door in Room II and thus would have been out of sequence with the original numbers.

45. The scaffolding can be seen clearly in fig. 40 (Brogi 5578). Reflected light, indicating that the glass has not been removed for the photograph, can also be seen in this image.

46. This view may be found on picture postcards, which were not introduced until twenty years later.

47. De Carolis-Patricelli-Ciarallo 1998, 107, "Rinvenimenti nella cenere," no. 191.

48. *NSc* 10 (1881–82): 45–46 (24 January 1882).

49. Anonymous 1882, 230.

50. Mau in Overbeck, 1884, 127.

51. Forbes 1886, 50–52.

52. Neville-Rolfe 1888, 83–84 (from a description of the museum).

53. De Carolis-Patricelli-Ciarallo 1998, 106, "Rinvenimenti nella cenere," no. 178.

54. Letter of M. Ruggiero to the Minister of Public Instruction, Naples, 3 January 1883, Rome, Archivio dello stato. The text is translated from the transcription published by Poli Capri 1996, 820–21.

55. The top and back of his skull and the fingertips of his left hand failed to cast because of exposure to the lapilli.

56. *NSc* 10 (1881–82): 606 (28 December 1882).

57. Forbes 1886, 50.

58. Neville-Rolfe, 1888, 87 (from a description of the museum). See also Mau 1884, 135.

59. Long after his death, he was accused by Adolfo Venturi, who had worked under him in the Belle Arti as a young man, of being actually subservient to the Germans. Venturi made this charge, and even attempted to cast doubt upon Fiorelli's claim to having invented the Pompeian casts, in his *Memorie* (Milan 1911). Many archaeologists came to Fiorelli's defense. For the controversy provoked by Venturi, see Beltrami 1927, reprinted in Fiorelli 1994, 167–72.

60. The exchange of letters, including Ruggiero's full accounting of the expenditures, is transcribed from copies in the Archivio di stato in Poli Capri 1998, 361–67. The copies were made by d'Orsi in terracotta and do not seem to have survived the war.

61. See Baedeker 1891, 95.

62. Fiorelli instructed Ruggiero to see that no copies were made for commercial exploitation.

63. Poli Capri 1996, 1171–72.

64. Ibid., 1173.

65. *NSc* 1889, 369 (11 October 1889).

66. Poli Capri 1996, 1181–82 (22 November 1889).

67. Poli Capri 1996, 1181–82.

68. Although absent from Morlicchio's guide [1901], plaster casts of tree trunks, no doubt including the *Laurus notabilis,* were added to the first room of the museum. See, e.g., Engelmann 1925, 191; Maiuri 1931, 84.

69. *NSc* 1889, 407.

70. *NSc* 1890, 128.

71. Ruggiero wrote to the Minister of Public Instruction (Fiorelli's superior): "I must not omit to commend to your Excellency's attention for an appropriate reward the names of the artisans Alfonso Davino and Vincenzo Bramante, to whose diligence and skill it is owing that such miraculous resurrection finds competent executors in continuing fully the ingenious idea of the illustrious Senator Fiorelli. A word of praise is due also to the Soprastante, Signor Seffoni, who never failed to assist in person at the most important and delicate operations of the excavation. I omit to mention Signor Inspector Professor Sogliano and Engineer Cozzi, to whose careful attention are owed in large part these most important discoveries." See Poli Capri 1996, 1188–90 (M. Ruggiero to M.P.I., Naples, 18 April 1890).

72. Engelmann 1925, 192.

73. Maiuri 1931, 84–85.

74. Brogi 5578. Pompei. (Museo.)

75. Gusman 1900, 13–21.

76. Ibid., 14, fig. (A). This figure can be seen in a supine (i.e., incorrectly inverted) position in its museum case in a photograph by Anderson (26540, Pompei).

77. Gusman also copied Sommer's photographs of the man from the Strada Stabiana (fig. 26 and its derivative, fig. 27) and the "emaciated boy" (fig. 43) and possibly that of the heavily clothed man (fig. 48). He does not seem to have made any views of his own directly from the casts.

78. Gusman 1900, 16–17.

79. Morlicchio [1901].

80. Morlicchio [1901], 8–11. I have corrected a number of typographical errors and also a few errors that appear to belong to the author. The latter regularly uses the word *model* (which I have retained) for *cast* or *mould.*

81. Mau 1899, 1907.

82. Mau 1907, 22–23.

83. It is clear that Fiorelli and Neville-Rolfe, in the excerpts from their museum guides printed in the text, regarded the leather belt found on several of the victims as a sign of slave status. This opinion is repeated by "F. and A. M."

in their *Illustrated Guide of Pompei Ruins* (Scafati: Rinascimento, 1943, 8): "Noticeable are those wearing leather belts, which denotes their having been slaves." Warsher 1930, 37, in an apparent reference to the cast of the "sick man" (no. 7), wrote: "We may notice a gladiator with his characteristic belt, who died quietly yielding to the inevitable."

Epilogue

1. Maiuri, *Pompei ed Ercolano fra case e abitanti* (1958), 196.

2. Ibid.

3. Mau 1928, 86–87.

4. Mau 1899, 356.

5. This period is surveyed from two different points of view in Sogliano 1904, 315–16, and Maiuri 1950, 1:9–40 ("Gli Scavi di Pompei dal 1879 al 1948").

6. Eulogies of Fiorelli (e.g., Mommsen's, published in the *Römische Mitteilungen*) noted his most important contributions as bringing order to the excavations of Pompeii and to the Naples Museum and starting the publication of *Notizie degli Scavi*.

7. In addition to problematic relationships with France; Germany; and, in particular, Austria, Italy was embroiled in a disastrous war in Ethiopia.

8. On the subject of archaeological patrimony ("la tutela") and the new government, see F. Barnabei 1991, III, n. 8 and passim.

9. Benedetto Croce, "Due parole al sig. prof. Ettore Pais," *Napoli Nobilissima* 12 (1903): 17.

10. This triple honor had eluded even Fiorelli, who was obliged to relinquish his university position when he accepted the positions of Soprintendente Generale and Director of the Naples Museum. Amedeo Maiuri and his successor Alfonso de Franciscis later held the three appointments simultaneously.

11. I.e., *Corpus Inscriptionum Latinarum,* vol. 5, supp.

12. Croce 1904, 92–94. Many of the relevant texts have been surveyed in McIlwaine, 1988, II, 532–36.

13. Pais did not hesitate to criticize de Petra and Sogliano for their role in refusing to purchase for the Naples Museum the "Tegola di Capoua," a long Etruscan inscription found in Capua in 1898 and subsequently "lost" to Berlin. Pais's attack appeared as "Excursus II" in his book *Ancient Legends of Roman History* (Chicago, 1905), written and published in the United States in the year following his dismissal. In addition to criticizing their judgment in the affair, Pais meant to draw attention to their failure to defend the patrimony once more.

14. This inference is based on two sources, namely, Pais's own stated "Reforms" (no. XXXVII) and the report of the commission of inquiry that ruled in his favor. See Pais 1903, 14, and 1917, 11.

15. *NSc* 1914, 228, 260–63, 365; De Carolis-Patricelli-Ciarallo 1998, 99: "Rinvenimenti nella cenere," nos. 50–52.

16. *NSc* 1914, 262.

17. Ibid., 262–63. The strange note on which this passage ends refers to the tenderness displayed by the group of two figures embracing at the right in the photograph.

18. See Maiuri, *Vita d'Archeologo* (1958), 19–20. Maiuri was soon tested by an act of vandalism to the Naples Museum's most valuable object, the Tazza Farnese, but he had it repaired and found the means of dealing with potential enemies.

19. Ibid.

20. See Maiuri 1948.

21. Maiuri 1951, 95. See also Guzzo 2003, 143 and 146 (fig. 6).

22. Maiuri, *Pompei ed Ercolano fra case e abitanti* (1958), 83–88 ("Le vittime di Porta Nocera"), esp. 86.

23. Maiuri, *Pompei ed Ercolano fra case e abitanti* (1958), 89–91 ("L'ultimo mendìco di Pompei").

24. See De Carolis-Patricelli-Ciarallo 1998, 99, "Rinvenimenti nella cenere," 78–79

25. See Cicchitti 1993.

26. I would like to express my thanks for her generous assistance to Robin Meador-Woodruff, who curated the exhibition when it visited the Birmingham Museum of Art, December–January 2007-8.

27. See Guzzo 2003, 103–5.

Bibliography

Abbreviations

CTP RICA group (Research in Campanian Archaeology: Halsted Billings Van-
 der Poel, Armando La Porta, Laurentino García y García). *Corpus Topo-*
 graphicum Pompeianum. Pars 2, *Toponymy.* Rome 1983. Pars 5, *Cartography.*
 Rome, 1981.
NSc *Atti della (reale) accademia (nazionale) dei Lincei. Notizie degli scavi di anti-*
 chità. Rome, 1876–.
PAH Giuseppe Fiorelli, ed. *Pompeianarum Antiquitatum Historia.* 3 vols. Naples,
 1860–64.
RMB *Real Museo Borbonico.* 16 vols. Naples: Stamperia Reale, 1824–57.

Articles and Monographs

Acton, Harold. *The Last Bourbons of Naples.* London, 1961.
Anonymous. "A Child of Pompeii," *Illustrated London News,* 80, no. 2236 (11
 March 1882): 228, fig., and 230.
Anonymous. "Les dernières fouilles de Pompéi." *L'Illustration* no. 1694 (14 Au-
 gust 1875): 101.
Baedeker, Karl. *Berlin und Umgebungen.* 7th ed. Leipzig, 1891.
Bajardi, Ottavio Antonio. *Catalogo degli antichi monumenti dissotterrati dalla dis-*
 coperta città di Ercolano. Naples: Regia Stampería, 1755.
Barnabei, Felice. *Le "Memorie di un Archeologo."* Edited by Margherita Barnabei
 and Filippo Delpino. Rome: De Luca, 1991.
Bascle de Lagrèze, Gustave. *Pompéi, Les Catacombes, L'Alhambra.* 2 vols. Paris:
 Firmin-Didot, 1872.

Bashkirtseff, Marie. *The Journal of Marie Bashkirtseff.* Translated by A. D. Hall. Chicago, 1889.

Bechi, Guglielmo. "Relazione degli scavi di Pompei da febbraio 1824 a tutto dicembre 1826." In *RMB,* 2:1–11 (at end of volume).

Beltrami, Luca. "Si riparla di Giuseppe Fiorelli." *Il Marzocco* 32, no. 23 (5 June 1927). Reprinted in Giuseppe Fiorelli, *Appunti autobiografici,* ed. Stefano De Caro (Sorrento, 1994), 161–72.

Bergeret de Grancourt, Pierre Jacques Onésme. *Voyage d'Italie, 1773–1774 avec les dessins de Fragonard.* Edited by J. Wilhelm. Paris, 1948.

Beulé, Charles-Ernest. *Le Drame du Vésuve.* 2nd ed. Paris: Michel Lévy Frères, 1872.

Blix, Göran. *From Paris to Pompeii: French Romanticism and the Cultural Politics of Archaeology.* Philadelphia: University of Pennsylvania Press, 2008.

Boissier, Gaston. *Rome and Pompeii: Archaeological Rambles.* Translated by D. Havelock Fisher. New York, 1896.

Bonucci, Carlo. *Pompei descritta.* 3rd ed. Naples: R. Miranda, 1827.

Breton, Ernest. *Pompeia.* 2nd ed. Paris: Gide et Baudry, 1855.

Breton, Ernest. *Pompeia.* 3rd ed. Paris: L. Guérin, 1869.

Brunn, Heinrich. "Scavi di Pompei, Cuma e Pesto." *Bullettino dell'Instituto di Corrispondenza Archeologica* (May–June 1863): 86–107.

Bulwer-Lytton, Edward. *The Last Days of Pompeii.* London: R. Bentley, 1834.

Buttà, Giuseppe. *I Borboni di Napoli.* 3 vols. Naples, 1877.

Caroselli, Susan L., and Susan F. Rossen, eds. *The Golden Age of Naples: Art and Civilization under the Bourbons, 1734–1805.* 2 vols. Detroit: Detroit Institute of Arts, 1982.

Chateaubriand, François-René. *Voyages en Amérique et en Italie.* Paris: Librairie Ladvocat, 1827.

Chateaubriand, François-René. *Oeuvres romanesques et voyages.* 2 vols. Paris, 1969.

Ciarallo, Annamaria. *Scienzati a Pompei tra settecento e ottocento.* Rome, 2006.

Ciarallo, Annamaria, and Ernesto De Carolis, eds. *Homo Faber: Natura, scienza, e tecnica nell'antica Pompei.* Naples, 1999.

Cicchitti, Amedeo. *Il primo calco trasparente.* L'Aquila, 1993.

Clemens, Will M. "Some Real People in Fiction." *Bookman* 16 (August 1902–February 1903): 486–91.

Corti, Egon Cesar. *The Destruction and Resurrection of Pompeii and Herculaneum.* Translated by K. Smith and R. Gregor Smith. London: Routledge and Kegan Paul, 1951.

Croce, Benedetto. "Pel Museo di Napoli." *Napoli Nobilissima* 13 (1904): 92–94.

Curti, Pier Ambrogio. *Pompei e le sue rovine.* Milan/Naples, 1872.

D'Aloe, Stanislao. *Nouveau guide du Musée Royal Bourbon.* Naples, 1853.

Dana, William B. "The Dead of Pompeii Exhumed—The Recent Remarkable Discoveries in the Buried City." *Merchants' Magazine and Commercial Review* 48, no. 6 (June 1863): 501–2.

Davenport Adams, W. H. *The Buried Cities of Campania.* London: T. Nelson and Sons, 1873.

De Angelis, Francesco. "Giuseppe Fiorelli: La 'vecchia' antiquaria di fronte allo scavo." *Ricerche di storia dell'arte* 50 (1993): 6–16.

De Caro, Stefano, ed. *Alla ricerca di Iside: Analisi, studi, e restauri dell'Iseo pompeiano nel Museo di Napoli.* Rome: Arti, 1992.

De Caro, Stefano, and Pier Giovanni Guzzo, eds. *A Giuseppe Fiorelli, nel primo centenario della morte.* Naples, 1999.

De Carolis, Ernesto, Giovanni Patricelli, and Annamaria Ciarallo. "Rinvenimenti di corpi umani nell'area urbana di Pompei." *Rivista di Studi Pompeiani* 9 (1998): 75–123.

De Carolis, Ernesto, and Giovanni Patricelli. *Vesuvius A.D. 79: The Destruction of Pompeii and Herculaneum.* Los Angeles: Getty Museum, 2003.

De Franciscis, Alfonso. "L'esperienza napoletana del Winckelmann." *Cronache Pompeiane* 1 (1975): 7–24.

Della Corte, Matteo. *Case ed abitanti di Pompei.* 3rd ed. Naples: Fausto Fiorentino, 1965.

Descoeudres, Jean-Paul. "Did Some Pompeians Return to Their City after the Eruption of Mt. Vesuvius in AD 79?" In *Ercolano 1738–1988: 250 anni di ricerca archeologica (Atti del Convegno Internazionale Ravello-Ercolano-Napoli-Pompei, 30 ottobre–5 novembre 1988),* edited by Luisa Franchi dell'Orto, 165–78. Rome: "L'ERMA" di Bretschneider, 1993.

Dupaty, Charles-Marguerite-Jean-Baptiste Mercier. *Travels through Italy, in a Series of Letters; Written in the Year 1785, by President Dupaty. Translated from the French by an English Gentleman.* London: G. G. J. and J. Robinson, 1788.

Dyer, Thomas Henry. *Pompeii.* Rev. ed. London: G. Bell, 1875.

Engelmann, Wilhelm. *New Guide to Pompeii.* Leipzig, 1925.

Etienne, Robert. "Die letzten Stunden der Stadt Pompeji." *Pompeji: Leben und Kunst in den Vesuvstädten* (1973): 53–58.

"F. and A. M." [?]. *Illustrated Guide of Pompei Ruins.* Scafati: Rinascimento, 1943.

Falkener, Edward. "Report on a House at Pompeii." In *The Museum of Classical Antiquities,* rev. ed., 34–89. London, 1860.

Fiorelli, Giuseppe. *Appunti autobiografici.* Edited by Stefano De Caro. Sorrento, 1994.

Fiorelli, Giuseppe. *Descrizione di Pompei.* Naples, 1875.

Fiorelli, Giuseppe. *Giornale degli scavi di Pompei.* Vol. 1. 1861.

Fiorelli, Giuseppe. *Giornale degli scavi di Pompei. Documenti originali publicati con note ed appendici.* Vol. 1. Naples: Alberto Detken, 1850.

Fiorelli, Giuseppe. *Gli scavi di Pompei dal 1861 al 1872. Relazione al Ministero della Istruzione Pubblica.* Naples: Tip. Italiana, 1873.

Fiorelli, Giuseppe. *Guida di Pompei.* Rome, 1877.

Fiorelli, Giuseppe. "Scoverta Pompejana." *Giornale di Napoli* (12 February 1863):3.

Fiorelli, Giuseppe. *Sulle regioni pompeiani e della loro antica distribuzione.* Naples, 1858. Reprinted in *Bullettino Archeologico Napoletano,* n.s., 7 (1 September 1858–31 August 1859): 11–13.

Fiorelli, Giuseppe. *Sulle scoverte archeologiche fatte in Italia dal 1846 al 1866. Relazione al ministero della istruzione pubblica.* Naples, 1867.

Forbes, S. Russell. *Rambles in Naples.* 3rd ed. London: T. Nelson and Sons, 1886.

Franchi dell'Orto, Luisa, ed. *Ercolano 1738–1988: 250 anni di ricerca archeologica (Atti del Convegno Internazionale Ravello-Ercolano-Napoli-Pompei, 30 ottobre–5 novembre 1988).* Rome: "L'ERMA" di Bretschneider, 1993.

Freedberg, David. *The Power of Images: Studies in the History and Theory of Response.* Chicago: University of Chicago Press, 1989.

Fucini, Renato. *Napoli a occhio nudo: Lettere ad un amico.* Florence: Successori Le Monnier, 1878.

García y García, Laurentino. *Nova Bibliotheca Pompeiana: 250 Anni di Bibliografia archeologica.* 2 vols. Rome: Bardi, 1998.

Gell, William. *Pompeiana.* 2nd ed. 2 vols. London: Rodwell and Martin, 1824.

Gell, William. *Pompeiana.* 3rd ed. London: H. G. Bohn, 1852.

Gigante, Marcello. *La cultura classica a Napoli nell'ottocento.* Naples, 1987.

Giornale degli scavi di Pompei. n.s. 4 vols (1868–79).

Goldsmidt, Augustus. "Account of the Discovery of Some Skeletons at Pompeii." In *Proceedings of the Society of Antiquaries of London,* ser. 2, 2:286–88. London, 1863.

Gray, Thomas. *The Vestal, or A Tale of Pompeii.* Boston: Gray and Bowen, 1830.

Gregorovius, Ferdinand. *Euphorion: Eine Dichtung aus Pompeji.* Leipzig: F. A. Brockhaus, 1858.

Gregorovius, Ferdinand. *Euphorion: Eine Dichtung aus Pompeji.* 2nd ed. Leipzig: F. A. Brockhaus, 1884.

Gregorovius, Ferdinand. *The Roman Journals.* Edited by Friedrich Althaus and

translated from the second German edition by Mrs. Gustavus W. Hamilton. London: G. Bell and Sons, 1911.

Grell, Chantal. *Herculanum et Pompéi dans les récits des voyageurs français du XVI-IIe siècle*. Memoires et documents sur Rome et l'Italie meridionale 2. Naples: Bibliothèque de l'institute français de Naples, 1982.

Guhl, Ernest, and Wilhelm Koner. *Leben der Griechen und Römer*. 6th ed. Berlin: Weidmann, 1893.

Gusman, Pierre. *Pompei: The City, Its Life and Art*. Translated by Florence Simmonds and M. Jourdain. London: W. Heinemann, 1900.

Guzzo, Pier Giovanni, ed. *Tales from an Eruption: Pompeii Herculaneum Oplontis: Guide to the Exhibition*. Naples: Electa, 2003.

Hall, James. *The World as Sculpture: The Changing Status of Sculpture from the Renaissance to the Present Day*. London, 1999.

Helbig, Wolfgang. *Wandgemälde vom Vesuv verschütteten Städte Campaniens*. Leipzig, 1868.

Herchenbach, Wilhelm. *Italien 6: Von Rom nach Neapel*. Regensburg: Manz, 1877.

Howells, William Dean. *Italian Journeys*. Marlboro, VT: Marlboro Press, 1988.

Humboldt, Alexander von. *Cosmos*. Translated by E. C. Otté and W. S. Dallas. Vol. 5. London, 1858.

Ivanoff, Sergio. "Varie specie di soglie in Pompei ed indagine sul vero sito della fauce." *Annali dell'Instituto di Corrispondenza Archeologica* 31 (1859): 82–108 (text); *Monumenti dell'Instituto di Corrispondenza Archeologica* 6 (1859), tavv. D'agg. D-E (plate).

Jenkins, Ian, and Kim Sloan. *Vases and Volcanoes: Sir William Hamilton and His Collection*. London, 1996.

Kockel, Valentin. *Die Grabbauten von den Herkulaner Tor in Pompeji*. Mainz: Philipp von Zabern, 1983.

Komunyakaa, Yusef. *Talking Dirty to the Gods*. New York: Farrar, Straus and Giroux, 2000.

Lalande, Joseph Jérôme de. *Voyage d'un françois en Italie fait dans les années 1765 et 1766*. 3rd ed. 7 vols. Geneva, 1790.

Latapie, François De Paule. "Description des fouilles de Pompéi (a. 1776)." Edited by Pierre Barrière and Amedeo Maiuri. *Rendiconti dell'Accademia di archeologia di Napoli*, n.s., 28 (1953): 223–48.

Layard, Austen Henry. Review of *PAH*. *London Quarterly Review* (American ed.) 115 (January–April 1864): 161–80.

Lazer, Estelle. *Resurrecting Pompeii*. London: Routledge, 2009.

Leppmann, Wolfgang. *Pompeii in Fact and Fiction.* London: Elek Books, 1968.

Leppmann, Wolfgang. *Winckelmann.* New York: Alfred A. Knopf, 1970.

Lippi, Carminantonio. *Fu il fuoco, o l'acqua che sotterrò Pompei ed Ercolano?* Naples: D. Sangiacomo, 1816.

Lytton. *See* Bulwer-Lytton.

Magaldi, Emilio. *Pompei e il suo dolore.* Naples: Emilio Magaldi, 1930.

Maiuri, Amedeo. *Bicentenario degli scavi di Pompei. L'inaugurazione dell'antiquarium. XIII giugno MCMXLVIII.* Naples: Gaetano Macchiaroli, 1948.

Maiuri, Amedeo. *Introduzione allo studio di Pompei.* Naples, 1949.

Maiuri, Amedeo. *Pompei.* Itinerari dei musei e monumenti d'Italia 3. Rome: Libreria dello Stato, 1931.

Maiuri, Amedeo, ed. 2 vols. *Pompeiana.* Naples, 1950.

Maiuri, Amedeo. *Pompei ed Ercolano fra case e abitanti.* Florence, 1958 [Repr. Florence: Giunti 1998].

Maiuri, Amedeo. *Pompeii.* Guide-books to museums and monuments in Italy 3. 5th ed. Rome, 1951.

Maiuri, Amedeo. *Vita d'Archeologo.* Naples, 1958.

Maniura, Robert, and Rupert Shepherd, eds. *Presence: The Inherence of the Prototype within Images and Other Objects.* Aldershot: Ashgate, 2006.

Mau, August. *Führer durch Pompeji.* 6th ed. Leipzig, 1928.

Mau, August. *Pompeii: Its Life and Art.* Translated by Francis W. Kelsey. New York, 1899.

Mau, August. *Pompeii: Its Life and Art.* Translated by Francis W. Kelsey. 2nd ed. New York, 1907. Repr. of New York 1902.

Mau, August. "Scavi di Pompei." *Bullettino del Instituto di Corrispondenza Archeologica* (1884): 126–39.

Mazois, Charles François, and Franz Christian Gau. *Les Ruines de Pompéi, dessinées et mesurées.* 4 vols. Paris: Firmin-Didot, 1824–38.

McIlwaine, I. C. *Herculaneum: A Guide to the Printed Sources.* 2 vols. Naples: Bibliopolis, 1988.

Minervini, Giulio. "Ossa e scheletri diseppeliti in Pompei." *Bullettino archeologico napoletano,* n.s. 3, no. 51 (July 1854): 1–3.

Momigliano, Arnaldo. "Ancient History and the Antiquarian." *Journal of the Warburg and Courtauld Institutes* 13 (1950): 285–315.

Monaco, Domenico. *A Complete Handbook to the Naples Museum.* English translation by E. Neville-Rolfe. 6th ed. Naples: Furchheim, 1893.

Monnier, Marc. *The Wonders of Pompeii*. New York: Charles Scribner, 1870.

Moormann, Eric M. "Literary Evocations of Ancient Pompeii." In *Tales from an Eruption: Pompeii Herculaneum Oplontis: Guide to the Exhibition*, edited by Pier Giovanni Guzzo, 14–33. Naples: Electa, 2003.

Moormann, Eric M. "The Sense of Time in Early Studies on Pompeii." In *Omni pede stare: Saggi architettonici e circumvesuviani in memoriam Jos de Waele*, edited by Stephan T. A. M. Mols and Eric Moormann, Studi della Soprintendenza archeologica di Pompei 9, 335–42. Naples: Electa, 2005.

Morlicchio, Francesco [?]. *Guide to Pompei, Illustrated*. Scafati-Pompeii: Pompeian Tipographical Establishment and Library, [1901].

Neville-Rolfe, Eustace. *Pompeii, Popular and Practical: An Easy Book on a Difficult Subject*. Naples: Furchheim, 1888.

"Nouvelles Archéologique." *Revue Archéologique*, ser. 2, 7–8 (1863): 210–11.

Overbeck, Johannes. *Pompeji*. Leipzig: Engelmann, 1856.

Overbeck, Johannes. *Pompeji*. 2nd ed. Leipzig: Engelmann, 1866.

Overbeck, Johannes. *Pompeji*. 3rd ed. Leipzig: Engelmann, 1875.

Overbeck, Johannes. *Pompeji*. 4th ed. Leipzig: Engelmann, 1884.

Pagano, Mario. "Metodologia dei restauri borbonici a Pompei ed Ercolano." *Rivista di Studi Pompeiani* 5 (1991–92): 169–91.

Pagano, Mario. "Una legge ritrovata: Il progetto di legge per il riordinamento del R. museo di Napoli e degli scavi di antichità del 1848 e il ruole di G. Fiorelli." *Archivio storico per le provincie napoletano* 112 (1994): 351–414.

Pagano, Niccola. *Guida di Pompei*. 5th ed. Naples: Fratelli Testa, 1873.

Pais, Ettore. *Ancient Legends of Roman History*. Chicago, 1905.

Pais, Ettore. *Relazione della Commissione d'Inchiesta (Ferrari, Sacconi, Basile) a S. E. Il Ministro della Pubblica Istruzione* . . . Rome, 1917.

Pais, Ettore. *Il Riordinamento del Museo Nazionale di Napoli*. Part 1, *Appendix*. Naples, 1903.

Palumbo, Antonio. *Catalogo ragionato delle pubblicazioni archeologiche e politiche di Giuseppe Fiorelli*. Città di Castello: S. Lapi, 1913.

Poli Capri, Paola. *More Letters and Documents*. Rome: H. B. Vander Poel, 1998.

Poli Capri, Paola. *Pompei, Ercolano, Napoli, e Dintorni (Lettere e documenti)*. 1st ser. 1861–77. 10 vols. Rome: H. B. Vander Poel, 1996–.

Pompei: Pitture e Mosaici. 11 vols. Rome: Istituto della Enciclopedia Italiana, 1990–.

Pompeji: Leben und Kunst in den Vesuvstädten (19 April bis 15 Juli 1973 in Villa Hügel, Essen). 2nd ed. Recklinghausen: Aurel Bongers, 1973.

Pozzolini-Siciliani, Cesira. "Gita a Pompei." *Nuova Antologia di Scienze, Lettere ed Arti,* 2nd ser., no. 15 [vol. 45] (Rome 1879): 60–87.

Presuhn, Emil. Pompeji. *Die neusten Ausgrabungen von 1874 bis 1878. Für Kunst und Alterthumsfreunde.* 7 parts. Leipzig: T. O. Weigel, 1878.

Richardson, Lawrence, jr. *Pompeii: An Architectural History.* Baltimore: Johns Hopkins University Press, 1988.

Rosenthal, Donald. "Joseph Franque's Scene during the Eruption of Vesuvius." *Philadelphia Museum of Art Bulletin 75,* no. 324 (March 1979): 2–15.

Ruggiero, Michele. "In qual modo e con quali effetti si può credere che seguisse l'eruzione," In *Pompei e la regione sotterrata dal Vesuvio nell'anno LXXIX.* 2 vols. Naples: Ufficio Tecnico degli Scavi delle provincie meridionali, 1879. 1:21–32.

Saint-Non, Jean-Claude Richard de. *Voyage pittoresque, ou Description des Royaumes de Naples et de Sicile.* 4 vols. Paris: Clousier, 1781–86.

Settembrini, Luigi. "I Pompeiani." *Giornale di Napoli* (17 February 1863):1. Reprinted in *Scritti vari di letteratura politica ed arte.* Ed. F. Fiorentino. 1:333–37. Naples: Morano, 1878.

Silliman, Benjamin. *A Visit to Europe in 1851.* 2 vols. New York: G. P. Putnam, 1853.

Snowden, Frank M. *Naples in the Time of Cholera, 1884–1911.* Cambridge, 1995.

Sogliano, Antonio. "Gli scavi di Pompei dal 1873 al 1900." In *Atti del Congresso Internazionale di Scienze storiche* (Rome, 1–9 April 1903), 5:295–349, Atti della sezione 4: Archeologia. Rome: Accademia dei Lincei, 1904.

Sogliano, Antonio. *Guide de Pompéi.* Rome: Accademia dei Lincei, 1899.

Sogliano, Antonio. "La scuola archeologica di Pompei." *Rendiconti della R. Accademia nazionale dei Lincei, Classe di scienze morali, storiche e filologiche,* ser. 6, 15, no. 5–6 (May–June 1939): 323–42.

Stark, Carl Bernhard. *Systematik und Geschichte der Archäologie der Kunst.* Leipzig: W. Engelmann, 1880.

Taine, Hippolyte. *Italy: Rome and Naples.* Translated by J. Durand. 4th ed. New York: Holt and Williams, 1872.

Thomas, Hylton A. "Piranesi and Pompeii." *Kunstmuseets Arsskrift* (1952–55):13–28.

Trevelyan, Raleigh. *The Shadow of Vesuvius.* London, 1976.

Vallet, Georges. "Un inedito di Georges Vallet: La découverte des cités vésuviennes et le dialogue entre les sciences de la nature et sciences de l'homme au XVIIIe siècle." Edited by Laura Vallet. In *Il Vesuvio e le città vesuviane, 1730–1860,* 11–28. Naples, 1998.

Vander Poel, Halsted Billings. *Corpus Topographicum Pompeianum*. Pars 2, *Toponymy*. Rome: Bardi, 1983.

Vander Poel, Halsted Billings, and Paola Poli Capri, eds. *Scavi di Pompei: Giornale dei Soprastanti*. 9 vols. Rome, 1994.

Varone, Antonio. *Pompei: I misteri di una città sepolta*. 2nd ed. Rome, 2000.

Venturi, Adolfo. *Memorie*. Milan, 1911.

Waldstein, Charles. *Ercolano*. Turin, 1910.

Ward-Perkins, John, and Amanda Claridge. *Pompeii A.D. 79*. London: Imperial Tobacco, 1976.

Warsher, Tatiana. *Pompeii in Three Hours*. Rome, 1930.

Werge, J. "Photography and the Immured Pompeiians." *Photographic News* (4 September 1868): 427–28.

Wickert, Lothar. *Theodor Mommsen: Eine Biographie*. 4 vols. Frankfurt, 1959–80.

Winckelmann, Johann Joachim. *The History of Ancient Art*. Translated by G. Henry Lodge. 2 vols. New York: F. Ungar, 1969.

Winckelmann, Johann Joachim. *Sämtliche Werke*. Edited by Joseph Eiselein. 12 vols. Donauöschingen, 1825–29.

Winckelmann, Johann Joachim. *Sendschreiben von den Herkulanischen Entdeckungen (Herculanische Schriften I)*. Edited by Stephanie-Gerrit Bruer and Max Kunze. Mainz: Philipp von Zabern, 1997.

Index

Printed and bound by CPI Group (UK) Ltd, Croydon, CR0 4YY

09/06/2025

14685645-0001